The Artist's Quest
for Inspiration

The Artist's Quest for Inspiration

PEGGY HADDEN

ALLWORTH PRESS
NEW YORK

04 03 02 01 00 99 5 4 3 2 1

Published by Allworth Press
An imprint of Allworth Communications
10 East 23rd Street, New York, NY 10010

Cover design by Douglas Design Associates, New York, NY

Page composition/typography by Sharp Designs, Lansing, MI

Cover image by Leonardo da Vinci
Interior art by Daniel Kopp

ISBN: 1-58115-027-X

Library of Congress Catalog Card Number: 98-74531

Printed in Canada

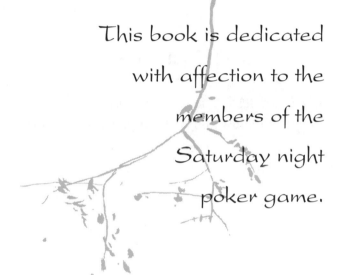

This book is dedicated
with affection to the
members of the
Saturday night
poker game.

ALSO BY PEGGY HADDEN

The Artist's Guide to New Markets:
Opportunities to Show and Sell Art Beyond Galleries

Table of Contents

Acknowledgments ... xiii

Introduction .. xv

Part I. Expanding on What You See

1. **Learning to Look and See More** 3

 How I Thought I Saw

 Seeing Beyond Labels

 When You've Been Inspired

 Enabling Inspiration

 Naming What You See

 The Ever-Expanding Universe

 Building a Style

2. **You and the Real Creative Problem** 29

 Sharpening Your Senses

Touching and Feeling
Smelling Inspiration
The Power of Taste
How You May Be Thinking About Inspiration
Ask Dumb Questions
Write Your Own Review

3. **Creativity and Self-Esteem** 47
What Kills Creativity
Building Your Confidence Balance
Professionalism and Self-Esteem
Afraid to Change?
Your Moods and Creativity
Giving Yourself Helpful Affirmations

4. **Fearing Creativity** ... 67
Facing Your Fears
Fear of Failure
Ambiguity: For and Against
Editing Your Work
Fear of Yourself As "The Artist"
Creativity and Living Forever
Finding the Child in You
Make a Mess
Inspirational Breathing
Intuition: Other Information We Have

5. **Exploring the Value of Solitude** 83
Your Time Alone
That Essential Aloneness
Stilling Your Mind for Inner Peace
Artists Alone Together
Artists On-Line
Artists Who Chronicle Society

Part II. Expanding on What You Expect

6. **Seeking the Source of Inspiration** 105
 Organizing Yourself to Receive Inspiration
 100,000 Trees
 Why You Make Art As You Do
 Diego Rivera
 Ben Shahn
 Thomas Hart Benton
 Artists As Activists
 Showing Ideas in Your Work
 Aesthetic Inspiration
 Which Inspiration to Follow?
 Caring for Your Gray Matter
 Nourish Your Brain!
 Selecting and Nurturing Ideas
 Don't Get in Your Own Way

7. **Journals: Another Path to
 Finding Inspiration** 133
 Why Keep a Journal?
 The Intensive Journal®
 Artists Who Keep Journals
 Journals Feed the Creative Process
 Artists at National Parks

Part III. Expanding Your Day-to-Day Experience

8. **Inspiring Yourself** ... 149
 Artists and Light
 Details
 Working in Two Ways
 Taking a Second Look

Nostalgia and Other People's Memories
Using Cause and Effect
Showing Motion
Reflecting Time
Inspired by Not Knowing
How Things Change
Allow for Spontaneity
Words Paint Images
Dreaming Inspiration
Starting Over from Scratch

9. **Finding New Places** ... 177
Inspiration in Everyday Places
A Journey Through Color
Exotic Places
Walking to New Places
Films as Sources of Inspiration

10. **Art Ancestors: Help from the Past** 191
Eugène Delacroix
Leonardo da Vinci
Modern Journals

11. **Creating Spaces for Inspiration** 203
Two Studios
Feng Shui
How You Work
In the Trenches

Part IV. Expanding Your Options

12. **Keeping Inspiration Alive** 215
Overcoming Blocks
Completing the Work

13. Exploring the Edges .. 227
 Brainstorming
 Self-Hypnosis
 Use Your Sleep Time!
 The Self-Help Bookshelf

In Closing .. 237
 Summoning Your Inspiration—Your Choice

Bibliography
Credits
Index

Acknowledgments

The author wishes to express her appreciation to the following for their invaluable assistance: the Museum of Modern Art Library and Film Department, the Mary Boone Gallery, the Pace Wildenstein Gallery, the Authors Guild, the Open Center, and the Leo Castelli Gallery. They were gracious with their time and helped answer a million questions. Individuals who deserve my thanks are: Barbara Yoshida, John and Pat Gunter, Sally Hadden and Robert Berkhofer, Paul Tschinkel, Lillian Lent, Milly Schoenbaum, Evan Morley, Betty Kronsky, Elizabeth Angele at the Goethe Institute, Anne Hellman, and most especially my editor, Nicole Potter.

Various quotes used here were located with the assistance of *Artists in Quotation* compiled by Donna

Ward La Cour (McFarland & Co., Inc., 1989). Her kind permission to use them is greatly appreciated. Ian Crofton's *A Dictionary of Art Quotations* (Schirmer Books, 1989) was also of great help.

Introduction

Of all of the artists' career issues about which I have written, the one that artists must face most often is their own artistic inspiration—how to make it come when it is bidden and stay as long as it's needed. An artist myself, I've been frustrated when inspiration is slow in coming. Technological feats can be learned and craft perfected, but we all know that the impulse to create a work can remain distant and unpredictable.

Your creativity is unique to you. Your method of working is as individual as you are. Within that framework, can your steps to inspiration be built upon, enlarged, sustained? I offer you an opportunity to learn about your creativity and to ensure that it will always be there when you need it. Here you will find the steps for living with and sustaining inspiration while you create and finish memorable artwork.

The Artist's Quest for Inspiration is divided into four parts:
- Expanding on What You See
- Expanding on What You Expect
- Expanding Your Day-to-Day Experience
- Expanding Your Options

The gray boxes in each chapter suggest exercises to try on your own. The ideas put forth in this book are designed to help you understand your creativity and its herald, inspiration.

PEGGY HADDEN
New York, 1999

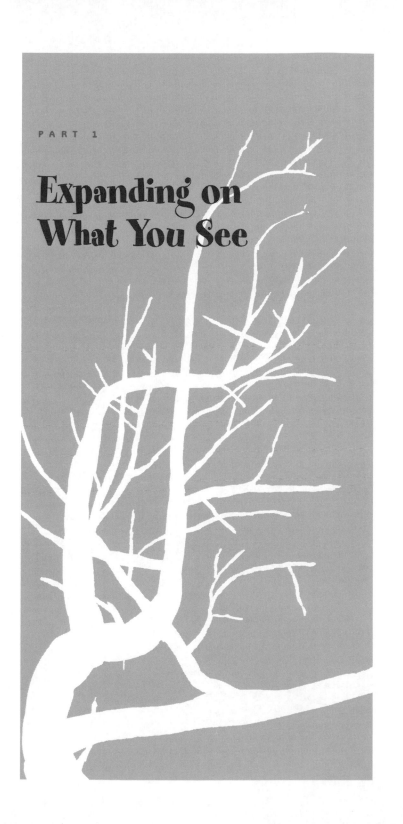

PART 1

Expanding on What You See

Learning to Look and See More

Creation begins with vision.

—Henri Matisse

Have you ever thought that some artists seem to find inspiration more easily than others? Ever wonder why some of them seem to be more in touch with new ideas and better prepared to receive inspiration and act on it? Can this expertise be learned? The goal of this book is to make you aware of your own creativity and how it works. With this knowledge, you will be able to find inspiration when you're ready for it.

One of the mysteries of art is that it does something to those who see it, but they're not sure what. Artists are very aware of this and, to be honest, sometimes we don't understand the power that art has, either. We also aren't sure what we do that makes an artwork seem wonderful to others. This book will not demystify art. But, hopefully, it will help you understand how you contribute to making art

wonderful and how you can find new ways to keep a
stream of creativity flowing steadily for years and
decades to come.

Artists become inspired by looking at everything
around them, seeing and collecting, and then apply-
ing what they observe to projects they wish to create.
Thus, if you saw more, your opportunity to be in-
spired would be greater. But what or how is it, you
ask, that others are seeing things that I'm missing?

John Berger's *Ways of Seeing* offers words that
speak to this point:

> Seeing comes before words. The child looks and
> recognizes before it can speak. But there is also
> another sense in which seeing comes before words.
> It is seeing which establishes our place in the
> surrounding world; we explain that world with
> words, but words can never undo the fact that we
> are surrounded by it. The relation between what we
> see and what we know is never settled.

We are all, thankfully, unique. What our brains
register when we see is one of the elements that
defines everyone's individuality. What is meant by
having a vivid imagination? Definitions say "full of
life," but what seems full of life to some may sit on the
page full of stiffness for others, unless they receive the
gift of inspiration. What inspires you to make a
drawing is not the same thing that would move me to
take up pad and pencil. Likewise, what gets me
drawing would probably not motivate you. Inspira-
tion is what makes all of us "one-of-a-kind." Without
our selective sensibilities, museums would be tiny
buildings and galleries would run a single artist's

exhibition for years at a time. This voyage to individual inspiration is a trip to be planned by you and for you. I hope that the ideas and information contained in this book will help guide you.

How I Thought I Saw

When I was very young, I found a fragment of a doll with the back of the skull missing. As I looked at the face of the doll, however, the eyes were still functioning and seemed to open and close as mine did. The mechanism of the doll's eyes allowed them to roll over and appear to close because of the flesh-colored paint on the opposite side. I must have investigated this operation quite carefully. I decided that when the doll's eyes were open, she saw the outside world, yet while they were closed, I could still see the open eyes from the back of her head. I concluded from this that when *my* eyes were closed, they faced the back of my head, but were still open. For years, I can remember closing my eyes and thinking to myself, "Now what I am really seeing is the inside of the back of my head." And I thought it was a great secret that only I had been lucky enough to discover!

What was the first thing you remember seeing?

A few years ago, I was asking everyone I knew that question. I myself recall the light coming through a pulled-down window shade in the room where I was sent to take a nap. The shade, probably a little lighter than a paper bag in color, became richer, a sort of butterscotch, when there was sun outside. I was probably three years old at the time. I loved that color and still do. My friend Suzanne says that she can recall exactly the wallpaper pattern that deco-

rated the wall next to her crib. Another friend, who grew up in the Southwest, remembers watching her mother walk away from her through the slats of a picket fence. She next remembers her mother coming back to her with her newborn baby brother. Often, our memories are connected to significant events in our past.

Do you remember incidents of visual discovery from your childhood? Choose an event and write about it in as much detail as you can recall. Add to it as you remember more. Later, in another chapter, we will construct a journal for you to keep. You may want to include these episodes there. You could jot down your thoughts about the incident now, or you might simply leave it as you have written it, like an island, or an isolated incident. Whatever you decide to do with it, or however important it seemed at the time it happened, it truly had an influence on you. After all, you've been remembering it for a long time!

Do you remember looking first with one eye and then with two? Things seemed to move, although everything in the first view was still there in the second. Do you remember when you tried to see your nose?

If you were like me, you thought, at least in the beginning, that everyone saw as you did. It was a big shock to find out that people saw the same thing differently. This realization may have come to us in our first school year, during "show and tell." While classmates talked about things with which we were all familiar, their impressions were completely different than ours. In fact, how we see and register objects is almost as individual as we are. No one actively sets

out to teach us how to see. Yet certain things are pointed out to us, while other things are allowed to drift past us, unmentioned. What catches our eye may or may not be what was originally pointed out by someone else.

The creative impulse suddenly springs to life, like a flame, passes through the hand on to the canvas, where it spreads farther until, like the spark that closes an electric circuit, it returns to the source: the eye and the mind.

—Paul Klee

Another element that impacts the way we see and what we see is our ethnicity, our cultural/familial background. Are you the child of immigrants? Were you raised on a farm or in a large city? Were your parents or those directly responsible for raising you older than average parents? If you have siblings, are you older or younger than they are? While a lot of these differences may be evened out through the socialization process (that is, going to school), some answers to the above questions will be part of your makeup for as long as you live. Even within a family, distinctions are evident. I am the oldest of five, and when I was a child, we almost never went out to eat. Our economic situation did not allow for restaurant meals. By the time my youngest sister was born, however, my mom was working, and she often took my youngest sister to a local cafeteria rather than cooking at home. While I didn't learn how to order food in a restaurant until I was in my teens, my youngest sister was a pro at speaking to a counter-

person, ordering her food, and acquiring a glass of
water, salt and pepper, or catsup by the time she was
seven years old! In amazement, I watched her exper-
tise at skills that had not come to me so easily.

In another early memory of mine, I am trying to
sprinkle salt on a bird's tail. I had been told the old
tale that if you could sprinkle salt on a bird's tail, the
bird would become your pet. I took the salt shaker
and spent the entire afternoon running around the
backyard, trying furiously to make this happen. Of
course, the catch to this myth is that you can never
get close enough to the bird to sprinkle *anything* on it.
Yet, our childhood understanding of superstitions and
old wives' tales not only provides fond memories,
which can be called upon later, but also contributes to
our evolving point of view.

Attention is important, too, because the things we
pay attention to comprise our conscious minds. These
are the elements we file away and can bring back
later—our memories. The collection of everything we
remember is what makes up our lives. Certainly, we
remember things to different degrees, from our old
street addresses to the first time we were given an IQ
score. For each of us, reality becomes those little
details of memory glued together, one after another.

A further (and fascinating) study of the limits of consciousness and how
much information we are able to absorb can be found in *Flow: The
Psychology of Optimal Experience* by Mihalyi Csikszentmihalyi.

List the five things you spend most of your time thinking about. Is one of
them art? We all pay attention to something every minute we are

conscious. How much of that time can be sliced off from other things to concentrate on future art projects? What about your tools? Do you have the pieces necessary to make the best art?

Think about what your attention is focused on. How might you expand your concentration and harvest more sensory information, which could be used in your conscious mind? While we have the ability to store a great deal of information, we can gather even more if we are using our attention-paying abilities to the max in the search for artistic inspiration.

We also have the ability (at least some of the time) to screen out the cacophonous "white noise" of background sounds around us and to aim our attention-receiving monitor in a specific direction. At one point the focus of our attention may be toward our family, say, or toward a team sport or nature. In infancy, attention is pretty scattered. You can observe the mind beginning to focus when a small child can think or speak of nothing else but a toy that she wants very badly.

Throughout this book, I have collected exercises that can help you prepare for inspiration. I've made available some note pages at the end, which you can use for writing down your thoughts and ideas as they come to you. As inspirations are ephemeral, they may not stay with you long. It may be better to make notes as you go along, rather than to try holding on to a thought until you've finished reading.

Painting, because of its universality, becomes speculation.

—El Greco

The importance of a focused mind can't be over-stated. A good exercise for sharpening focus and paying attention follows.

Draw fifty arrows about three to four inches long and two inches wide and cut them out. Paste or tape them up in your studio at various spots, highlighting things you'd like your attention drawn to—maybe a postcard or a container of something that is almost empty and will soon need to be replaced. Leave these arrows in place for a week and notice how your attention is drawn to them each time you enter the room.

This exercise can help you see how easy it is to direct your own attention. Ways to both capture your attention and focus it more intently are helpful in concentrating. The people who make TV commercials can tell you that. Better concentration can make you more aware of the flickers of inspiration that may not be strong enough yet to reach your conscious attention.

Seeing Beyond Labels

Our ancestors named the things that they saw, and the need for language evolved when at least two of them tried to communicate with each other. For the artist, whose thinking and planning is historically done alone much of the time, having a name for things is mostly unnecessary as long as she uses other mental and physical attributes to distinguish the object for herself. Today, we are so overwhelmed with language and the media from an early age, that it becomes difficult for us to see a thing without having

an appropriate name pop into our minds to describe it. Try seeing a thing without thinking of its name. The title of contemporary artist Robert Irwin's biography, *Seeing is Forgetting the Name of the Thing One Sees,* presents this idea perfectly. Seeing an object without naming it allows it to be ambiguous or something else altogether. An object might change from being one thing to another. Surrealist René Magritte brought this idea home to us when he painted a man's hat and titled it *Ceci n'est pas une pipe* ("This is not a pipe.") For you as an artist, an object without a name can be very handy. Discoveries found on long walks may have been put out on the street as garbage, but they may have just the right shape, size, or intricacy to add to an assemblage or painted work you're making. I remember finding an object that was made of foam. It had an arresting shape and I was fascinated with it. Wondering what it was, I took it home to use in a work of art. Imagine my embarrassment and consternation when I was advised that it was a cushion for the aid of specific medical problems. I was happier not knowing!

If we knew what we saw, we could paint it.

—Robert Henri

Try looking around you now, at whatever objects may be nearby, and make an effort to see them without thinking of their names. Study their shapes, colors, textures, and so on; allow yourself to see and explore without automatically categorizing them. Consciously look at five objects without tying them to names. It's harder than you think!

Immediately, you may see other uses for these objects. Over the days that follow, continue this exercise so that it becomes easier and easier to accomplish. Write down what you observe and how it affects you as you practice this exercise. You can easily prove to yourself that names are not indispensable. Think of someone whom you see everyday and whose name you *don't* know—maybe someone at work or someone who walks a dog where you walk yours. Perhaps you've seen him for years, but you've never learned his name. You may be satisfied to say hello to him each day and *never* know his name. Here, you can see how unnecessary a name truly is—you know who he is without having a language label of him. You may know all kinds of information about him, such as where he lives, the name of his dog, that he's recently lost lots of weight, and so on—you just don't happen to know him *by name*. Does this make you act differently when you see him? Does he need a name? Not for me, you say. I know who he is.

An example of this name/nameless experience was brought home to me one day when I decided to throw away some of my old drawings. These were "semi-successful" efforts I had carried around with me for years, liking parts of them and saying I would fix what was not perfect at some point in the future. Abstract in content, they were painted shapes on paper with pastel lines drawn around them, the pastel smeared. One day, in a cleaning frenzy, I decided they had to go; I could keep them no longer. I tore them up into smaller, more manageable pieces. On the way to dispose of them, I glanced down at a fragment of one of them. "You know," I said to myself, "I like that piece better than I liked the whole drawing!" I stopped.

What was to stop me from keeping the fragment and making *it* the whole work? If photographers could crop a shot, leaving only what they wanted to be seen, why couldn't I crop a drawing? Slowly I turned around and retraced the steps to my apartment. *I knew* that the fragment was part of something larger, that it had existed in life as part of a "less than perfect" drawing, but no one else did. To anyone else, it would be as complete as it had ever been, all of it they would ever see. Words like *whole* and *fragment* and *complete* became meaningless. If I said the fragment was the whole thing, then it was. Seven years of collage making to explore this idea followed, combining bits taken from drawings, which were now experiencing a second life. When the bits from several drawings were combined, they became a new whole.

Did you know that Philip Pearlstein, the well-known painter of figures, once worked for *Life* magazine, where his job included cropping photographs? He said, "Often you'd . . . get this gigantic blowup photograph back so you could use just one small part of it. It was fascinating seeing how scale changed. By scale, I mean the size of the objects in the picture in relation to the outer edge." When you next see one of Pearlstein's paintings, study the intelligent way the contents sit within the edges of the borders. Or are trimmed partly away so you see only part of them. Ask yourself if the ability to crop photographs influenced Pearlstein's work. Now, try cropping a piece of your own work, blocking out parts that really don't add anything to the piece. Does that make your work more powerful? What does this say about the scale of your images in relation to the whole work? Are your images too small for the overall size of the artwork? Could they be larger or the canvas smaller?

By expanding the way you see, you can open yourself to greater inspiration. Here's an exercise that will stretch how you see. It's simple and can be practiced anywhere.

Choose five items that seem to have much in common, such as five hand tools from the garage or five cooking utensils in the kitchen. Now imagine these five elements having a conversation. For example:

"I am very special because I am very wide."

"Yes, but I am very special because I am very efficient."

"Yes, but I am very special because I can chop most effectively."

"Yes, but I am very special because I can roll the smoothest crust."

"Yes, but I am made of glass, so I am transparent."

Try the conversation with the items in front of you, so that you can really observe them closely. What's different, what's the same, what makes them rival each other, which is older, or newer, and does that matter? Continue this exercise, finding new objects for the conversation every day until you have finished this book.

This exercise will help you single out the small differences between items that are similar but, on closer inspection, have characteristics that make them distinctive. Once you become more accustomed to sighting these differences, you'll realize that you are starting to see with greater acuity.

When you begin meditation, your instructor tells you to focus on a simple thing, perhaps a rose. You concentrate so hard on that one rose that the rest of the world around you simply disappears. You take note of all of the rose's special qualities. There is absolutely nothing else in your world except that rose. Later, if you place another rose next to the original

one, you can easily tell them apart. Even tiny differ-
ences will be evident to you because you have learned
to see what is distinctive in each one. Consciously
begin to enlarge your capacity in order to see even
the *slightest* differences.

To learn more about the different ways we've been taught to see, read
Ways of Seeing by John Berger—I used a quote from this book earlier.
Now in print for almost twenty-five years, this is still a favorite book of
many artists who are curious about how art has been viewed throughout
time by the general public. This slim paperback presents an insightful
look at how humankind has viewed paintings since before the invention
of perspective. How paintings related to the buildings that housed them,
how painters related to their subjects, how women were presented, how
wealth and the wealthy were portrayed, and how the rewards for morality
were depicted are only some of the topics that are tackled here.

Berger also examines the changing relationship between the artist
and the buyer. How was art commissioned and what types of art were
sought? Did art change when used with text? (Yes, it became illustra-
tion.)

With the invention of film and the camera, the way people saw
images changed forever. Berger compares and contrasts movie film (a
series of edited images that build an argument and reinforce a point of
view) and still art (a single image able to maintain its own authority).
Portions of *Ways of Seeing* have no text, yet so convincing is the use of
images, that words aren't necessary. Alternative ways to view the old
masters are only some of the many riches contained in *Ways of Seeing*.

Art made in the past may seem stale and unimpor-
tant to you now, but think again. Just as you do today,
artists of the past worked with whatever tools they
had available at the time for the art they made. While

their tools or their subject matter may seem out of date to you now, you can still learn more from just looking at the ways other artists have rendered their work than you can by reading all the books written about technique. These people are our ancestors. They've faced the same problems that we encounter today. Perhaps art historian Leo Steinberg put it best: "All art is infested by other art."

Other sources for you from the past may include photographs or trips to museums. Don't forget specialty museums, like military history or the National Air and Space Museum in Washington, D.C. An afternoon spent at the Isamu Noguchi Museum, in Long Island City, Queens, can put your mind into a new place and give you plenty to think about.

When You've Been Inspired

Go back in your mind now to when you last had a feeling of inspiration. We all experience its golden tinglings differently. By reliving that moment, you may be able to anticipate how inspiration will come to you next time. There are many phases to the creative process, including: fervent work, followed by little success, followed by a turn to relaxation, followed by a sharp encounter (insight) when least expected.

Try to remember what happened when you felt a good idea arrive. What time of day was it? Had you been asleep before it happened? What physically indicated an inspiration? Several different kinds of experiences may signal the onset of inspiration. These include:

- *visual*—you may have experienced strong mental images or vivid dreams

- *audible*—the lines of a song that you sang as a child or hearing someone speak whose voice sounded familiar may have inspired you
- *smell*—familiar smells from your youth may bring forth a flood of memories that got your creative juices flowing
- *visceral feelings*—sudden tears that just stole over you, or maybe a quick rush of energy caused by a shiver of remembrance

What did you feel? There are many different ways that we experience inspiration. Maybe a chill ran up your spine. Possibly you heard a click, like the tumblers of a lock falling into place or saw pieces of a puzzle that were there all the time, now suddenly fitting together. Perhaps you didn't hear or see anything at all, but a warm glow came over you. The voice of your curiosity ("I wonder what would happen if I . . . ?") might have prompted an inner response that was totally unexpected. Perhaps you felt a physical jolt. Any of your senses could have made you feel that wonderful "juice" flowing through you, urging you to begin a new project or solve an old problem. Maybe you felt suddenly moved to behave in a certain way, which is generally called "being inspired."

Of several bodies, all equally large and equally distant, that which is most brightly illuminated will appear to the eye nearest and largest.

—Leonardo da Vinci

Remember those sudden haircuts we have all given ourselves? What about adding extra ingredients

to a recipe? Speaking of recipes, what part does hunger play in your inspiration process? Are you hungry when the great ideas come? Ernest Hemingway, in *The Moveable Feast,* recalled going to the Luxembourg Museum in Paris hungry:

> . . . all the paintings were sharpened and clearer and more beautiful if you were belly-empty, hollow-hungry. I learned to understand Cézanne much better and to see truly how he made landscapes when I was hungry. I used to wonder if he were hungry too when he painted; but I thought possibly it was only that he had forgotten to eat.
>
> It was one of those unsound but illuminating thoughts you have when you have been sleepless or hungry. Later I thought Cézanne was probably hungry in a different way.

Often, we are reminded of past events when we hear familar music. When Dan Wakefield was writing his nostalgic book, *New York in the Fifties,* he played certain records that he had often heard during that period. They helped him awaken certain emotional ties to the past. On a walk, not long ago, I heard someone whistling a popular song from the early 1900s, "By the Light of the Silvery Moon." I listened intently to see if he'd get every note right. He did. It is captivating to hear songs that bring back the past and make you happy.

I think creative responses are helped by singing old songs. I know it can lift my mood. Even in private, singing can help you remember incidents from your past that might have drifted off to a corner of your mind's attic.

The arts are often eliminated from today's school curriculum. I hope music won't be abandoned, because it is one of the pathways back to our past, a road that can help us to relive the past. Here are some old standards that you probably don't even know you know: "Let it Be," "Satisfaction," or "Yesterday."

Some artists can only create when they are angry or sad. For them, experiencing one emotion is the tiny door to other feelings, the key that unlocks a whole range of emotions. Expressing any sentiment will help you get in touch with all your other feelings, like crying that turns into laughter. Often, we put a hold on any emotion after a painful loss, but ultimately, we need to have access to our emotions if we want to be able to access inspiration. Another pathway is opened.

Seeing depends on knowledge
And knowledge, of course, on your college
But when you are erudite and wise
What matters is, to use your eyes.

—E. H. Gombrich

Enabling Inspiration

It's also important to remember that, as an artist, you won't get better technically by *just thinking* about your work. Whether you've had formal art training or not, you'll have to get in there and hack around, getting better technically as you do. That is your responsibility. When I decided to begin using straight lines in my work, I started by using various types of

sticking tapes to help ensure linearity. But the tapes I tried either leaked, leaving the line blotchy, or tore when I tried to remove them. I was so frustrated that I vowed I would learn to paint absolutely straight or curved lines wherever I wanted them, without a ruler. It took me the better part of a year to accomplish. I had to judge how much paint to allow on the brush, which brush worked best, and how fast I could paint. Most colors required several coats, and painting the second coat exactly over the first made it even more difficult. One system that I read about helped me immensely. To get really straight lines, I was advised to place a grid of threads or string (one set horizontal, one set vertical) over the canvas, the ends tied to small nails (or staples) on the top and bottom sides of the stretchers. These I would remove after the painting was completed. By the time I got this system firmly under my belt, I had completed eight paintings that incorporated perfect lines as part of the composition. I had gained a new skill, although it was not learned overnight.

As far as my painting is concerned, I think too much and too carefully about it. I can envisage it too clearly. I can see my form. That is what is killing me.

—André Derain

Some time later, I got an exhibition and showed those paintings in a solo show in a small gallery in New York City's East Village.

In talking about inspiration and creativity, we need to face the painful fact that sometimes our choices are limited by our technical proficiency. If you

have had a brilliant inspiration to make something new, but have never worked in the way that is required to accomplish it, you will have to perfect the necessary steps in order to get the brilliant result. Otherwise, becoming inspired won't help you. Lots of artists get great ideas and then can't follow them through to the finished product—a stunningly rendered work of art.

Let's be honest—the act of creativity appears to be a mystery. And we want it to be, at least to others, if not to ourselves. The ability to create beautiful works of art is a rare gift, and this gift makes artists special in society. No wonder it is painful (and even worse than that) when inspiration disappears and we, who have basked in its blessings, don't have the slightest idea how to get it back!

Naming What You See

Inspiration literally means "breathing in," says Natalie Goldberg, in her book *Writing Down the Bones*. She elaborates, "Breathing in energy, breathing in everything around you. Taking everything about you into consideration."

Here, each of you is your own best friend. You have your past work to analyze and learn from as a framework for the future. You can study the imagery you have used in the past, and extract from it the images you liked. They'll go into your new work. You will build on these. These images may not even have names. They are just shapes you like. In a way, this follows our discussion in the section concerning nameless things.

Sometimes, though, certain words can make

images come to you. Before, we practiced removing the names from things; now we will construct an exercise that does just the opposite.

Certain words, by themselves, can conjure up an image. Notice that a set of words that starts out as a list of concrete nouns becomes more descriptive and evocative as you keep at this.

Some words help you see images. For this exercise, make a list of words that work this way for you. Read them and add a few more every day. This way, the list will grow as you write them down and keep reviewing all of them. If you change your mind, you can substitute another word for one that you've decided you don't like. If it is a bit difficult for you to get started, think of a place or time, and the words will come more easily. Here's an example:

Rain • Summer • Path • Sundresses • Sea • Ocean
Dolphins • Rum • Azure • Calypso • Leafy • Sultry

Every day, make a list of words that bring an image to mind. Continue adding on so that each day the list grows and you have the chance to see these images over and over, each new day. Try to keep this very personal, so that the images are uniquely yours. From one day to the next, you may find that the images change. Don't worry. You are storing *image templates* in your mind for use at a later date.

The Ever-Expanding Universe

You may have noticed that, in the exercises I suggest, that I try to get you to expand, to always add a bit more. My theory is that the more options you give

yourself, the less apt you are to find yourself running out of gas.

If you think of other possibilities for each exercise, and then one idea doesn't work out, you will have more with which to work. You do not have to slink off like a cartoon character and come up with another full-blown concept. Brick houses, even big ones, are built with lots of little bricks.

People sometimes say (though mistakenly), "Only I can know what I see." But not: "Only I can know whether I am color-blind." (Nor again: "Only I can know whether I see or am blind.")

—Ludwig Wittgenstein

Likewise, working in your studio may prompt you to show a lot of your work or only one piece. Showing visitors my work, I clear everything away except for one piece. But for the times when you are *working* in the same place, the more examples you can find for color, volume, shape, and so on, the more choices you are offering yourself. Both sides of the argument can be made. You may find that when you are surrounded by blue works, for example, you tend to paint everything in shades of blue. If the suggestion offered by paintings hanging around your studio is intruding upon new work, you will have no choice but to take the finished blue works down. Maybe you need to simplify your surroundings, substituting a few black-and-white works or line drawings, at least until you are past the selection of colors for your new work.

Here is a studio exercise for you to try. Start with your tools in front of you—these may be brushes, tubes of paint, a piece of sandpaper, a ruler or triangle, a hammer and chisel, and so on. Now, pick up one of the tools. There is something that tool does really well. Focus your attention on having that tool tell you what it does best. This is an exercise where you can be as free as possible. Give the tool five minutes to tell you what it feels like doing. Then, try another tool. Continue until the exercise has included five tools. The next day, try the same exercise with five different tools.

Listening to your tools will give you back options that you discarded long ago. Now, regain all of those possibilities by listening. Think about how you hold these tools as you work and consciously change this. If you've held them loosely, try working with your grip tightened. If the opposite is true, try lightening up. It will seem strange at first, like changing your style of driving a car, but you'll discover new ways through this exercise, in which you and your tools, working together, can evolve.

Building a Style

When we were student artists, just beginning to exercise our creativity, much of the artwork we produced may have been derivative, similar in style, and rendering to the works of better-known artists. Everyone has a little Picasso period, a little Matisse period. For me, it was Van Gogh, and I vividly re-member cutting skeins of yarn, trying to duplicate his thick brush strokes in a cloth version of *Starry Night* for a freshman class assignment. As we got older and

saw more art, most of us grew and moved on, trying out parts of a style or mixing artists—rendering skies à la Vlaminck, say, while emulating Van Gogh's brushwork. Self-confidence in our own ability grew, and we began to experiment on our own. Some artists never get to this final stage, which is why we all know an artist who paints "in the tradition of Bonnard" or makes "Joseph Cornell–type boxes." This imitative phase can be a trap for those who seek to move on but aren't sure how to do so. If you see yourself stuck at this point, read on.

In painting, no matter how honest or unhackneyed the artist's vision may be, the visible world must be transformed to accommodate it to the flat surface of the canvas.

—Linda Nochlin

What makes a style? What gives a work a visual fingerprint guiding viewers to recognize an artist's way of painting? Certainly, field and subject matter, but also the techniques an artist uses to render volumes, do shading, portray light, use color, choose content. Style here is used in a fine art sense, not to be confused with a fashion or trend. An artist's style can change as she grows and has new experiences, such as Georgia O'Keeffe's did when she moved from New York City to the arid deserts of the Southwest.

Inspiration, it appears, is much less apt to occur like a bolt out of the blue than as the result of years of hard work within a given field. Yet young artists seem to be able to find it easily, which may make us older artists dubious of just what our experience has taught

us and covetous of the fearless "not knowing" of youth. Perhaps ignorance spawns bliss. On the other hand, maybe it is harder for older artists to burst with creativity because we feel that we've "been there, done that." Perhaps our jadedness cuts us off from much that a younger artist finds new and exciting. Perhaps we are rejecting too much that we think we've tried before and can learn, like the young, to pursue each "new" idea with naïveté and enthusiasm. It is worth a thought.

Back to style. Many times we go to exhibitions of art by a well-known artist who has worked for years within certain guidelines, developing a recognizable, personal style. If we're already familiar with the artist's work, we almost know ahead of time what we will see. It is always interesting, however, when we find that the artist has taken her personal style one step further than we last remember it.

An example of this may be found in the recent work of James Rosenquist. His colorful style of painting evolved in the Pop Art era of the sixties, when, as a sign painter, he worked on large billboard-sized projects. He has said that he learned about his subjects by painting them in large scale and for commercial purposes. Among these were dolls, plates of spaghetti, and parts of automobiles. His airbrush techniques were perfected during this time, too. On his own, he combined these same subjects in his fine-art canvases. As awareness of and opposition to the war in Vietnam grew, he added parts of jet planes to his images.

I can well remember going into the Leo Castelli Gallery, then located on Greene Street in SoHo, an area of Manhattan noted for its galleries and shops, to

see Rosenquist's wonderful and gargantuan *F-111* (named for the plane most linked, in the minds of the public, to the war in Vietnam). It was a New York "must see" that season and wrapped around the inside of the gallery, covering three walls.

A trip I took not long ago, to the Metropolitan Museum of Art, revealed how Rosenquist's style has moved on since the sixties to include the juxtaposition of paintings, one over another, as if a previous work has been cut into with a giant pair of scissors. I had the sensation of looking at two artworks at the same time. Yet, "both" of those works merged to convey the distinct feeling of a Rosenquist. The artist's style has remained, but it has been brought to the next level.

 A musical note or a color in a painting do not exist by themselves.

—Daniel Buren

Sometimes, an artist discards one pattern of descriptive markings for different ones altogether. The early series of two-dimensional "Black Paintings" by Frank Stella, done around 1959, would be unfamiliar to anyone who only knows the artist by his later works, such as the "Irregular Polygon and Protractor Series" of 1966 and 1968, which incorporated geometric planes painted in bright, colorful hues. Stella says that he was criticized for the inaccessibility of the black works, which didn't give critics an opportunity to compare and contrast parts, since the works were uniformly minimal. This earlier work is in sharp contrast to the artist's later colorful creations, yet one can follow his manner from one series of works to the next, because there is a continuity in how the lines of

the black series became narrow stripes on their own and were carried over.

As you've already seen, we are exploring creativity from the ground up. While you may have begun this book believing that creativity is a marvelous mystery that "just happens," you can probably already see that it is possible to broaden your receptivity to its arrival and strengthen its impact in many ways. One of the first of these is to sharpen your senses as receptors for receiving creativity. Now let's get ready to be re-inspired!

CHAPTER 2

You and the Real Creative Problem

*If I create from the heart, nearly
everything works; if from the head,
almost nothing.*

—Marc Chagall

When writers go through writer's block, according to Anne Lamott in *Bird by Bird,* they are not blocked, but *empty.* Artists often suffer from the same problem. We may have gotten so wrapped up in this blocked feeling that we've stopped allowing anything to come inside our minds except our own misery. Lamott says her writing students simply have to fill themselves back up again with "observations, flavors, ideas, visions, memories." Lamott suggests that they first admit that they are not in a creative period and then move on to filling up again. She suggests that they write *something* every day, even if it is only three hundred words about how much they hate writing. The same advice could be modified for visual artists. Go into the studio every day and work for at least an hour on whatever small artistic project can make you feel, even in a blocked period, like you are still making

art. It's important to be there waiting for inspiration, even if you're not sure that it's going to come today.

To entice inspiration, you must first fine-tune your devices for receiving it when it does come. Your five senses are your receiving equipment for inspiration. If you are like me, you sometimes forget that we still have all five of them. A day job sitting at a desk may give our seeing and hearing senses a workout, but not smelling, tasting, and touching. And what about the activity through which the senses were initially developed—playing?

The brush stroke at the moment of contact carries inevitably the exact state of being of the artist at that exact moment into the work, and there it is, to be seen and read by those who can read such signs, and to be read later by the artist himself, with perhaps some surprise, as a revelation of himself.

—Robert Henri

Sharpening Your Senses

On the two-block-long street where I lived as a youngster, there was a sign at the corner that warned drivers: "There are 108 children and 40 dogs living and playing on Mahood Avenue," and it seemed like all of them were in my backyard. I especially remember times spent in a sandbox far back in the yard under a shady tree. The cool, fluid feel of the dry sand was so pleasant. Not too long ago, I actually entertained the idea of building such a sandbox in my living room and covering it with glass to use in lieu of

a more traditional coffee table. I'd even made plans to include a sand bucket and some rubber toys. I could take off the glass and play when I was alone. No one would ever know but me. Only the fact that sand would have to be transported seven flights up prevented my plan from ever being realized. Wet sand was fun, too, and must have been very satisfying to me, since my thoughts return to it so often. I think my interest in architecture started there, where we built so many forts and castles. Thinking about sand now brings forth tactile memories that are still with me as I sit writing, rubbing my fingers together, still remembering the grittiness of the grains.

Touching and Feeling

Touching is an important sense—one that we don't employ as much as we grow older. Our sense of touch may have grown rusty from lack of use and may need to be sharpened. If you have dogs or cats, you have probably noticed how they plot and plan to be in just the right place to be scratched or petted. Even the feeling of the sun on their coats can prompt them to seek it out. We once had a dachshund named Duchess, who loved to sleep in the sun. She moved throughout our two-story house every day, following the sun's path. At any time of day you could find her by the window the sun was coming through. In the winter, she coordinated this with where the heating vents were located so that she could maximize her enjoyment. A pat or a scratch, all animals have learned, is best obtained from humans by making oneself available to their touch. As several studies on the effects of touch and reduction of stress have

shown, touching is necessary for humans, too, in order to keep up good health. For example, older people who have the opportunity to pet and play with an animal regularly have been said to stay in better health.

I couldn't portray a woman in all her natural loveliness. I haven't the skill. No one has. I must, therefore, create a new sort of beauty, the beauty that appears to me in terms of volume of line, of mass, of weight, and through that beauty interpret my subjective impression. Nature is a mere pretext for a decorative composition, plus sentiment. It suggests emotion, and I translate that emotion into art. I want to expose the absolute, and not merely the factitious woman.

—Georges Braque

For more on the sense of touch, I asked my friend Katherine Sergava what exercises she assigned to the actors she teaches at the HB acting school in our neighborhood. Her students, Katherine says, particularly newer ones, are so awkward in their portrayal of intimate love scenes (probably embarrassed, too!) that they begin by grabbing one another to kiss, with a suddenness that makes the whole scene unbelievable. Katherine urges them to introduce touch by taking each other's hands and moving gradually into an embrace—first kissing the fingers of a hand and then, perhaps the elbow, the shoulder, and finally, the lips—all of which is more natural and, thus, believable. The exploration of tactility enriches the scene in the

theatre and this is true in art, too. Materials that have substance and texture can add dimension to an artwork. Think of Robert Rauschenberg's stuffed angora goat with the tire around his middle in *Monogram,* the "combine" piece (assemblage) made in the 1950s; or think of the wonderful live parakeet in Edward Kienholtz' piece, *The Wait,* owned by the Whitney Museum. Have you ever seen the dadaist Fur Teacup by Meret Oppenheim at the MoMA?

Color-field painters speak of the experience of color as tactile, too. In the documentary, "Painters Painting," artists Larry Poons and Jules Olitski tell us how they shape and model colored canvases so that, as Olitski says, "the color itself is the subject."

Consider that we speak of the coolness or warmth of color, of a color's transparency. For years, artists have employed tactility in their art to make us feel it. It's an option you might have forgotten was there for you.

Make a list of materials with tactile qualities, and try one out in a piece of artwork. Don't forget warm and cool, sharp and soft, pliable and unbending things, things that are porous, as well as glass and other smooth objects. There are also large and small bits, mirrored, flat, and three-dimensional!

In terms of materials, artists have found several ways to add texture. If you paint in acrylics, you may feel that there is a certain flatness to your work. You probably know that you can get more shine by adding a gloss medium to the paint mixture or a dry look by adding a matte medium without altering the color, but

an artist I know gave height to her paint by adding Rhoplex (available through New York Central Art Supply at 212/473-7705), which is a fattening medium. Her works, at that time, were studies of stripes. She painted them in varying widths and added variety by pouring some of the stripes using rubber hair-styling bottles. To these, she added the Rhoplex medium, which caused the poured stripes to become thicker and more 3-D, actually casting a shadow.

The development of an ability to work from memory, to select factors, to take things of certain constructive values and build with them a special thing, your unique vision of nature, the thing you caught in an instant look of a face or the formations of a moment in the sky, will make it possible to state not only that face, that landscape, but make your statement of them as they were when they were most beautiful to you.

—Robert Henri

For oils, either a wax medium or a gelled alkyd medium will create the same effect. I spoke with Robert Gamblin of Gamblin Artists Color Company in Portland, Oregon (503/235-1945). He said that the difference between the wax medium and the gelled alkyd mediums is the finish each gives. The wax mediums will make everything matte, while gelled alkyd mediums will make the surface more shiny. He said that, because the gelled alkyd mediums have odorless mineral spirits, they carry a health warning for petroleum distillates.

Smelling Inspiration

To heighten your sense of smell, take a walk through the fragrance department of a local drug or department store. While many perfumes are packaged in boxes and wrapped in clear plastic, you should still be able to find a few test bottles and experiment with the different brands that are for sale. Check out the lemony, the musky, and the woodsy scents. Few of us seek out new or unusual scents, content with what is familiar. Think of that person I'm sure you know, who has worn Old Spice for decades. In fact, we are all used to the same aromas, both in foods and in scents.

Recently, a friend and I were at a flea market and discovered a baby's high chair. As we came upon it, a flood of olfactory memories came rushing back: the smells of childhood. The damp, often washed, wood surface and the variety of foods eaten from the tray. (Remember Zwiebach cookies and Gerber foods in those little jars!) At another time, the smell of a cigar brought to mind visits from my grandfather. What do scents say to you? Zesty ones, like lemons from a fresh pitcher of lemonade or oranges you picked off a tree in Florida, may be familiar stuff to you, but don't forget to include on your scent palette a freshly shaved coconut you might have once smelled on a trip to the Caribbean or the exotic muskiness of sandalwood boxes.

Color alone is both form and subject.

—Robert Delaunay

Let's think about the evocative drawings made by Matisse on an excursion to North Africa in 1912. His drawings included richly dressed figures in exotic robes and the arches and minarets around the marketplaces. Think about the seaside room settings that framed his works in Nice, later in his career. Surely, smells and flavors inspired him, along with colors, costumes, and the exoticism of remote peoples. One can hardly picture those artworks evolving without the smell of flowers and fresh fruits. Think, for instance, how many of his sketches included groups of lemons.

The collar must go around the neck, must tell of its trip around the beautiful form.

—Robert Henri

The Power of Taste

Finally, let's talk about taste. Not aesthetic taste, but in-your-mouth taste. Think of eating ice cream. First, the sight of the ice cream combines with an idea of what the taste will be like. How many kinds of ice cream do you suppose there are? We are stimulated to take one bite, followed by another, possibly larger, or perhaps this one includes some chocolate sauce. If you have before you a whole banana split, what a variety of tastes awaits you!

There is a long history of artists and writers who used the sense of taste in their work. Many expressions such as having a "lean and hungry" look or having the "fire in your belly" relate to creativity as a phenomenon connected to hunger. Remember Marcel

Proust describing the wonderful taste of madeleines in *Remembrance of Things Past*? Now, no actual food appeared there—this *was* merely writing—yet the taste of food was very present. The same is true of painting. What of Cézanne's juicy bowls of apples? It's hard to picture Gauguin's Tahitian natives without the luscious fruits and flowers surrounding them.

In reviewing several new cookbooks for the *New York Times,* William Grimes pointed out that the best cookbooks "open a window on a different way of life or a new way of thinking." In fact, he writes, "[Cookbooks] could, with some justice, be shelved in one of the bookstore sections assigned to travel, biography, history or the personal essay, which is why cookbook fans often spend less time at the stove than stretched out on the sofa, turning the pages. . . ."

Writers and painters have long used the prospect of delicious tastes to make their artworks more viscerally tempting to the reader or viewer. Food prepared using unusual combinations, such as a salad with both oranges and onions (sounds odd, but it's delicious!) or tomato jam can inspire your taste.

A point is not part of a line.

—Leonardo da Vinci

An integral aspect of Robert B. Parker's *Spenser* detective stories is the preparation and eating of food. Although this element may seem unusual for art or a detective story, Parker says of his character Spenser: "He's the kind of guy who believes in doing things right." Eating well also "gives him something to do to offset the grim march of exposition." Spenser's character is broadened, you know more about him,

and the story builds in legitimacy. Now maybe you can think of reasons to employ these sensual experiences in your work.

Taste is such a personal thing that it is not easy to exercise this sense. Let's think of wine tasting. Wine has many aspects of taste that you can identify, such as fruitiness, tartness, acidity, richness, crispness, tanginess, smoothness, and so on. As you are dining, try to verbally place the foods you are eating on a chart of tastes and work at giving them names. For instance, an Indian dish might have a "curried" taste or you might describe raw vegetables as "crunchy," while certain dishes, for their warmth and familiarity, would fall into the "comfort foods" category. "Spicy" might come to mind when describing some dishes, while "highly spiced" might imply foods cooked with condiments.

How You May Be Thinking About Inspiration

All people appreciate being asked to create—perhaps because the opportunities to do so in life today are too rare. My sister Pat once told me about asking friends of her husband to write a poem in honor of his fortieth birthday. The responses were enthusiastic, well prepared, and long! While one might have assumed that friends would write no more than a couplet, she got several pages!

If all the colors are bright there is no brightness.

—Robert Henri

Our overall aim in this discussion of inspiration is to help you see how to make inspiration come to you. But, perhaps inspiration has been trying to tell you things that you just couldn't hear. In regard to writing her book, *The Woman's Book of Creativity,* C. Diane Ealy, Ph.D., described thinking about her book as a whole, not part by part. This was experiencing the book holistically, that is, all the sections and ideas together, rather than as individual chapters. The dictionary defines *holism* as the view that an integrated whole has a reality independent of and greater than the sum of its parts. When she actually wrote the book, her method was linear, that is, first *A*, then *B*, then *C*. If she had written about it in the way she had originally thought about it, she says, her "ideas might have seemed scattered and unconnected."

Grey is between two extremes (black and white), and can take on the hue of any other colour.

—Ludwig Wittgenstein

We were taught in school that linear thinking is logical and that any other process is both illogical and no good. Dr. Ealy acknowledges that linear thinking has many valid uses, such as keeping financial records or giving and understanding directions. Unfortunately, however, linear thinking precludes many of the elements that go into an inspired project. You may get an inspiration holistically but not perceive it because you are thinking linearly. Say you want to do a project in a completely blue hue. You may know vaguely that you want it to be large in scale and site specific. Perhaps you were assigned a site of a specific size

with its own limits, or perhaps the site itself inspired you. Maybe it was a traffic island in the midst of a highly congested street. It would not be viable for your creation to hang over into passing traffic. The details for this blue work may not be clear to you in the initial stages, but may reveal themselves to you as you begin working on the piece, or as in the example described above, some of the requirements may be dictated by the circumstances. With holistic thinking, you do not need to begin with *A* (the blue color) to get to *D* (a rough sketch of the projected work). You can begin anywhere and move on to thinking in any direction. Perhaps you begin at *D*. You can then move on to *B* (the theme with which you want to imbue the piece) without even considering *C* (the limitations imposed by the commission). "Holistic thinking," says Dr. Ealy, "allows all possibilities to coexist. This is an important part of the creative process. If you must gather material about an issue, a holistic approach enables you to collect a great deal of data and decide later what's most important."

Good painting, good coloring is comparable to good cooking. Even a good cooking recipe demands tasting and repeated tasting while it is being followed. And the best tasting still depends on a cook with taste.

—Josef Albers

Many of us, both men and women, think holistically, even though we were given examples when quite young that made linear thinking seem far superior. It may not have been called linear then, but that's what it was.

On Judging Your Own Pictures: We
know very well that errors are better
recognised in the works of others than in
our own; and that often, while reproving
little faults in others, you may ignore great
ones in yourself. To avoid such ignorance,
in the first place make yourself a master
of perspective, then acquire perfect
knowledge of the proportions of men and
other animals, and also, study good
architecture, that is so far as concerns the
forms of buildings and other objects which
are on the face of the earth; these forms
are infinite, and the better you know them
the more admirable your work will be.
And in cases where you lack experience
do not shrink from drawing them from
nature But, I say that when you
paint you should have a flat mirror and
often look at your work as reflected in it,
then you will see it reversed, and it will
appear to you like some other painter's
work, so you will be better able to judge of
its faults than in any other way. Again, it
is well that you should often leave off work
and take a little relaxation, because, when
you come back to it you are a better
judge; for sitting too close at work may
greatly deceive you. Again, it is good to
retire to a distance because the work
looks smaller and your eye takes in more
of it at a glance and sees more easily the
discords or disproportion in the limbs and
colours of the objects.

—Leonardo da Vinci

"[H]erein," says Dr. Ealy, "lies the trap: Because you want to know as much as possible, you may want to continue gathering data, (or have all the details) rather than begin the problem-solving (for artists, the construction of the artwork)." She continues, asserting that, when this occurs, you may appear to "lack focus."

I believe this is why artists are often at a disadvantage when we meet or work with business people.

Another instance where we appear to have a shortcoming is when preparing a proposal (a *linear* document) for a work of art that we hope to make. Because we holistic thinkers are in the minority, we must provide the information that is asked for in a linear way, even if we are not comfortable working this way.

Many of us who were taught from early childhood to think linearly may actually think that inspiration should present itself to *us* linearly—but it just doesn't. Like Christmas morning or a walk into a circus fun house, everything seems to be going on around us at the same time. When creativity comes to us, it is not *quiet* or *orderly*.

We are all capable, however, of thinking linearly when we need to. Think about how you enter a room where you have never been before. A large amount of information hits you all at once—colors, shapes, sizes, objects. If you are staying in this place for only a few minutes, a limited amount of information sinks into your brain. You are absorbing an environment rather than counting the pieces of furniture. You are responding holistically, rather than linearly.

How can you do both—think linearly and holistically at the same time? Dr. Ealy suggests a simple

solution. Set yourself a deadline before you begin planning, and stick to it. You will never be able to see your whole artwork before you begin it. Thinking back over work you have done in the past and were pleased with will help as well. Have faith that you will know what to do as you need that information.

What you want to express is a much bigger thing than how you may go at it.

—Donald Judd

If you have been thinking about a new project, and information about how it will work best has not been making itself available for your use, try reading this part of the book again, stopping at each sentence and examining how you have been thinking about the project. Now, approach it differently, either by being more linear or by taking a holistic approach. Don't let the battle of linear versus holistic thinking prevent your creativity from happening.

Ask Dumb Questions

One of the elements played out in childhood that is essential to creativity is asking "dumb" questions. Marcia Yudkin, author of the audiotape, *Intuition: The Key to Creativity*, says that there are really no "dumb" questions, and questions that seem dumb are the ones that produce discovery and invention. Dumb questions are important to the creators of this world. She describes how Dr. Edwin Land's invention of fast-developing Polaroid film could be traced back to his daughter's "dumb" question.

One day, Dr. Land and his young daughter were

walking on a beach when he stopped to take a photograph of her. "Can I see it now?" she asked. When told she'd have to wait until the film went to the lab, she wanted to know why. Although the question seemed dumb at the time, because *all* film had to be processed in a lab, it prompted Dr. Land to consider the need for faster-processing film.

The inner element, i.e. the emotion, must exist; otherwise the work of art is a sham. The inner element determines the form of the work of art.

—Wassily Kandinsky

The rest is history, as Dr. Land invented a film that could be developed anywhere in just one minute. If one looks behind the pat answers to dumb questions, the door to the flourishing of invention and discovery will be opened. For artists, a dumb question might have been, "Why can't they invent something that cleans up brushes after painting with oils and doesn't smell?" A dumb question such as this might explain how the invention of Turpenoid, a turpentine substitute that doesn't smell, was made!

Write Your Own Review

You may have been lucky enough to receive a favorable newspaper review for an exhibition of your work. Even if it was only a line or two (as I once got from the *Boston Globe* after participating in a group show), those kind words are forever yours to keep, and we all relish the applause. Everyone loves praise, and laudatory words can be a real help in building a

career. In reality, you probably have a pretty clear
idea of what you would like to have said about your
art. Come to think of it, you could probably write a
pretty sharp review.

Why not write yourself a review? Write it as if you (as a critic) had just
attended a one-person exhibition by an artist whom you had never met.
Include all of the parts you feel are relevant, such as comments on color,
content, and overall appearance. You might want to touch on the curating
or choices of work, including how they were shown and how they related
to each other. This exercise may give you some insight as to how critics
see an exhibition, and it might help you to make your choices in the
future. Go ahead—It doesn't have to be long!

Andy Rooney, CBS-TV's commentator, says on the
subject of reviews: "There are so many good words
that might be used in a review of my book that I
hesitate to suggest them. I know though, that a
reviewer is often under the pressure of a deadline so
let me just offer a few to reviewers who might be
reading this: 'memorable,' 'hilarious,' 'shocking,'
'erotic,' 'enormously witty,' 'highly evocative,' 'mov-
ing,' 'sinewy,' 'poignant,' 'essential reading,' 'inspir-
ing,' 'one of the most important books of this or any
other year.'"

I once wrote an artist's statement, which I sent,
along with other press materials, to a local arts writer.
Imagine my surprise when I discovered that whole
paragraphs of my writing had been "borrowed" and
used in a review that he wrote about my exhibition!
You may as well say what you would like to hear
about yourself—you might just get your wish!

Creativity and Self-Esteem

> The artist is born, and art is the expres-
> sion of his overflowing soul. Because his
> soul is rich, he cares comparatively little
> about the superficial necessities of the
> material world; he sublimates the pres-
> sure of material affairs in an artistic
> experience.
>
> —Hans Hofmann

On CNN, a while back, I watched the writer Eliza-
beth Drew being interviewed about her new
book on mentors that she has had. One mentor in
particular, she said, had given her confidence.

"You know," she noted, "confidence makes better
writers." I have been thinking along this line myself
for some time. I think confidence makes better artists,
too. I've noticed that when I have no confidence, I
can't paint.

What is confidence? Simply, a belief in yourself.
Another word for it is self-reliance. My dictionary
says that it's "the fact of being certain." It's having a
belief in what you are doing. As who? Doing what?
The answers to those questions are up to you.

I think writers and visual artists are some of the most noble and fearless people of all, because we have to keep trying to succeed, and *in public*, at that. Working diligently for long hours seems like not working at all. We are on a roll, we fly from one project to another, we scarcely need to sleep. But we can only make something new when we are at our optimum best, when we feel strong enough to conquer what already exists. We must believe that we are able to create before we can unleash our minds and invent anything new. Creating is like permission from us to ourselves to invent something unique. In order to create, you must feel that the world is somehow incomplete and would be better off with the addition of a creation of yours. Somewhere in your consciousness lurks a feeling, perhaps a deep desire, that an object should exist and that you should create it! Here, we are describing the desire to create. Before something new can exist, it has to be desired. As visual artists, this desire is almost unconscious, because we live with some form of it so constantly that it doesn't have to develop into consciousness at all.

What Kills Creativity

Creativity is tied directly to our feelings of self-esteem. Feelings of self-worth are born with us and give us the nod to try out new ideas. If our self-esteem becomes damaged, it may intimidate us from trying out anything new. Several events from our childhood may have placed stumbling blocks in our creative paths. According to *The Creative Spirit* (written by Daniel Goleman, Paul Kaufman, and Michael Ray to

accompany a PBS series), these "creativity killers" may include competition (like constantly being compared to a sibling), limited choices, interruption (a lack of open-ended creativity time) and rewards (when they are given so often as to be of no real value).

The picture must not become a patch-work of parts of (your) various moods. The original mood must be held to.

—Robert Henri

To regain self-esteem lost as children, we need to make a conscious effort to remember each "creativity killer" experience as negative and to address them by building up the confidence we lost way back when.

It is time now to invent an advocate for yourself—someone who will compliment your work and in whom you can believe. She should have a name. Let's try Circe. Circe is unabashedly on your side and has abundant faith in you and your ability to solve any problem.

Have you ever come upon a work of art that you did in the past and been surprised by how good it still is? And this was a work that you had written off, found flaws in, torn apart critically. It is so much easier to believe criticism than any compliments. Why is that? We are more prone to believe negativity. Perhaps our parents, in their desire to protect us, trained us to react defensively. Now, give Circe the right to compliment you—and give yourself the right to believe her.

Building Your Confidence Balance

There is, in every one of us, a confidence bank. For assets, we have all the strong, positive things we

believe about ourselves. We can make withdrawals any time, without the capital amount diminishing. That always remains the same. What exactly do we keep in it? Surely, memories of any good published reviews that we may have been given for work we've exhibited. Also, praise we've gotten from admirers, especially teachers and peers whom we look up to. And, we have the memory of sales of work that we've made. Check out the affirmations at the end of this chapter. They should be employed for confidence building, too.

Every man, at three years old, is half the full height he will grow to at last.

—Leonardo da Vinci

How can we keep building up that balance, working on our confidence, on the persona that we present to others and must preserve for ourselves as artists? Certainly, by continuing to participate in the art scene and having our work displayed publicly, we will convey the sense of being serious about our art. This is important, because professionals in the art world need to believe that you are committed to pursuing your art over the long haul. One way is to continue working on yourself in those areas where you know you can use some improvement. It's never too late to take a class.

We can exercise our confidence by continuing to try new things. If every drawing you've ever made was eighteen-by-twenty-four inches or smaller, then tell yourself it would be good "artistic aerobics" to create a billboard-sized work. At first, you'll be horrified at the prospect, but then, as you get into it, you'll

be so caught up in the technical details of the whole project that it will seem perfectly normal to you.

For some years now, my motto has been, "The way to eat an elephant is one bite at a time." Take on a project you've never tried, and you'll be very impressed when you complete it. So will lots of other people. Once you begin it, you won't even think about how scared you were to try it.

Professionalism and Self-Esteem

One of the first things we talk about in workshops is how confident you appear as a professional and how you come across on the phone. I've noticed that many people on the phone in business situations give only their first name or no name at all. This is unprofessional. People on the other end will automatically assume that this person must be an intern or someone who is incapable of helping them.

Practice saying your name—first *and* last—loud and clear. For the next week or so, make a conscious effort to listen closely to yourself every time you give your name. You might be amazed or dismayed, but it will definitely be time well spent. Some people swallow their name or drop their voice, as if they want to get that part out of the way quickly. Sometimes you will have to ask them to repeat their name, as if you were virtually pulling it out of them. The way people respond gives clues to the way they think about themselves.

This is also true of people who call you. Anyone calling wants to know to whom he is speaking—and if he is returning a call to you, it is your job to com-

municate first who you are and what your original call
to him was about. It's a little thing, but so fundamen-
tal that it can turn around the entire direction a phone
call will take. You may find this to be such an interest-
ing exercise that you will continue paying attention to
the way you and others say names in the future. This
may be the only chance you'll have to make the right
impression.

*Your work is not, and cannot be, a
reproduction.*

—Robert Henri

Also, answering machines are so popular now
that it is very likely that you will have to leave a
message. Be prepared. Think in advance about the
message you want to leave in order to get a prompt
response. You might come across as less than profes-
sional if you have children shouting, traffic noises, or
dogs barking in the background. If quiet is impos-
sible, go somewhere else to make the call. During
heavy street construction near my apartment last
year, I was forced to make art-related calls from a
phone booth at the public library. Don't let your
confidence be undermined by failing to prepare for
less-than-perfect conditions.

Another way to strengthen your confidence is by
reviewing your résumé frequently and updating it
regularly. See what it will take to make yourself
appear a stronger, more accomplished artist, and
work toward those goals. If you have participated in
twenty group shows, then the group shows category
is already an accomplished fact. Choose another
category that needs strengthening—perhaps exhibit-

ing in a corporate space or creating an installation. If a solo show is impossible to line up, then go for a four-person exhibition. This will offer you a chance to show more work than another group show where you may have only been able to show a piece or two. A small, four-artist show may also give you a shot at a more personalized review.

What about a collaboration with another artist or someone in another area of the arts? Work with a poet or puppet master, a dancer or filmmaker. A friend of mine, Bascha Mon, created a Japanese garden installation with a waterfall and enhanced it with Haiku poetry that was read aloud. Combining diverse elements such as these will create a new category on your résumé and open up new possibilities for your work and exhibitions to come. It's good exercise to think in this wide-open way, too.

. . . and I thought, enough of this, I'm not an abstract painter, what the hell am I going to do? Should I get a job in a shoe store, sell real estate, or what? . . . I felt like a painter, yet I couldn't make paintings.

—Ralph Goings

I am a résumé junkie. I find résumés everywhere to keep for good examples. If you find a good one, it might serve as a model for your own, and perhaps it will give you ideas for new things to try.

By studying the résumé of someone whose work is similar to my own, I found that he had exhibited in five local museums that I was not even aware of. This meant two things: (1) I now had five new places to

apply for exhibitions and (2) they had already indicated their interest in work like mine.

Afraid to Change?

Many artists get rigid, afraid to change or push forward, because of a fear of the unknown. They are limiting themselves and, unfortunately, their work echoes this. Perhaps it is time to show at a local college or university gallery; maybe you're ready to explore some of the new genres, such as digital art, or to produce an artist's book. An intensive weekend of papermaking changed the look of my work and gave it a kick and learning the craft was not that expensive, either.

Still another way to build your confidence is to invite groups into your studio for a show-and-tell session. It's a chance to polish your role as an artist. Many art schools or civic groups will welcome the opportunity to show their members an artist's workspace, and you'll grow in answering their questions. Have someone introduce you who can say lots of nice things about what you've done, things that you'd sound pushy saying about yourself. Give the group leader a typed summary of your art accomplishments when she arrives.

All of this will yield a deposit in your confidence bank, which can be called on whenever you need it. You'll gain a nice polish by answering questions and confidently tackling newer and bigger projects.

Here's an unusual confidence builder: Make a video, or have someone else make one about your work. Produce this video with the intention of

showing it to dealers and possible buyers. Also, show it to *yourself*. It can be a strong confidence-building tool. It will motivate you to focus better, too. The cost will run anywhere from $75 to several hundred. Don't skimp on it though, because you'll see the unprofessional spots and undermine your own good intentions. By making your own and running it for yourself when you are alone, you will reinforce your accomplishments and strengthen your faith in your abilities. When you turn it off, ready to start work again, you're confidence level will be *way up*.

It often happens that these rough sketches, which are born in an instant in the heat of inspiration, express the idea of their author in a few strokes, while on the other hand too much effort and diligence sometimes saps the vitality and powers of those who never know when to leave off.

—Giorgio Vasari

It has long been a tradition among Japanese artists to meditate before picking up a brush and creating a single mark. Just as a martial arts expert must be mentally prepared in order to break a brick with his bare hands, Japanese artists understand that one must be ready *on the inside* before starting a painting or drawing. A pause from your daily activities can help you get in touch with your inner self before you begin making art.

Because making art is often a serial activity, you may need to study what you were doing when you last worked on a piece in order to get your feelings into focus to start again. If you haven't worked in a

serial mode yet, you might enjoy it. Artists who work this way actually expand one work into many. One time, they might explore the tactile elements in a piece; another time, they might try a new point of view. The hero in one piece may become the villain in the next. Eric Fischl's works all have different imagery, yet they all convey an uneasiness beneath the surface as he delves into growing up in the suburbs. A consistent feeling runs under these pieces, and that feeling is what is being studied here, almost the real subject of the paintings. Works such as *The Old Man's Boat and The Old Man's Dog, Barbeque,* and *Time for Bed* are easy to "read" works that convey the unease that is a signature of Fischl's style.

He who would have you believe that he is waiting for the inspiration of genius, is in reality at a loss how to begin, and is at last delivered of his monsters, with difficulty and pain.

—Joshua Reynolds

Self-assurance cannot be overlooked when you want others to believe in you. Confidence improves your physical appearance as well as the way you speak, your ability to look someone in the eye, and the credibility you have.

Finally, being confident about what you are doing allows you to do it better. Think back to your childhood again, and learning to walk—it wasn't easy at first. But think how good you felt about accomplishing it. The aura of succeeding will enable you to take bigger risks. Nothing succeeds like success. Everyone loves a winner, and giving yourself more confidence

can make you that winner. Remember Elizabeth Drew and her mentor. Confidence makes better writers, and it definitely makes better artists, too.

Your Moods and Creativity

Many artists experience depression when they are unable to work, and many will also suffer when a major artwork is completed. We've probably all felt the inevitable letdown that comes after an exhibition has opened. Because there is such a buildup before a show, it is inevitable that after it opens and the preparations have been completed, we wander around aimlessly, or maybe don't get out of bed at all.

Warhol's indifference made me care even more.

—David Reed

More extreme cases occur occasionally but, according to Kay Redfield Jamison, writing in *Scientific American* in February 1995, "Recent studies indicate that a high number of established artists—far more than could be expected by chance—meet the diagnostic criteria for manic depression or major depression given in the fourth edition of the *Diagnostic and Statistical Manual of Mental Disorders*. In fact, it seems that these diseases can sometimes enhance or otherwise contribute to creativity in some people."

These illnesses are not, however, necessary in order to be creative, and the majority of known artists do not experience serious mood swings. In fact, it is unfortunate that some aspiring artists subscribe to the romanticized notion that cultivating alcoholism or

other self-destructive behavior will make them more creative.

Dan Wakefield's wonderful book on creativity, *Creating from the Spirit,* tells of his struggles with alcohol and drugs. He lists ten myths about creativity, which I have reprinted here. Read Wakefield's book to discover how he explodes each myth.

- Myth #1: Creativity is only for the artistic elite.
- Myth #2: You have to suffer to be creative.
- Myth #3: Only the arts are creative.
- Myth #4: Creativity is not manly.
- Myth #5: Women's work is not as creative as men's.
- Myth #6: You have to live in an ivory tower or by a pond to create.
- Myth #7: Creativity is a full-time job.
- Myth #8: Creative people don't have good relationships.
- Myth #9: Creative people are children and aren't responsible.
- Myth #10: The older you get, the less creative you become.

I think it's clear that these myths have no particular basis in fact. Yet when we are feeling discouraged, we sometimes find ourselves believing these negative statements, and by believing in them, we give them power.

Giving Yourself Helpful Affirmations

To gain greater confidence, we all need to feel safe. Only then can we exercise the desire to create. To develop a safe feeling that engenders the confidence

to create a work of art, we need to think positively and write down some positive feelings that we have about making artwork. To get started, you'll want to take a cue from Eric Maisel, who has written a wonderful guide of affirmative sayings on creativity, titled *Affirmations for Artists*.

> Begin by making a short list of positive remarks about yourself and how you feel about making artwork. By keeping these "sayings" nearby (or maybe in plain view) you can strengthen your own positive feelings, self-confidence, and belief in finding inspiration. This can give you a better sense of who you want to be and what you can successfully accomplish. Build up your confidence the way you build up your muscles.

In one corner of the room where I write, there is a line written hastily on a yellow sticky pad. It reads: "Thought for the day: It helps to keep at it." In reality, that is the thought for every day, for whatever task I am involved in. That simple message from me to me keeps me focused on whatever project is there and makes it really, really important. Here are some affirmations you might find helpful:

1. I am an artist, and I have chosen a life that will give me pleasure in all of the things I make. I owe others and myself for my good fortune in coming to this life, and I will try to show my thanks in my work.

> By beginning with a thankful attitude, you'll escape any embarrassment that might occur because you are concentrating this exercise on yourself.

2. I feel a special joy in my gifts with my use of colors. I will strive to make this a joy to others as well.

By offering to brighten the lives of others, you lend a giving feeling to your gifts.

3. If there are techniques with which I am unfamiliar, I can learn them. I'll find the very best teacher and give myself a quality education. I'm worth it.

By offering to learn more and perfect yourself, you promise, as well, to nurture yourself.

4. My art will strive to portray truth as I see it. I will genuinely try to reflect how I feel and bring honesty to my work at all times.

By dedicating your work to the pursuit of truth, you show your honest attention and admiration for your work.

5. I will study my work critically and learn from my mistakes. As my strengths grow, I will sense the character of my work, which will help me in building a vision.

By weeding out both the good and unnecessary elements, you will strengthen the body of your work and help yourself feel more in control of your art.

6. I will conscientiously schedule visits to museums and galleries regularly.

Trips such as these will feed you new ideas, even if the artwork was done long ago. By observing how your artistic predecessors have solved certain logistical problems, your store of knowledge will grow.

7. I will live to be an art citizen, seeing as much that is challenging to me as an artist as I possibly can.

This is easier said than done. We all carry traits from our art-student days with us forever, but consciously try to make yourself as aware of what is new as possible.

8. I will keep growing. My life as an artist is connected to the growth that occurs in all other arts, as well as my own.

This includes dance, theatre, music, poetry, and other visual arts. By filling your world with changes in all of these fields, you offer yourself more exposure to what others see as new. Don't just watch reruns.

9. I will honor the art of the past. I can learn from it and I am always able to absorb more insights about accomplishments in my field.

As you become more knowledgeable about art history, you will be more confident about discussing all art, including where your own art fits.

10. I will conscientiously try to seek out support among my peers and foster a sense of community with other artists. I recognize my reluctance to do this, but will acknowledge that I am healthier when I pursue dialogues with others.

We learn from each other, and the realization that other artists share our anxieties and doubts should give us strength to reach out.

11. I will actively encourage the comments of others about my work. At the same time, I will acknowledge my own point of view and question both sides of every issue.

Hearing what others say about your work can help you gauge how believable or unbelievable your imagery is. From these comments, you may learn where your technical skill may be lacking. However, you should counter any negative comments with your own artistic intentions.

12. I will study my past work in order to find my voice and look for positive ways to strengthen it.

Your best teacher will be your last work before a new one is begun.

13. I must conscientiously continue to refill myself with new thoughts and experiences.

By seeking out an ongoing array of new experiences in your life, you won't have recurring blocks and stoppages.

14. I won't let my failures drag my spirits down. By always working on several projects at the same time, I will never find myself without a plan for creating artworks.

Artists who tell me that they've never had an art block also say that they have so many choices that there are just too many things to make!

15. I am a creative person and have been blessed with a special gift. I will remember to use my gift in projects that benefit others as well as myself.

Contributing your artwork or your time to community projects may lead to greater exposure of your work and even to future sales. Don't rule out making contributions like this to groups who need your help—within reason.

16. Change is difficult to adjust to, but basically good. I won't be afraid of change.

New developments in supplies, as well as changing artistic techniques, should never be a threat to you. Look, listen, and learn!

17. I will strive to leave elitism out of my artwork, because I realize that elitist art is difficult for people in the general public to understand. Likewise, I won't pander to sentimentality.

Art that is too easy will soon bore those who look at it. Strive to make artwork that will continually offer something fresh and new.

18. I won't avoid new tools; I will always try to add new elements to my work and will not fear them.

Keep abreast of what's new in your supplies—it will help you accomplish new works!

19. I will seek out new work and look for it wherever it is being shown. I will encourage new art and new artists. I know how hard it is to begin.

New art is often in poorer parts of town because new artists have little to spend on fancy and expensive neighborhoods where more established art gets shown. Find a pal and brave this new world together. The new art will challenge you and you'll see it first.

20. I will realize that there are times when the work is slow, and I will not let it depress me. I will remember that work takes its own time and sometimes I am not ready for what my unconscious mind wants me to know. I will learn patience.

The important element here is to keep working and honing your craft so that you're ready when a good idea comes!

21. I will stay focused on my work. I will rule out anything that distracts me (television, radio, family arguments, political causes, hobbies, telephone calls, and so on) or that makes my attention wander.

Many artists have used causes like those mentioned above, as reasons for not making art. Be sure you limit time spent on things that shorten your creative time. See Jerry Mundis's interview on creative blocks in chapter 12 for finding other reasons people stop creating.

There is no profession . . . in which you may expect less happiness and contentment than in painting.

—Carlo Ridolfi

Fearing Creativity

> Creative minds have been known to
> survive any kind of bad training.
>
> —Anna Freud

Creativity is defined as "the ability to transcend traditional ideas, rules, patterns, relationships, or the like, and to create meaningful new ideas, forms, methods, interpretations, etc." This kind of mandate also generates uncertainty and misgivings in us. Creating takes courage.

Rollo May, writing in *The Courage to Create*, says that this "creative courage" is the most important kind of courage of all. "[It] . . . is the discovering of new forms, new symbols, new patterns on which a new society can be built." May continues, stressing that, more than anyone else, "those who present directly and immediately the new forms and symbols are the artists—the dramatists, the musicians, the painters, the dancers, the poets, and those poets of the religious sphere we call saints. They portray the new symbols in the form of images—poetic, aural, plastic,

or dramatic, as the case may be. They live out their imaginations. The symbols only dreamt about by most human beings are expressed in graphic form by the artists." Because we can never know exactly where our imaginations will take us, we are sometimes afraid of the journey.

Facing Your Fears

Whether they admit it or not, almost all artists have some fears. These fears come from many sources— some real, some imagined. We may have fears based on our beliefs about the art world. Often times, we see the established art world as a solid wall, which we alone must try to conquer. Whenever I give work- shops, I am amazed at how powerful and monolithic artists think the art community is. Artists tend to view the different and varied businesses that make up the art world as one united group. Remember: Those in art businesses include individual private dealers, gallery owners, art consultants, curators, museums, private collectors, corporate collectors, successful artists, the art presses, and all of those scoundrels who pose as any of the aforementioned. And they've *all* just had a meeting and voted you and your art *out*. Think about how ridiculous that sounds. This "them versus me" mentality is very self-defeating and serves as nothing more than a good excuse for an artist not to try. Many artists think that they must begin a career in a certain, prescribed way. But take Keith Haring for example, who started in the subways of New York City, making drawings for ACT UP (the AIDS Coalition to Unleash Power, a militant activist group through whose protests Haring's drawings

became widely known). Those white drawings on black paper that covered subway posters are worth thousands of dollars today. Don't let academia frighten you. Certainly, those illustrious degrees many artists have signify their advanced, detailed study, but sometimes study becomes an end in itself and the artist loses touch with what art is really about. Find your own way.

Fear of Failure

Other anxieties may have to do with how your work stacks up against that of other artists. Perhaps you fear that your talent will fall short. But, what is often called talent is really just what one does easily. David Bayles and Ted Orlando, in their book *Art and Fear,* advise us that, "Talent is a snare and a delusion. In the end, the practical questions about talent come down to these: Who cares? Who would know? and What difference would it make? And the practical answers are Nobody, Nobody and None."

Just dash something down if you see a blank canvas staring at you with a certain imbecility. You do not know how paralyzing it is, that staring of a blank canvas which says to the painter: you do not know anything

—Vincent Van Gogh

Technique can be acquired and perfected by *anyone* willing to put in the necessary hours. Moreover, talent is only one part of becoming an artist. What other kinds of fears do artists have? "I made a

nice artwork once, but that was just an accident. I could never do that again." A lack of faith in one's own abilities has plagued many artists, but only by making lots of artwork can those fears be stilled. Again, from *Art and Fear*: "You make good work by (among other things) making lots of work that isn't very good and gradually weeding out the parts that aren't good." By becoming facile at the craft part of your work, you will become confident that success is not an accident. Worries that you are not young enough, not attractive enough, or live too far from where the action is may bother you. None of these qualities really matter. If members of the art world can find the Rev. Howard Finster, a retired minister who lives in rural Georgia, they will be able to find you, regardless of your address. Rev. Finster's self-taught "outsider" art has attracted a wide and diverse audience and originated a whole new category of art.

Well, you say, what about fear of failure, fear of not having something to say, of not having sufficient training or knowledge of technique? We all know that art that is about ideas has more longevity than art that is just about good technique. Also, no community in the world offers you more opportunities to learn an unknown skill than the artist's does. Just figure out what you need to learn, then find somebody to teach it to you. What your art is about will become clear the more of it there is to see.

Ambiguity: For and Against

Ambiguity can work for you in creating a work of art. It can be the changeable quality that makes a painting intriguing. Sometimes, by leaving part of a work

vague or unfinished, we can inject a little uncertainty and create a good effect. But, only allow the smallest bit of uncertainty to manifest, as too much ambiguity can cause chaos and destroy your viewer's interest.

Creativity can be described as letting go of certainties.

—Gail Sheehy

Why does decision-making provoke fear and anxiety? We have to make choices in life all the time, and these choices (along with the internal struggles they provoke) may cause ambivalence and confusion. How we address confusion is important in our ability to move forward and find inspiration in our work.

One thing that you will surely discover is that, coming to trust yourself, you will be very capable of making good decisions—and many of them. There is not only one way a painting can be painted. Trust yourself. Trust your gut.

Editing Your Work

Let's talk about editing your own work. While you may feel that your work is not perfect now, begin by thinking about a comparison between you and yourself. This will give you some guidelines to finding the "you" in your work.

To begin, select a piece of your artwork that most pleases you. Using that piece as a benchmark, judge your other works by comparing all of those pieces to the one you like best. If choosing one piece is difficult, begin with two or three. Maybe they are from different periods in your

career. Be as critical as you can allow yourself to be. This judging period may take you several weeks. For now, there is no artist but you, no art but your own. You can learn a lot by putting two pieces of your work side by side and consciously deciding what works and what doesn't. For each piece that you hold up to the benchmark now, try to see what you like and pick out what you want to keep. Be sure to take into account brushwork, the success of the color, subject, and how strongly you have portrayed it. Likewise, look for any aspects you consider weak and could do without. How satisfied are you with your backgrounds? Do they come forward too much, detracting from the importance of the subject, fighting with the natural depth of field you sought? By identifying these elements, you are able to see what is both good and not so good. Looking at your work and seeing only the negative elements isn't fair to yourself. Conversely, saying that everything is successful doesn't allow for any improvement. If you like all of your work, then what is it that you especially like? What do you like least? When you try to be objective about your work, you give yourself the chance to improve. Once you are truly accepting of your own weaknesses and strengths, ready to objectively look at and learn from your own work and shore up what you may lack in technique, you are on your way to becoming the artist you seek to be.

Keep your benchmark work and go back to look at it often. As you practice the suggestions you've given yourself, you'll be able to see improvement in the work you're making now. Now that you've taken a look at the techniques you employ, why not examine your choice of subjects?

If finding subjects is a problem for you, make a list of five things that are characteristic of yourself. Use five adjectives that would accurately describe you. Using this list, you may start to see what kind of art would

interest the person you've described. It may be a combination of two of the descriptions you used for your list, such as brightly-colored fantasies, geometrically-inspired landscapes, or comic-book war scenes. Don't limit the possibilities. Maybe you are drawn to installations or multimedia pieces involving sound, moving lights, or things that the viewer must discover by traversing an environment that you have created. Maybe a geometric background exactly frames your thinking.

The development of creativity appears to be enhanced by certain components in the life of a child. These variables are:
1. an open environment
2. the active use of creative skills
3. a result of previous knowledge
4. a disciplined use of technique
5. an association with artists.

—Alica L. Pagano

Fear of Yourself As "The Artist"

Maybe you are afraid of criticism by others. Most good artists have received both good and bad reviews throughout their careers. Of course, you could eliminate that problem by not showing your work in public at all, but that's a pretty desperate step to take just to avoid criticism. What about fear of not having the magic? This is a fear that is more prevalent when you know very little about how the commercial art system works. As you come to know more about how art is made and sold, the concept of magic will quickly disappear. We only attribute to magic that which we cannot otherwise explain. For any of these and various other reasons, you could decide to quit trying. If,

however, you are still interested in finding inspiration and showing your artwork, read on.

The first thing you need to understand is that artists are ordinary people just like you. They are mothers, grandmothers, aunts, uncles. As a rule, they work incredibly long, hard hours with tough, un-relenting materials and are often forced to lead thrifty lives, selling artwork only once or twice each year, and splitting the profits with a dealer. They probably have to supplement their income, too, with teaching or some other day job. According to statistics from the Research Center for Arts and Culture at Columbia University, only 14 percent of all artists support themselves entirely from the sale of their artwork. For the other 86 percent of us, an outside job is necessary.

Still, you may feel that professional artists have "something I don't have." Some artists do have the benefit of excellent educations, but others are entirely self-taught.

Your fears have to do with one important quality that you must strive to gain—the acceptance of your-self. You cannot worry about the talent someone else has. You must keep working.

One of the best supports you can give yourself as an artist is the company of other artists. Make an effort to find fellow artists you feel comfortable being with, then seek them out often. For more on the subject of artists' communities, see chapter 7.

While most fears that artists have must be laid to rest before creativity can proceed, the desire to create may function even under fearful conditions. A recent

article in the *New York Times* recounted the harrowing tale of a Jewish painter in hiding, who continued to paint during what must have been an extremely stressful period in the 1940s in Belgium. Creatively speaking, the article asserts, Felix Nussbaum painted his best-known works while hiding from the Nazis with his wife in a basement in Brussels from 1942 to 1944. The Nussbaums were eventually found and sent to Auschwitz, where they died at the end of July 1944.

Creativity and Living Forever

Perhaps the desire to create echoes our wish for immortality. Life spans a limited time, after which we will be on earth no more.

Again from Rollo May, in *The Courage to Create*: "By the creative act, . . . we are able to reach beyond our own death. This is why creativity is so important and why we need to confront the problem of the relationship between creativity and death."

There will be new ideas in painting and each new idea will have a new technique.

—Robert Henri

Thus, the desire to break out of the limits of our life span prompts us to create, to leave something behind us—a desire as old as the cave drawings at Lascaux in southern France. None of us thinks of retiring from making art. It seems too much like living itself. Visiting a museum is not like going to see dead people. Rather, it is like going to a place where we can instantly revive the artists, hear their views, see what they have to say. To be included in their midst would

be a way to live forever. Thus, we all feel that the final pinnacle our work could achieve would be its inclusion in a museum collection.

Finding the Child in You

Art begins in play—play, ceremonies, games, signals. Chances are, you, like the rest of us, tried to draw on the walls. Concentrate on when you were really small, in the first five years of your life. What was your favorite form of play? Playing is part of creativity, and staying playful has always been an important part of making art. One of the most appealing things about artists is that they remain childlike in their perception of the things around them. One of the most helpful things you can do for yourself (as an artist) is to *find the part of yourself that is still childlike.*

Older children love to do the same things over and over, and this helps them to become confident. Grownups, like children, gain confidence as they repeat processes and get more and more adept with each repetition.

My first class in screen printing, just a few years ago, exemplified this. I remember the first time I pulled the squeegee across the screen. Watching someone else demonstrate how to use the wood-handled ink spreader did not prepare me for how the squeegee would wobble or how the silk screen ink would pass through the screen unevenly without a certain amount of pressure. It's necessary to pull lots of squeegees over lots of silk screens before you can make it look easy (and get perfect results)! Like many childhood lessons, repeating it often does help you get better at it. While repetition has its place in

learning, the spontaneity of younger children and their ability to imagine the impossible, in addition to the fact that they have no fear of making mistakes, gives them a fearlessness that we all admire. Artists need these "childish" qualities—both the freedom to imagine the impossible, and the patience to familiarize themselves with untried skills.

> *Progress in art does not consist in expansion, but in an awareness of limits.*
>
> —Georges Braque

I am struck again and again by how much of new art incorporates found objects. Children love to find things that they don't know the name or use of. While adding found pieces used to apply only to assemblage or collage, newer works of all kinds are including street finds wherever they seem right. Perhaps this development stems from the contributions of Robert Rauschenberg.

Children are born with a feeling of complete freedom to try anything, but today's Moms and Dads juggle busy work and home schedules with little time left to give children the open-ended chunk of time necessary for creativity. The day care schedule may not allow for it either. Interruptions can stifle a child's creative growth and are one of the worst creativity killers of the late twentieth century.

Make a Mess

When you were small, you may have been discouraged from making a mess. Think about studio floors you have seen since then. What about the floors you

were first exposed to in art school? Not exactly ads
for Mom's perfect kitchen floor were they? We must
be ready to wreak a little mayhem in order to allow
our creative efforts to blossom. A parent's persistent
warnings not to make a mess could have been all it
took to inhibit your creative stirrings. In the midst of a
good creative episode, a container may be over-
turned, liquids running everywhere. A studio gives us
a place where it is okay to make a mess; and if not a
studio, then a classroom. I recently visited an art
center where signs in the ladies' room urged students
to clean brushes and paint containers thoroughly in
another, larger sink rather than using the vanity sized
one there. The signs were phrased in such a way,
however, that the students weren't chastised for
making the scene messy. No blame was placed for any
artistic exuberance.

*It does not matter how badly you paint,
so long as you don't paint badly like
other people.*

—George Moore

Art instructors realize that we all make messes
and that they must be permitted to occur. If you were
chastised for making a mess as a child artist, give
yourself permission (now) to play freely and be messy,
so that your feelings of freedom will allow you to try
new ideas.

Inspirational Breathing

Experts say that whenever you become aware of
blocks or limits stopping you from expanding crea-
tively, slow and deep breathing exercises can be

helpful. A yoga position held for just a few minutes,
or a quick run around the block can help you separate
art making from the rest of your day. The following
exercise works to improve concentration, so you will
be ready and able to receive inspiration.

Sit comfortably on the floor with your legs crossed. Think only about your breathing. Try to imagine a lighted candle and put all of your attention on the flame. Imagine the flame on your forehead, between your eyes. After taking long, deep breaths for one to two minutes, bring your hands together, palms touching, the fingers of each hand extending back toward each wrist. Push your palms together, forming a circle with your arms. Bring your fingers together, while continuing to press your palms together. Meditate for one minute.

Raise your hands over your head with your palms still touching. Still concentrating on the candle's flame between your eyes, breath deeply. Hold this position for one to two minutes. Interlock your fingers and pull your hands apart but resist the pull. Meditate for one minute concentrating on your breath and listening to the silence.

Return your hands to your knees. Raise your arms at your sides to about a sixty-degree angle. Spread your fingers wide apart and breath deeply for three minutes.

Try a headstand for one minute and a shoulderstand for three minutes. The way you go into these positions is important and should be learned the first time you try them. Work with a yoga instructor to make sure you progress in an orderly way that is safe for you, before you attempt them alone. These positions will ease any stress you may be feeling and give you a sense of relaxation. Do not overextend them, as they can cause stiffness to occur across your back and shoulders.

Sitting again, bring your hands to your knees with your thumb and index fingers touching, palms facing up, the other three fingers extended forward. Meditate, focusing on the top of your head, for three to eleven minutes. Open your eyes and relax, feeling stilled.

Intuition: Other Information We Have

Do you talk to yourself? Most of us do, whether openly in public or only when we are alone. This is one of the ways that intuition shows itself. Intuition is very much like inspiration. Your hair may stand up on the back of your neck and you may, as with inspiration, get a chill down your spine when your intuition speaks. Although we often assume that it will tell us only negative things, the voice of intuition may have something positive to tell you. While the voice inside you might tell you that a choice would not work because it truly did not want you to succeed, it might also hold the key to a question you're pondering. Let's look at both your positive and negative intuitive voices. You may be more willing to listen to your negative voice. Perhaps you were chastised by someone older to listen to it, although, in the end, it offered only discouragement. This little voice might say:

"How can this idea be true?"

"Who are you to try this idea?"

"This idea cannot possibly work."

"It's never worked before, why should it work now?"

These little voices are childhood memories of those who discouraged your creativity in the past, and which you continue to carry around with you today. For your creativity to make use of your intuition, you must listen to both its positive and negative side.

Apparently, we keep a lot more information somewhere in our brain than we think we do.

What if the little voice is positive? Your un-
conscious mind may be trying to communicate to your
conscious mind the answer to a question you've been
mulling over. Marcia Yudkin says, "If you did know [the
answer to a question], what would the answer be?"

*It would seem from what has gone
before that true orthodoxy would teach
us to belong to our own time; but this is a
complicated business, and to be quite
sure, I would prefer to belong to all time.*

—André Derain

Roy Rowan, in *The Intuitive Manager,* interviewed
hundreds of people in the business world and came
away with the conclusion that, while most CEOs
hesitate to call their hunches "intuition," that was
exactly what motivated their decisions. Physical
feelings may accompany intuition. Sayings such as
"feeling it in our bones" or "gut feelings" reveal to us
how very close and honest intuition can be if we learn
to depend on it. Intuition can be trained to come to us
when we beckon it, mostly by a little daily practice. If
you can set up the right conditions for your intuition
to surface, you will be more apt to hear from it. By
clearing your thoughts, you will be allowing intuition
to approach you. As little as twenty to thirty minutes a
day—spent in your studio, for example—can help you
to reach the intuition that is there now, waiting to
speak to you.

As Roy Rowan says, "This amorphous, ill-defined
instinct known as intuition has to be understood,
nurtured and trusted if it is to be turned into a power-
ful . . . tool."

Exploring the Value of Solitude

> When the mind is very quiet, completely still, when there is not a movement of thought and therefore no experience, no observer, then that very stillness has its own creative understanding. In that stillness the mind is transformed into something else.
>
> —J. Krishnamurti

Artists almost always make art alone. In this chapter, you will see why solitude is valuable and essential for creation to occur. We'll look at ways artists can conquer the loneliness that long periods of isolation bring. We'll also consider those artists who need to be in a crowd in order to create their art and why they do. Collaborative artists usually unite to make a piece containing parts of each other's previous solo works. In fact, their past solo works are what have probably prompted them to work together in the first place. They will accomplish this work through a kind of brainstorming (a technique we will explore further in chapter 13), but individual periods of

solitude are necessary for each artist before working together.

No revelation will come to an artist who cannot hear the signals of inspiration coming. Artists must be able to hear their own thoughts and, moreover, they must listen for them. For this reason, you must take off your headphones and clear a channel in your mind to hear the messages that your unconscious sends you. These signals are different for everyone and come at vastly different times of day for each of us. For some artists, waking fresh from a night's sleep will be the purest time—before phone conversations, the newspaper, and the radio or TV can intervene. This is why it may be the best time to make notes to yourself in a journal. You will need to examine how inspiration has reached you in the past, such as the ways described in chapter 1, to analyze the method by which it may signal you again.

Your Time Alone

We, as a nation, almost obsessively seek the company of others: We eat, argue, play, and mourn together. We assemble as reading groups, tennis groups, walking groups, bridge groups. We deliver ourselves to rock concerts, sports events, and shopping malls to participate in mass activities. For many of these gatherings, we earmark special times to meet. We do not typically set aside time to be alone.

In fact, it is almost considered unnatural to seek to be alone. We live in a culture oriented to spending time with others. Any quiet time we do have is the target of the advertising world haranguing us with sales pitches. Yet, at certain times, everyone needs to

be alone. You may have felt this after someone very close to you passed away, as if you and life itself could not go on in the absence of that person. Sometimes, a period of quietness and solitude is necessary for you to determine exactly how you *will* go forward. A need for isolation may come to you when a plan for your life fails to bring you the happiness you expected and you decide to seek another path. Maybe you simply feel the need to be alone in order to sort things out. This inclination is not wrong; in ancient times, civilizations required a period of solitude before the ceremonies that marked the passage from youth into adulthood. Oftentimes, we must get away from others in order to follow our thoughts. An old expression called this "collecting ourselves."

The things one experiences alone with oneself are very much stronger and purer.

—Eugène Delacroix

When we are contemplating a new idea, these feelings are especially true. A new idea doesn't come with all of its parts already crystallized into language yet. Sometimes, you only get a flash of an image that quickly disappears, or is replaced by another. You can't tell people about an idea when it is very fresh; it is still evolving, still finding a place to nest and grow. An image of wings turns into gills, then gets scales, then folds up and is no more. Only after a time of quiet can words come that accurately describe an idea.

Even as we get into a taxi, we are greeted with recorded messages. It seems that no space around us

is free from some voice trying vainly to catch our attention, to keep us company. No one will fight for silence but us. And yet, solitude is essential for the artist. Picasso said, "Without great solitude no serious work is possible."

The wonders of quiet give us time to contemplate and imagine. "All art," Oscar Wilde said, "is based on exclusive and delicate sensibilities." For artists, the space offered by solitude provides room for innovation. That doesn't mean inactivity. In fact, for artists, aloneness is often very active. Think about the time you spend in your studio. Much of it is spent not making art, but experimenting, tinkering with supplies for a desired result. If you have a shelf of books on art, this may be another excellent way to invite inspiration. Some of my favorites: *The Banquet Years* by Roger Shattuck (about artists in the beginning of the twentieth century), *Off the Wall* by Calvin Tompkins (about Rauschenberg and Jasper Johns, Merce Cunningham and John Cage), *Formulas for Painters* by Robert Massey (how to make glazes, varnishes, and gessoes).

Here are some excellent books to add to your library—another "alone" thing to do: *The Magic Mountain* by Thomas Mann, *Silence* by John Cage, *Letters to a Young Poet* by Rainer Maria Rilke, and *Let Us Now Praise Famous Men* by James Agee.

That Essential Aloneness

The first reason why we need time to be alone is to discover ourselves. We can go through a busy life,

day after day, never finding out who we really are, but in solitude there are no interruptions, no distractions, nothing to divert us from ourselves. We artists need to know who we are. We have chosen a complex, individual way of living with many difficulties to overcome. A strong sense of who you are will make these problems worthwhile, turning them into positive challenges or, at least, putting them in perspective. Solitude gives us a chance to look at where we are, much as we step back from the canvas to look at our artwork, to see what needs adjustment and what is exactly right.

Alone one gets acquainted with himself, grows up and on, not stopping with the crowd. It costs to do this. If you succeed somewhat you may have to pay for it as well as enjoy it all your life.

—Robert Henri

The second reason to be alone is to open ourselves up for receiving inspiration. You have to be open—make room in your consciousness for inspiration to settle and feel at home. To accomplish this, you first have to admit to yourself that you don't have the keys to creating *at this time*. This admission will prompt you to seek inspiration. I don't believe inspiration was ever found without someone actively *looking* for it. My friend Jim Green, a tai chi expert, says you need to start every day by asking yourself, "What can I learn today? What can I discover?" as if you were a little, innocent child. Don't start the day in a blasé manner, sure that you know all you'll need to know. Be a little unsure, a little accessible, unfettered by

what hasn't been able to help you thus far. Being open requires a little timidity and humility, a stance we may not be too thrilled to take.

I know I just told you in the last few chapters that you need to gain confidence, but at the outset of your search for inspiration, a touch of modesty won't hurt you. Watch for signals from people and places that you feel *can't* help you. Remember that old saying: "Out of the mouths of babes." Paying attention to signals such as these requires you to listen very carefully, to practice solitude. It pays off!

It was only recently that I realized why my friend Marilyn, a writer, was taking a bath at the exact same time every day. At 9:30 in the morning, any day of the week, you could never get her on the phone. She used this long, warm bath directly before she began to write as time to be alone and gather her thoughts. What I've just realized is that this is actually *part* of her working process. She can't be interrupted, she is confronting only herself, and she has time to go over what she hopes to complete for the day.

We can develop a good relationship with ourselves only when we have a clear impression of who we are. Perhaps Leonardo da Vinci put it best. "When you are alone," he said, " you belong entirely to yourself."

It takes courage to be alone. It isn't the easiest state to adopt, as I can very well confirm. Some time ago, I broke up with a man I had been seeing for several years, and I could not bear to be at home by myself, often going out for any reason, or none at all. Looking back, I think the evolution out of that state occurred because I started painting again and needed to think more. Crowded, busy places didn't allow for

that. The value of being solitary soon became evident, and I think the whole experience gave my work an inner depth that it had not had before.

Solitude is not necessarily a quiet time. When I'm alone I talk out loud, often arguing a problem both pro and con. Don't you talk to yourself as you paint? Being solitary and working alone gives you the opportunity to try things out, change them, and change them again until you're satisfied, without having to explain why to anyone.

Here's another exercise to get you creating. Using a discarded magazine on a particular subject, such as home improvement or the stock market, fold the pages in as many different ways as you can think of. You can tear or cut shapes out for a see-through effect, too. Since we have been discussing solitude, try to accomplish this exercise without sound. Giving yourself a quiet-time creativity project such as this will help you to concentrate on the changes that occur. Let your solitude help you see the juxtaposition of imagery from one page to the next and how just changing one tiny thing can give you a completely different creative twist.

Stilling Your Mind for Inner Peace

One of the surest ways to become introspective and able to reach a certain peacefulness is through meditation. While I am not a big follower of New Age thinking, I do believe that you must come to a stage in your creativity where introspection takes over.

When I first took up yoga, it used to take me quite a while to get to a truly quiet place, essential to being able to meditate. As time went on, it became easier

and easier to go directly into deep meditation. I have heard others say the same thing. I think this is an acknowledgment of learning about yourself. Once you have done a certain amount of it, you can become very quiet very fast. I think meditation can be very helpful in your quest for inspiration.

To prepare for meditation, first locate a quiet space. You'll find that certain rooms or outdoor sites lend themselves to this. Leave your alarm watch or cell phone where you can't hear the ring. Once you find your meditating place, sit on the floor or ground, bending your knees and crossing your ankles in front of you. Sit erect, elbows on your knees, your hands limp. Close your eyes. Breathe deeply, and listen to your breath. Concentrate on your breathing. Thoughts may dart in and out of your mind. Just let them come and go. Watch them come and go. You will be aware of yourself, aware of your breath. Just relax. You'll probably breathe more slowly, as you feel the calmness opening up around you. You will feel yourself going deeper and deeper into a receptive calm, safe state. Wait to see what images you notice. Some images will come to you more vibrantly than others. Do not try to catch them but let them come and go. You won't lose them; after your meditation is finished, they'll be there for you to write about and think over.

The satisfaction you will feel having a clear mind, without any outside experience creeping in, should show you the value of meditating. You're making space for inspiration to find shelter in your inner being. The ideas swirling through your mind now, at the beginning, are forerunners establishing a place where new ideas can be nurtured when they emerge later with greater intensity. You are preparing or "stilling" your mind, acknowledging the arrival of

new thoughts and fixing a place to regard them. As
ideas for your new work occur to you in future medi-
tations, they will sharpen, becoming more focused as
they reach your consciousness and become viable
concepts for future art.

To help your concentration, simple yoga exercises should be practiced
each day on a regular basis. Begin with five minutes of relaxation,
allowing yourself to become completely still and calm. Editors Lucinda
Hawksley and Ian Whitelaw, in *Yoga/101 Essential Tips*, stress correct
breathing for best yogic practice. Your breathing exercises can be mixed
with other yoga exercises or praticed by themselves. Hawksley and
Whitelaw recommend that you begin sitting cross-legged, with your
head, back, and spine aligned. Place one hand on your lower rib cage and
the other hand on your abdomen. Inhale slowly, feeling your chest and
abdomen expand. Breathe deeply, feeling your lungs fill with air in their
lowest part, then middle, and finally the top. Yogic breathing (known as
Pranayama) is essentially done through the nose rather than the mouth,
using one nostril or two. For one-nostril breathing, use the last two
fingers of the right hand to close each nostril in turn. Your exhalation
should be longer than inhalation. Inhale to a count of four. Exhale to a
count of eight. Repeat ten times. After you feel comfortable doing the
single breathing, try alternative nostril breathing, retaining your breath
for a count of sixteen. This exercise will develop calmness and clarity of
mind.

When you spend time alone, you might want to
concentrate on spiritual experiences you have had.
Whatever your beliefs may be, you hold a store of
memories that you may not have explored too closely.
Start to do it now. Ideas to explore include you and
your relationship to God, where people go when they

die, what sort of contribution you want to make to the world; things that are endlessly fascinating to all of us, but that may have been avoided in keeping up with the daily routine. If you give them some time, you will be rewarded with imagery that can be used in your art.

Artists Alone Together

How can you make it up to yourself for all of the time that must be spent alone? Artists who get together ponder the problem, coming up with makeshift solutions. Several I know meet on Friday afternoons to have coffee together and "talk shop and wrap up the week." Another group I have heard about has an informal breakfast one morning each week, its doors open to any artists who can get there. The neighborhood art bar (just ask around, there's always at least one) is always a possibility for darts, pool, beer, and talking art. In all cases, the idea seems to be to fit time into your schedule for "letting off steam" together. This is more important than it sounds: In these informal gatherings, artists exchange news about new exhibitions and leads to new galleries. Although they would never admit it, these artists are "networking"— a corporate term for swapping business leads. A long week spent alone in the studio can be rough, which may account for several studio sites where several artists share space. This not only cuts down on the studio rent, it offers the artists involved a chance to find someone to talk with while working. It is not perfect at all times—for example, when one of the artists has an important visitor coming, such as a museum curator—but the artists I have spoken to say

it can be worked out if everyone is warned ahead of time. Privacy could be a problem, unless some ground rules are laid down. However, it's definitely more economical and better than having no studio at all.

It seems to me that today if the artist wishes to be serious . . . he must once more sink himself in solitude. There is too much talk and gossip.

—Edgar Degas

Here is an idea for keeping yourself company. Several years ago, in our artists' nonprofit organization's newsletter, we published a listing of all of the radio and TV stations we could find that were devoted to the arts. Our list included community college classes on public access channels, cable channels, radio talk shows, and so on. We listed the date and time for each one, and it was really amazing how many we located.

Another article we ran listed the time and location for life-drawing sessions in our area, which were open to all. For a few dollars, you could spend an evening or a Saturday with a group of artists, limbering up your sketching muscles with like-minded souls. These sessions might take the form of a class, with someone giving instruction as well as running the whole operation, or they might be peer gatherings, with one group member "hosting" the session. These meetings are one of the natural places where inspiration can occur. Where you live, these kinds of meetings may be held in community colleges or historical societies (with models sometimes available in period costumes), or with private group organizers who will

arrange for a model, keep time, offer you a cup of tea, and so forth. Look into it—it's a very good way to meet artists, spend an evening, and even improve your work. It is a good opportunity to try out a different style than what you normally use.

Surprisingly, some sketching I've done at these sessions has been of remarkable quality—possibly because I took myself less seriously and was more "playful" and so was able to work just for the sake of doing it. Of course, these drawings were usually done on newsprint paper and won't last.

While I was researching this subject, I came upon some thoughts from Leonardo da Vinci concerning whether it is better to sketch with companions or not. Da Vinci insists that "drawing in company is much better than alone, for many reasons. The first is that you would be ashamed to be seen behindhand among the students, and such shame will lead you to careful study. Secondly, a wholesome emulation to be among those who are more praised than yourself, and this praise of others will spur you on. Another is that you can learn from the drawings of others who do better than yourself; and if you are better than they, you can profit by your contempt for their defects, while the praise of others will incite you to farther merits."

Artists On-Line

Another way to heal a case of "the alones" is by surfing the Web. You can find sites for many art locations, art schools, and museums. Here are some of their current addresses.

www.artdealers.org

This site introduces the Art Dealers of America, including a selection of links listing member galleries, their specialities, their current exhibitions, how to obtain catalogs, plus extensive links to museum sites all over the world.

www.artswire.org

A program of the New York Foundation for the Arts, this site offers grant information, statewide art making opportunities, articles concerning art education, a conferencing system for members, a listing of available jobs, and a weekly art-world news article.

www.fedncenter.org

The Foundation Center site provides help in writing proposals, offers publications of the Center for sale, and specializes in presenting what's currently new in grants and grant making. The Center offers a program called "Grantseeking on the Web" at its computer lab in New York City, which is a hands-on training course, constructed to help you expand the scope of your funding research.

www.artsedge.kennedy-center.org

The Artsedge Kennedy Center site provides an opportunity for those interested in art education to get a complete picture of the K–12 art program. Sponsored by the Department of Education, the National Endowment for the Arts (NEA), the JFK Center of the Performing Arts in Washington, D.C., and the Kennedy Center Education Department. It offers the cutting edge in current thought regarding art education.

www.metmuseum.org

The Metropolitan Museum of Art site highlights all that is current at the museum and offers a map of the vast New York City institution. There is access to the museum gift shop—which offers the largest art bookstore in America—where you can shop online, become a museum member,

and request a catalog. A section on the Met's upcoming exhibitions can help you plan a trip to New York.

www.mistral.culture.fr/louvre/
The Louvre Museum in France offers you a "visite virtuelle" to the famous institution and gives you vital information as to what galleries are open on which days—a great convenience when planning to see the many collections there.

www.lacma.org
The Los Angeles County Museum introduces a unique West Coast perspective, with news of planned exhibitions, a collection of film and music programs, a pavilion dedicated to Japanese art, a visit to the gift shop, and such unusual programs as the Art Rental and Sales Gallery. This offers local artists the opportunity to loan their work, with the Art Museum Council's blessing, to perspective buyers. The artist gets 75 percent of any loan or sale price, and the balance is accumulated into a fund for the museum's future projects.

www.publicartfund.org
New York City's Public Art Fund has a site that shows the new projects it is presenting around New York, such as comic art in the subways, art on buses by Barbara Kruger, and outdoor sites such as traffic islands and the lobbies of midtown buildings. Shows may last as long as a year and usually feature emerging artists.

www.artnetweb.com
MIT's Visual Arts Center features installations, readings, and such unusual art exhibitions as the recently presented *Port*, which features the works of a group of artists—some known, some not—all conceptual in nature. The Center offers a slide registry for artists around the world and poetry by living poets.

www.thing.net

Formerly a bulletin board site run by the Journal of Contemporary Art, this site now focuses on contemporary art and cultural theory. The site exhibits Net-specific art and offers the discourse that surrounds it. It includes reviews of contemporary work and links to other contemporary sites.

www.echonyc.com

Echo calls itself a "cybersalon" of New York City. Over eight years old, Echo's site also has links to New York's Whitney Museum. The staff at Echo has written *Cyberville*, which you can buy at the site and which deals with much of the New York City art scene and new media. There is a chat room, live interviews, a reading series, and Web hostings.

www.ahip.getty.edu

The Getty Museum in coastal California greets you with a complete outline of the activities it offers and suggests that you plan a trip to the museum. The museum is a combined information, conservation, re-search, and leadership institute, and it provides information for its grant programs.

www.lycos.com and *www.yahoo.com*

Both Lycos and Yahoo! are popular search engines that offer extensive art sections.

www.christies.com and *www.sothebys.com*

These two auction houses both offer extensive links and provide daily information on what is to be sold each day.

www.reviewny.com

Review magazine is featured each month with reviews on current exhibi-tions in New York's art world. This site gives you a head start if you are

planning a trip there soon. This is probably the only place to get a review of work that is still on exhibit, find the location where you can see it, and contribute either your agreement or disagreement with the review.

www.guild.com

This site offers fine arts and crafts for either purchasing or commission for your home. For years, the Guild has offered fine quality sourcebooks to decorators, and artists rave about its photographic and layout expertise for showing works of art.

www.artusa.org

This is the site of Americans for the Arts, an arts advocacy group. It includes a statement of support for the NEA and listings.

www.sculptor.org

This is an individually run site by a Virginia sculptor, dedicated to sculptors everywhere. Sources for supplies, techniques, job offerings, and individual Web pages fill over one hundred pages of information to help sculptors more accurately direct and manage their art. The site gets more than ten thousand visitors a month!

http://rtuh.com/adl

This site contains the Art Deadlines List with news about juried competitions, exhibitions, and calls for entries, proposals, papers, jobs, and internships. It is an individual Web page also—and great!

www.nmwa.org

The official Web site for the National Women in the Arts Museum in Washington, D.C., this offers name listings of curators, librarians, and everyone who may be of help to you. There is a map of the museum and a listing of current exhibitions, too.

Artists Who Chronicle Society

For every rule, there is an exception. For all the artists who must create in solitude, there are several notable anomalies. The most recent of these was Andy Warhol.

When I get my hands on painting materials I don't give a damn about other people's painting: life and me, me and life. In art, every generation must start again afresh.

—Maurice Vlaminck

Warhol grew up fantasizing about movie stars and the lives of the rich and famous. These fantasies, which took hold despite his own impoverished circumstances as part of an immigrant family in Pittsburgh, brought him to New York, where he began a career in fashion. His early success as a shoe illustrator for the I. Miller stores evolved into higher-profile exhibitions of his work in galleries in the art world. Warhol's paintings of the rich and famous, whom he'd dreamed of meeting as a boy, were countered by paintings of a demimonde of transvestites and drag queens. His art mirrored both extremes of café society, and there was intense interest in his films, as well as his paintings and silk screens. Pop Art was the rage all around Warhol, and he made his portraits of the rich and famous look like portraits had never looked before. His interest in fame, those pursuing it, and those who already had it led him to a life of intense club-going, and his studio, known as The Factory, was open round the clock and always full of

hangers-on. His young assistants came mostly from the advertising world; many were acknowledged to have been part of the art-making team, although the art was all planned by Warhol alone. As a student in those days, I remember seeing him out on the town, his cohorts surrounding him wherever he went.

For a quasi–Andy Warhol creative exercise, cut a photo from the newspaper of two inches or less and reproduce it on a copier fifty times. Place the reproductions side by side, tape them together on the back, and make each photo look different. It will give you lots of ways to treat a similar image.

Another artist with an interest in café society as subject matter was Henri de Toulouse-Lautrec. In late nineteenth-century Paris, he wanted to capture the nocturnal high life in society and nightclubs. Born into a well-to-do family, Toulouse-Lautrec had suffered boyhood injuries, which left him a mere four-foot-six-inches tall, a dwarf really, but he found acceptance among the artists, café denizens, models, and circus clowns whom he met in the clubs at night. They flocked to his studio in Montmartre, where he staged lavish parties with large spreads of food. Still another artist, fellow Parisian Edgar Degas, took his subject matter from social scenes—specifically, from the throngs at the theater, the opera, and the race track. Each of these artists found content for his work in the dynamic social scene, seeking out the faces and situations that his art portrayed. Here, we can detect a need or desire to mix with society in order to accurately depict it. Both Degas and Toulouse-Lautrec

contributed to the way artificial theatrical lighting was painted after the coming of gaslight and the beginnings of electricity. Warhol's art chronicled pop culture and showcased fame as art. All three of these artists used irony to imply a darker side of society. Their choices of where and how they made art are less about aesthetics than about being where their subject matter would be found. How much of their individual time was spent alone in the planning of their art is difficult to determine.

Art doesn't come out of art, and you don't work with one foot in the art book, and no painter has ever really been able to help another.

—Robert Rauschenberg

To understand exactly what can be learned from sketching while people-watching, you should make at least a small effort for yourself. Some of the best places for people-watching are cafes. People seem to lose their inhibitions and relax when they are with friends and eating in public. Another easy place to watch people is on public transportation—buses and trains. One of the best quick sketches I ever made was while I was in the back of a bus. I saw a teenager walking outside the bus and counting change in his hand. Although its not a great sketch, it reads very clearly and it is easy to tell what he's doing. If you are a bit afraid of being approached as you draw, this is a good place to feel safe. All of the passengers on the bus have their own agendas for the day and won't have time to ask why you're sketching them. Looking back over my own sketches years later, I am amazed to see what I learned and taught myself in these sketching trips. They really are invaluable. Just from an afternoon of public sketching, you gain a clear understanding of how

Degas, Toulouse-Lautrec, and Andy Warhol could be lured into making it a life's work.

While there are artists who thrive in a busy and cacophonous milieu, the majority find that solitude is necessary for creativity. Many brave artists have endured isolation as they sought a clearer perspective on, and a more objective approach to, their work. Some have died lonely—their friends gone, their art forgotten. We, at least, have the benefit of their stories and, hopefully, will find a way to balance the need for companionship with the need for seclusion.

Individuality is the beginning and end of all art.

—Unknown

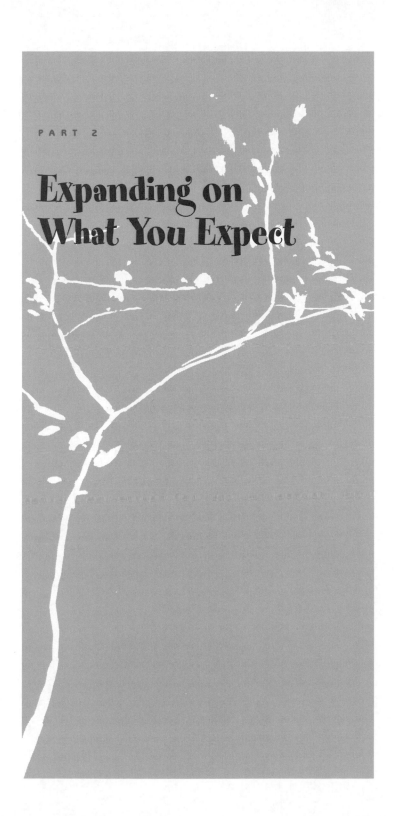

PART 2

Expanding on
What You Expect

Seeking the Source of Inspiration

Every act of creation is first of all an act of destruction.

—Pablo Picasso

In talking about becoming re-inspired, we must admit that we are often overwhelmed by the mass of information we receive. I suggest that organizing your inspiration will help, and you can make this happen.

Organizing Yourself to Receive Inspiration

Think of this process like preparing an index for a book. It doesn't matter how wonderful the book is, without an index, the readers won't be able to find what they are looking for, or go back to something extraordinary that they had discovered. Indexes come in several formats and can be arranged by names, institutions, groups, or concepts. To "index" the sources of your ideas, you might use categories such as childhood memories, color thoughts (how many

blues are you fond of, for example, or the exact blue of a night sky you once noticed), interesting combinations of materials (say, twine and silk, or plaster and oil paints), your thoughts about your beliefs, your past work, influences of other artists, and so on.

Speaking about how you work, it may be easier to break the artwork up into parts:

- A sketch
- A color scheme
- Mixing your paints
- Stretching your canvas
- Choosing your tools
- Putting down the large, overall themes
- Corrections
- Painting in darker colors, then lighter ones

As you sort these memories into groups, think of packing up after an overnight camping trip. Everything must fit neatly into your backpack: Unruly bedclothes won't fit; everything must be folded and neat, rendered down into pillow-sized squares; comforters, blankets, and quilts must form a neat stack. Now, see yourself back at home again, unfolding your memories one at a time, examining each one, and putting them away until you need them again.

Organizing your thoughts also helps you to see them as less mysterious and more manageable. If you gain the mental agility to be able to move from one part of your creativity to another, you will have made sense out of chaos. Like an index, you can provide yourself with cross-references that will allow you to move from one area, such as a childhood memory, to another, such as foods and tastes. At first glance, these sensate memories might seem far away, yet they

It is clear that discovery and invention in both science and art require exercise of creative imagination. And the creative process seems to be basically the same in both fields. A mind trained and at-tuned to possibilities, an immense amount of work and methodical planning, then leaps of intuitive insight followed by swift consolidation.

—Stanley Rosner and Lawrence Abt

will come quickly when summoned. You might benefit by drawing yourself a small map or making note of important landmarks, much as you would on a walk in the forest, in order to find your way back home again. By writing down a few key words, you can mark the trail, in case this train of thought is interrupted but seems to be getting you somewhere. Another way to look at this, for those of you who remember diagraming sentences in English classes, is to lay out the structure of your "art mind" much like you would a sentence. Start with the main idea (like the subject of the sentence), scaffold out to the action (the verb of the sentence), and afterward, add platforms for the unfinished ideas you will complete later (adjectives and adverbs). Use different colored markers so that each part grabs your attention.

Here's an exercise that will illustrate, through the use of a simple line drawing, how your mind organizes information. Place a circle on a piece of paper to represent your art idea. Now, drawing lines and working backwards, try to map how the idea came into existence. There are probably lots of roads that led to the finished state. Your drawing will look

something like a biological drawing, with roads leading out from the circle in the center to other circles and other veinlike lines. Little side paths will represent how elements of the idea came to be. It is a map of your creativity and cannot be completed until the final idea is known, as this will become the heart of the entire thing. Like a spider's web, this drawing will grow out from the center, becoming more ornate as you realize all of the elements you've used along the way (your intent, the media you want to use, the palette of colors that will make it most graphic, etc.). Don't forget to include in your map other attempts you have made to make similar pieces and what you learned from them. (Or maybe make a separate drawing if things get too crowded.) Also, include any restrictions (if it is for a proposal or a competition with specific size or shape requirements) that might limit you in any way.

Sometimes, we can branch out from a very simple topic to a vast subject. Here's an exercise that will help you explore that concept.

100,000 Trees

Choose a subject for a simple drawing. Let's say you choose a tree.

Now, at first glance, a tree will probably appear in your mind as a photo or a line drawing. But let's take it a bit further. Let's create this tree in terms of the negative space around it. This art-school term simply means, everything *but* the tree, like the air around it (the positive space, then, *is* the tree). To define the negative space on the page, try filling in all of the space from the edge of the paper, working toward the center, suggesting a limb-like bulk without using any of the lines you might traditionally use if it were a line drawing. Let the tree emerge from everything around it.

Now, try doing this using a piece of crayon on its side or lead from a mechanical pencil or chalk. Note that the tree changes each time you draw it, depending on the medium that you use to render it. You could even make the tree appear 3-D by adding acetates over your original page, making limbs appear to move out toward you.

Continue to add to your list of ways for rendering this tree. Draw on the concepts you could use, for instance, additions such as scraps of paper (maybe newsprint), which you could glue onto the page. Make the tree more graphic (that is, have markings suggestive of written or printed characters), using tiny letter *T*'s to form the whole tree. How about drawing the tree as if you were inside it, looking down? Try imagining the tree in different seasons, with and without leaves, or with snow. This time, draw the tree in one, continuous line, never lifting your pencil from the page. Try drawing the tree as seen from below, and above. Pretend that you *are* the tree! This will make you view its branches much as you would your arms and legs.

Now, think of all the creatures that live in the tree. While you may see the tree as a simple object, the things that live in it probably see it as their town. There are probably several thousand homes in this tree.

In the city, many trees grow up with metal guards around them. These protect the young tree from traffic that parks too close, but later, the tree grows around them, and the guards become part of the tree's shape. What about all of the tree's parts you can't see—the roots that plunge into the ground, and are usually hidden? Maybe there's actually more of this tree underground than above. Think of news programs you have seen where an earthquake or hurricane has occurred. Trees have been uprooted, torn from where they normally sit, and parts of them that we never see have been ripped out of the ground. Our task is to render the tree so completely that any viewer *believes* in the validity of the parts they don't see as well as those they do.

Think about how our tree sits on the ground. Maybe you can show this tree with roots going into the ground, some parts still resting above ground. Maybe the size and apparent weight of this tree will help the viewer believe that there is much more of it unseen, beneath our feet.

Sometimes a tree can show its age, through knots in its bark or scars from lightning or illnesses it may have endured. It is a rare tree trunk, indeed, that does not tell its viewers some of what it has encountered in life. If you were depicting an older tree, how might you do this? Certainly, you could show the vast number of rings if you cut down the tree, but how would you convey its age as a living thing? Maybe the weight of the tree has caused it to bend or sag with age. There is an old tree near my home in Greenwich Village that has grown out of its original place and now displaces the sidewalk next to it, breaking it up, the tree's roots traveling under the sidewalk and back out on the other side.

And how would you show a sapling?

True creativity comes when we explore how many *more* ways a tree might come into being on the page. This is one of the ways in which computers are learning to work today, but there are still limitations. You will notice that as you create more versions of a tree drawing, your emotions will show through the drawings. Try drawing the tree while you feel angry or dreamy. Your feelings will come through as you draw. This could be called the emotionalism of the drawing. Not possible from a computer!

Leonardo da Vinci would not feel our tree to be complete without showing light and shadow. He felt that studying light and shade were so important that he devoted six notebooks to that subject alone.

Now, think of a subject like our tree. Try retracing the steps we followed in the tree drawing with your subject, until whatever you chose has been so well examined that you know everything there is to know about it. Render it in every way you can imagine. You'll find it is like stretching your muscles—art muscles.

Why You Make Art As You Do

Even something as straightforward as our tree drawing will not be rendered neutrally. It may be influenced by your politics or a point of view that you have strong feelings about. If you live in a rural setting, you may know what kind of a tree you are drawing, while an urban reader may see the tree as an overgrown nuisance and harmful to traffic. Both the style and substance of your artwork have as much to do with how you think as they do with how you see.

An artist should paint as if in the presence of God.

—Michelangelo

I remember seeing a restaging of *Parade*, the play created in 1917 by a group of Cubist artists. That play was widely acclaimed because Diaghilev, Nijinsky, Satie, Cocteau, and Massine were also involved, and it is thought to have heralded changes in several art fields, including ballet, the visual arts, and music. (Although it was staged in Europe, the original stage curtain is owned today by the Brooklyn Museum of Art.) The costumes were by Picasso, who in his Cubist fervor, had made them all very square and boxlike, ignoring the shapes of the actors who wore them.

The way in which you render something might have to do with your favorite art medium. For instance, if you are a collage artist, you may see a tree as made of many bits of paper, while a portraitist sees it as a line drawing. Many things will dictate to you the way you will render an object. You should try to

find what is in your background that causes you to prefer to work in a certain style or medium and that makes certain subjects compelling. There are many powerful personal, social, and psychological reasons why artists feel driven to represent particular objects and themes.

J want a picture to seem as if it had grown naturally, like a flower. J hate the look of interventions—of the painter always butting in.

—Willem de Kooning

For example, the subjects of works of art have always been influenced by the political leanings of the artists. Let's consider some of the more famous cases.

Diego Rivera

Diego Rivera was a Mexican artist whose murals were gaining attention in the 1930s, at the same time that John D. Rockefeller, Jr. was building the architectural landmark to be known as Rockefeller Center in New York City. Rockefeller Center, located on Fifth Avenue, would comprise several buildings in the Art Deco style with many artworks embellishing the entrances, and three large murals planned for the central building, then called the RCA building. The overall theme that the artists were to portray was "Man, at the Crossroads, Looks toward his Future."

Rivera's leftist political leanings were no secret at that time. However, Rockefeller commissioned Rivera, along with José Maria Sert of Spain and Frank Brangwyn of England, to create the RCA building

murals and asked them to coordinate their designs around the overall theme. Later, Rivera would maintain that Rockefeller knew early on of his intentions to include Communist ideals as elements in the murals. Rivera, who considered this mural to be his masterpiece, was known for his works that depicted large groups of diverse people. When his Rockefeller Center mural neared completion and recognizable faces could be discerned, it became obvious that Rivera had included a portrait of Lenin, the young Communist leader, shown joining the hands of a soldier and a black man, while unemployed laborers stood behind waving red flags. At this point, Rivera was approached and told that the mural was not acceptable to the Rockefeller family, and he was asked to make certain changes to bring his mural more into line with those of the other two artists. When he refused, he was paid in full ($21,000 for three murals) and told that his mural would not be exhibited. This event became highly publicized in the New York press throughout the spring and fall of 1933, and artists and art students rallied to his support. Because the Rockefeller family embodied the spirit of capitalism, the choices made by Rivera caused many to take sides.

Writing in *Harper's Monthly Magazine,* Walter Pach expressed his opinion that, "What neither the critics of the fresco nor its Communistic defenders realize is that the significance of this vast work does not hinge on a particular detail. It resides in this artist's whole attitude toward life, life's purposes, and the means of fulfilling them."

The entire event was certainly an attention-getter and although Rivera did not finish his murals, he may

have felt that it had served a greater purpose by not being displayed. It is not clear whether or not Rockefeller did know of Rivera's politics when he was hired to create this mammoth mural or whether Rockefeller was simply so secure in his position as the commissioner of the work that he felt he could influence Rivera's art. At any rate, to this day, the murals at Rockefeller Center are most notable for the ones that aren't there—Diego Rivera's.

Ben Shahn

Another artist whose work echoed his politics was Ben Shahn. According to writer Michael Kimmelman in his recent article in the *New York Times*, Shahn's artistic career spanned the period "from Joe Hill through the Rosenbergs to the Rev. Dr. Martin Luther King, Jr." All three stood with the common man: Joe Hill, a union organizer; the Rosenbergs, accused of spying for Russia and executed; and Martin Luther King, Jr., a civil rights leader. Consistently the champion of the social underdog, Shahn's painting of anarchist Italian immigrants Nicola Sacco and Bartolomeo Vanzetti made him famous. Sacco and Vanzetti were shoe factory workers in 1921, when they were charged with murdering two men and stealing $15,000 in a much-debated trial, seen by many as a frame-up. Both Sacco and Vanzetti were executed in August of 1927. The U.S. government's treatment of the immigrant anarchists, who spoke no English, aroused much support for them and strong feelings in America.

Shahn's working style was one reason his art so perfectly caught the mood of many in the country.

"Using tempera," the *Times* article described, "Shahn stuck to a few canny devices: meaty hands, patchy colors, a mix of deep telescopic space and flat, collagelike elements. . . . and, famously, a catchy shorthand means of drawing faces and hands."

It was during those years that the inner critic first began to play hara-kiri with my insides. With such ironic words as, "It has a nice professional look about it," my inward demon was prone to ridicule or tear down my work in just those terms in which I was wont to admire it. . . . "Is that enough? Is that all?" began to plague me. Or, "This may be art, but is it my own art?"

—Ben Shahn

The article went on to describe Shahn's position today. "It is still deeply impolitic to criticize him, his admirers interpreting criticism as an attack on what he claimed to stand for, as if, to reverse the equation, revering Velazquez meant advocating monarchism or praising Picasso meant condoning misogyny. We forget how much taste in art became a grave moral matter in Shahn's day and no doubt remains so among many of his followers. At the time, Shahn represented an alternative to abstraction, whose meaning, being difficult to grasp, seemed morally suspect. He made people feel enobled because through him they could associate themselves with causes that they considered just. Or put differently, he confirmed what they already believed."

Thomas Hart Benton

Our last example of political influence on artwork is Thomas Hart Benton. Living and painting during the 1920s, '30s, and '40s, Benton created works of art that celebrated the rural Americans. His farmers, railroad workers, and millhands showed their brawny muscles in a way that can be compared to the writings of Steinbeck. In his autobiography, *An American in Art: A Professional and Technical Autobiography,* Benton discusses his painting and his politics:

> John Steuart Curry and Grant Wood rose along with me to public attention in the thirties. They were very much a part of what I stood for and made it possible for me in my lectures and inter-views to promote the idea that an indigenous art with its own aesthetics was a growing reality in America. Without them, I would have had only personal grounds to stand on for my pronounce-ments. . . . we were all in revolt against the unhappy effects which the Armory show of 1913 had had on American painting. We objected to the new Pari-sian aesthetics which was more and more turning art away from the living world of active men and women into an academic world of empty pattern. We wanted an American art which was not empty, and we believed that only by turning the formative processes of art back again to meaningful subject matter, in our cases specifically American subject matter, could we expect to get one.

Benton, Curry, and Wood were called Regional-ists, the same name taken by some southern writers who had particular interest in their regional cultures.

Benton felt that the name had been given to the artists somewhat "loosely, but with a fair degree of appropriateness." He was proud to note that his painting came from the street and that ordinary people could understand his work. His mural for the Missouri state capitol building in Jefferson City was typical Benton, with both real and fictitious characters out of Missouri's rich past, such as Huck Finn, Jesse James, and the brawling barroom couple, Frankie and Johnny.

He moved from the Midwest to New York City and had a studio on West 13th Street near my home in the West Village. Jackson Pollock was an assistant to Benton early in the latter's career. Benton's neighbors in the building on West 13th Street included another artist émigré to New York, Edward Hopper.

Where are the sketches that were made? Some of them are in dusty piles, some turned out to be so good they got frames, some became motives for big pictures, which were either better or worse than the sketches, but they, or rather the states of being and understandings we had at the time of doing them all, are sifting through and leaving their impress on our whole work and life.

—Robert Henri

Another mural, titled *America Today,* painted by Benton in 1930–1931, hangs in the lobby of the office building of Equitable Life, at 1290 Avenue of the Americas, in New York City. Benton painted other murals for the New School; his work was featured in an exhibition called *Benton and the American South.* Among the murals in that exhibition was one recount-

ing the Amistad story, later to be told in a Steven Spielberg film of the same name.

Critics of Benton's works saw them as "provincial," and this type of criticism led him to leave New York City and return home to work in Kansas City, Missouri.

You can't change your mind up on a scaffold without the risk of everything going awry. You must solve your problems before you get up there.

—Thomas Hart Benton

By the end of World War II, the Regionalists were out of fashion, replaced by an international group of artists, many of whom had emigrated to New York because of conditions in Europe. Abstract Expressionist painters were making early noises, and the Regionalists were largely forgotten. Benton felt that the moneyed interests behind much of the art world worked against his vision for American art, and he painted his last two murals, one for the Truman library and another in commemoration of Niagra Falls in 1969. Benton passed away in 1975.

Artists As Activists

The three artists mentioned above all lived and worked in the period from the 1920s into the 1940s. These were traumatic times for the country and for art as well. The Great Depression of the 1930s was the catalyst for a great deal of social unrest, including the beginnings of the union movement and the early years of Communism. Art was important during this

period, even without the vast changes taking place within it. It mirrored the turbulent times, and more than one artist caught (or was caught up in) the spirit of the era. It remains true even today: Many of you will comment on the contemporary social climate through your work.

A weak background is a deadly thing.

—Robert Henri

Artists today are activists for causes as diverse as environmentalism, artists' housing, AIDS research, and street art. If you use your art to speak out for what you believe in, you will be participating in a proud artistic tradition. Your inspiration might come from how you feel about a particular cause.

Showing Ideas in Your Work

Conveying an idea in your work may be difficult. Abstract thoughts can be hard to pin down and show well, and this is something they don't give us much help with in art school. One of the best ways I've found for putting forth concepts is described below.

Pay a visit to your local library and stop by the children's area. Study the illustrations in children's books. The variety that these illustrations come in seems endless. Forget the style they are illustrated in, just focus on the content. Illustrators of children's books possess the ability to convey concrete facts in simple, clear terms. Whether or not you have children, you can learn how to present difficult concepts in your art in new ways by studying the focusing abilities of children's-book artists.

Aesthetic Inspiration

Perhaps your inspiration has to come through the
route you have worked out for art and beauty, that is,
aesthetics. A true definition of aesthetics is the love of
beauty, the sensitivity to art or to what is beautiful. An
aesthete is refined, discriminating, a true lover of that
which is beautiful. But aesthetics is defined by the
time in which it is experienced. Binding the feet of
young Chinese women was once looked upon as
producing a beautiful result. The passage of time has
changed the prevalence of that opinion.

*A shadow is always affected by the
colour of the surface on which it is cast.*

—Leonardo da Vinci

Have you ever had the experience of living in one
town where everyone wore socks with their loafers,
and bought the loafers maybe a half size larger than
they needed, so that the loafers didn't fit tightly? It
was the *only* way to wear loafers. Then, you moved to
another town, where they wore close-fitting loafers,
either barelegged or with stockings, but never, *ever*
with socks and never any larger than the feet that
they were covering. You were completely out of
fashion. Not just fashion, but your whole taste level
was cast into doubt because if you would dare to
wear something that misguided, you might not have
table manners and your whole system of judging
what was beautiful would be called into question. If
you moved a lot during your growing up years, you
probably became accustomed to having exactly what
was *not* in style. Even if you only moved once, you

came to realize that what was highly desirable in one place was looked down upon in another.

Today, a brand of blue jeans may define the person who is wearing them, what that person likes, hopes to be, the social class that person may appeal to, and so on. It is more than a fashion, but includes fashion. Aesthetics in the United States has changed many times throughout its past, and the theory of what is beautiful and what is desired has changed, too.

Aesthetics has an effect on art, too. For those of us who came to New York as students, it was an eye-opening experience. Not only did our peers have certain aesthetic senses, but our professors each expressed one as well. And because New York is such a big and influential place, and the natives here tend to really believe they are right all the time, their sense of aesthetics made ours (some of us didn't even know we had one) look small. Because there were so many aesthetes here, the aesthetics we brought seemed all wrong. This was not just the case with fashion but, artistically, with regard to how one thought about what was colorful, interesting, or worth considering at all.

> All the past up to a moment ago is your legacy. You have a right to it.
>
> —Robert Henri

In art, the way an object is presented, the very importance of that object itself, in other words, its form and content, is important to the artist who hopes to understand why his own work is accepted, relished, shunned, or sought. The source of your

inspiration may come from the collective unconscious of current thinking and trends. This concept of a relationship between cultural aesthetics and artistic success has been exceptionally hard for me to accept or use to my own advantage. When I came here from a state land-grant college, no one had ever mentioned aesthetics to me, although I had studied art there for two years. But I already knew, from the moving-and-getting-the-loafers-wrong story that I've just recounted, that there was more than one kind of taste in the world and since I was now moving to New York, I expected to be a bit out of tune when I arrived.

But, the thing about out-of-tuneness is that it is easier to overcome—to adopt and adapt to—each time you move. If you are painting satellites and rocket ships, but you're still using the inside of a cave to paint your work on, I would seriously doubt that the art public will get what you're talking about. The aesthetics of your thoughts and work will not be communicated through the antiquity of your methods.

It isn't merely a question of whether you picked up your aesthetic sense from Grandma Moses or from Jeff Koons. It's more than that. It is the manner in which you project yourself. You may be a mannered aesthete, or a sloppy one. You may paint everything around you from the point of view of a bug in the road. Your heroes may be John Wayne or Hootie and the Blowfish. But two things are important here. One is to figure out how you got this way, to realize that something made you the way you are. The other is that you have the option to change, anytime you want to.

Which Inspiration to Follow?

Sometimes, an abundance of riches can befall you. You get one inspiration, then another, then another. Which is the real one? Which is the one that will yield a fruitful blossoming of your talent, an opportunity to make a masterpiece? Again, Marcia Yudkin, speaking at Saratoga Springs, offers an answer. Marcia says that if an inspiration comes back to you at least three times, you should take it as a serious sign from your inner self and consider acting on it. If your unconscious mind is so bent on your taking up this project, maybe you should pay attention. If you are having dreams about a particular art project, this may be your inner self, tugging at your sleeve for your attention.

Art is something absolute, something positive, which gives power just as food gives power.

—Hans Hoffmann

What if you follow this inspiration and then, later, it doesn't pan out? What if you get the message from your inner self and pursue it only to be disappointed with the final result? In my estimation, all you've lost is time, the time you've spent going down the wrong road. And maybe you had to take that road to learn something about yourself. At any rate, try to retrace your steps, to see where you might have chosen an option incorrectly. Like taking a walk, you can back up, think about your choices, then choose another path. Perhaps your choice *was* correct, only taken too soon. By carefully analyzing when you fitted each

selection in, you can see what would have happened if you had put the same choices in different order. Sometimes, you truly have all of the information you need, you just need to take the time to reevaluate what should happen first, second, third, and so on.

Caring for Your Gray Matter

Maybe one of the problems you have with creativity and inspiration is the idea that creativity comes only to the twenty-somethings. You are in for some surprisingly good news. Because the "baby-boomer" generation is coming into retirement age now, it has become a popular trend to consider aging and how we cope with it. Everyone is interested in defending themselves against an age-related loss of memory, and the time to start thinking about that defense is now. Suggestions for what may be done to combat this problem come from a variety of sources and it is not that difficult for artists to adopt them into a program that keeps them thinking and creating at peak performance. No matter what your age now you can concentrate on diet, exercise, vitamin supplements, and stress management to fight aging disorders. We are not talking about disease here, but common signs of inattention and forgetfulness that seem to be an inherent part of the aging process. Let us see how preventive measures can help each of us toward better reception of inspiration.

Deal first with your diet by making the most of planning *when* to eat particular kinds of foods. You may not be aware, for instance, that eating certain foods early in the day, and other foods later, can change your energy level. This step is most helpful

when supplemented with vitamins, minerals, trace elements, and natural medicinal tonics. It goes without saying that unless you are physically in good shape, inspiration will be harder to achieve. Health and fitness magazines recommend that you eat a low-fat diet, dense in nutrients, to enhance your energy. They advise eating a filling meal, but say to lighten what you eat by including in your diet at least 25 percent fruits and vegetables. By eating high-protein foods for breakfast and lunch, you will be most alert, while a meal high in carbohydrates for dinner, such as pasta, can be calming and help you to relax.

When inspiration doesn't come, J go halfway to meet it.

—Sigmund Freud

The next element of the plan centers on managing your stress level. While stress may not seem to be a problem for you, unconscious stress may be taking a toll. You can make an effort to figure out when you do feel stress, whether it's when competing in art competitions, drafting proposals, working on your artist's statement, or preparing for an exhibition. Once you have identified what causes your stress level to climb, you can then call on a tension detractor to help you return to your healthier self. Tension detractors can include meditation, relaxation with close friends, or joining a support group. Once you admit that certain situations are stressful to you, you are on the way to eliminating them. It may be beneficial to you to write these stress factors down on a piece of paper so that you are aware when they are around and can cut them off quickly.

Exercise therapy is the third age-related strategy. The most valuable contribution to brain longevity is the stimulation of the flow of blood to the brain. As we become more sedentary, it may be more difficult to get fresh blood to the brain. Mental exercise, as well as specific mind/body exercises, is an important way to bring a healthy flow of blood to your brain while sharpening your attention and decision-making capabilities. Exercise can also directly benefit your mood, often relieving depression, as well as be a tension detractor. Card games, playing a musical instrument, or working a crossword puzzle can be just as helpful for relieving tension as more active exercise, such as walking, yoga, square dancing, or riding a bike.

Inspiration demands the active cooperation of the intellect joined with enthusiasm, and it is under such conditions that marvelous conceptions, with all that is excellent and divine, come into being.

—Giorgio Vasari

The last step of our program is the part you possibly neglect the most. We all take a vitamin or two, but to give yourself an added boost, a sound vitamin regime can raise your energy level by a hefty percentage and increase the likelihood of a healthier "seniorhood" all-around. The human body produces DHEA for peak mental performance, but less of it every year from one's late twenties on. Needless to say, you should consult your doctor before supplementing your natural DHEA. However, because the brain and endocrine system need DHEA for optimal

function, having lower than average levels of DHEA may make the synthetic version of it, available in health food and vitamin stores, a valid choice.

A well thought out program for a healthy brain deserves your attention and can guide you toward better concentration, energy, and learning ability for a lifetime of peak mental performance. DHEA is but one of several supplements that you may want to employ and we'll look at several others in the next section.

Nourish Your Brain!

Artists at any age want their brain to work in top condition. As artists grow older, they may feel their creative ability is slipping away from them. It's not so easy to paint or draw for eight hours straight any more. A short break for a nap is often appealing for any of us. But your brain, like your heart needs exercise and nourishment to function well and stay sharp. Lifelong brain power can be maintained through exercise, diet, stress reduction, and good sleep habits. I think artists are too adept at working with variables and making changes in their work to accept the given wisdom that as you age, your mind becomes less inquisitive and less interested in finding new solutions to problems than in the past. Many of the artists we admire did their best work at an advanced age. Today's artists have grown up with too many advancements in medicine to not expect that progress will be made in keeping the brain functioning well. Several viable experts offer good habits for the top performance of any brain, whether young or old, and their suggestions deserve artists' attention

for peak mental performance, no matter how many candles our birthday cake has on it. Age-related loss of memory is a problem we can challenge with our choice of diet, a good dose of exercise, and a common-sense plan.

"Youthful minds," or those characterized by dynamic brain power, learning ability, creativity, and emotional zest, are the goal of artists everywhere. We must work toward them with a plan.

Be sure that your diet includes fresh fruits, vegetables, and grains. Nutritional supplements help keep your body and brain sharp. I should remind you here to check with your doctor to be sure that specific supplements don't cause or further existing health conditions.

Some brain-sharpening supplements include:

- *Vitamin B* provides the brain with energy. As one ages it may be assimilated into the body less efficiently. Dose: 50 mg per day of mixed B-complex vitamins.
- *Vitamin E* not only prevents the lessening of brain activity, it also reverses deterioration. Dose: 400 to 800 international units per day.
- *Ginkgo biloba* is widely known to have very good effects on the brain. This herb comes from ginkgo trees, and can improve cerebral circulation and memory. I have friends who noticed a marked alertness with ginkgo supplements. Dose: 120 mg per day. As this supplement does not have the endorsement of the Food and Drug Administration yet, it is important to choose a brand carefully. Ask a friend who takes *Ginkgo biloba* to recommend a brand she finds effective.

- *Green grass juices,* such as wheatgrass, and green teas appear to enhance the function of the brain. Green grass juices are often available by the drink at health food stores. Or, a pot of green tea can sit on the stove while you work. All artists should be careful not to overstimulate the brain with caffeine. Caffeine comes to us not only in coffee and tea, but in some soft drinks as well.

Everybody's influenced by everybody.

—Andy Warhol

Along with diet and vitamins, artists should consider the benefits of sensible exercise, including mental exercise, that the brain needs. Playing chess or other board games can help keep your mind functioning clearly. Try learning a new language. Aerobic exercises like running, biking, swimming, or walking briskly for twenty to thirty minutes three or four times a week will increase blood flow to your brain. Another set of exercises that contributes to brain restimulation is healthful yoga meditation. If you have not considered yogic exercise, look into a yoga center near you and consider joining a class that offers specific exercises to channel blood flow to the brain.

Selecting and Nurturing Ideas

All athletes have to train in order to perform well. Quite simply, most fields of endeavor require as much preparation as possible. While you may see yourself as safely ensconced in a field where you start out perfect and simply go forth using what is already in

your mind, like everybody else, artists have to pay their dues as they pursue the work they love. It might be helpful here to think of yourself as a monk. Monks come to their vocation knowing that they will learn and broaden their experience as they work at perfecting their lives. Like monks, artists have an inclination to become part of what calls them, and they must set out to grow throughout their lives. Monks live in monasteries. Make your studio a monastery where you can cultivate an idea and watch it grow.

Think where you hope to be in ten years. Maybe you want to have artwork sold and a more impressive résumé to show what you have accomplished. Perhaps there are large projects that are not feasible now but will be more likely once you have more experience on your résumé. Like a monk, becoming more familiar with yourself will give you better focus on your strengths and where you need further work. Quiet contemplation is one of the best ways to nurture any idea.

Don't Get in Your Own Way

Many artists have very definite ideas about how they always work, and a clear sense of their own persona. This is healthy, but it often gets in the way of exploring and trying new things. If you often start sentences with the phrase "I would never do that" or "That isn't my style," you may be already sealing your own vault against trying anything that you aren't already a master of. By being rigidly opposed to sampling new materials or trying new things, you shut off many corridors that could offer ways to change and keep growing. Although there is a case to be made against

changing your art style every week, perhaps a greater danger lies in stifling your creative growth by never trying a new perspective or adopting a different way of seeing. Look at the many phases Picasso went through, yet we still recognize his work instantly. Picasso also learned from his painting contemporaries, then went ahead and often outdid them at their own ideas. You must gain enough confidence in your ability to find something and make it your own.

Art is not a matter of what you can see, but what you can make others see.

—Edgar Degas

In a journal or sketchbook, every artist has great ideas that never reached fulfillment. They were good thoughts that simply were never pursued, because something else was more pressing, more stimulating. As we go back through our notes and sketches, we often shake our heads, saying something to ourselves like, "That would have been great; I really would have liked to see that completed. What got in the way of bringing that idea to fruition?"

The answer is, most likely, *"I did."* Don't get in your own way. Go back now and see what still impresses you that you thought of in the past. The idea is already there. You had it, you just didn't act on it.

Journals: Another Path to Finding Inspiration

Men and words are ready made, and you, O Painter, if you do not know how to make your figures move, are like an orator who knows not how to use his words.

—Leonardo da Vinci

The road to finding inspiration is usually far from straight and narrow; more likely, it's winding and unfamiliar. Hence, I'll suggest some seemingly indirect methods for your quest. One of these is keeping a journal.

Why Keep a Journal?

Often, you may have just the glimmer of an idea; maybe you can't talk about it yet. A journal should be the first place for you to record a new idea. You don't have to write in it every day; in fact, many artists have told me they sometimes go five years before they come back to make a notation and rediscover a journal entry. Simply put, though, you should have a

place where you can keep thoughts, both complete and partial. Negative responses like "I'm not a good enough writer" and "What if someone reads my innermost thoughts?" or "It takes time and that's something I haven't got" are no excuse. If you're serious about evaluating your abilities as an artist and expressing your feelings, you'll make a few minutes available every day. Otherwise, you won't ever have the time or inclination to find your strengths, either. Self-expression in words is important, too, even though it may be a little foreign to most artists, who are more visual than verbal.

Forget those mental images of five-year diaries you struggled to keep as a preteen, which limited your entries to a paragraph a day. Real journals are beautiful and unusual to look at. You can enlarge on the individuality of yours by adding photos, drawings, postcards, bits of cloth or paper, stamps, stickers, or even yarn. You can record as many ideas as come to you before you close it to continue on another day. For wonderful journals and journal-making materials, may I suggest a look at the *Collage* catalog from Kate's Paperie. It is guaranteed to start you thinking about your very own journal and beautiful writing materials, as well. This catalog is an inspiration in itself. (To acquire this $3 catalog, write: Collage, 561 Broadway New York, NY 10012-3918, or call: 212/941-9816 or 800/809-9880).

Keeping a journal can reduce stress, too. Just get mad and let off some steam within the pages of your journal; you'll instantly feel better, more calm. Many people feel safe writing down thoughts and feelings that would be inappropriate to say out loud.

Another wonderful thing about keeping a journal

is that it allows you to be in two places at the same time. You are both the character on the journal page and the reader and interpreter of these written thoughts.

Like a sketchbook, a journal should contain *good* and *bad* ideas. In fact, it is the combination of the two that makes it lifelike. In reading back over what you have written, you don't have to be judgmental. Maybe you have tried to keep records of your thoughts in the past, with little success. Think about how to open yourself up more deeply, to express your feelings and keep those undeveloped (as yet) ideas alive until you decide it's time for them to become works of art.

The Intensive Journal®

Ira Progoff, who passed away not long ago, was the father of journal keeping in America, at least in the twentieth century. His Intensive Journal program is a memory-keeping method that won wide acclaim. In a book review for the *Los Angeles Times,* Anaïs Nin described the Intensive Journal as such: "One cannot help being amazed by what emerges from this skillful inner journey. All the elements we attribute to the poet, the artist, become available to everyone." Dr. Progoff's workshops, books, and cassettes, now offered by Dialogue House Associates, across much of the nation, make available to the public a profound system of journal writing that can help people gain insight into their lives. Dr. Progoff wrote several books, including *At a Journal Workshop,* which guide readers toward more successful record keeping through carefully designed, practical exercises and a structured workbook. The Intensive Journal program

has been approved for continuing education in counseling, psychology, social work, and nursing by many states coast to coast. For a schedule of Intensive Journal workshops or to order materials, visit their Web site at *www.intensivejournal.org,* or call Dialogue House Associates at 800/221-5844 for a schedule of workshops located near you.

Artists Who Keep Journals

Josette Urso is an artist who uses her old calendars as a kind of journal. She uses large calendars with blocks two to three square inches for each day. Every block is filled with notes to herself, markings in different colored pens, drawings, and so forth. She saves and collects these calendars, both because she likes the overall way they look and uses them as a reference for calls she has made, phone numbers, or other information she may need later. As far as keeping a journal, she doesn't use a notebook but mostly writes on loose sheets of paper whenever she has a thought or idea that she'd like to keep. Because the pages are loose, she feels she is less likely to be judgmental of the content. The pages represent loose, floating thoughts that can be kept or discarded, rather than parts of a book. This allows her journal entries to be freer, more expressive than a bound volume might. She has a "thoughts about my work" folder, which contains new ideas as well as finished artwork. She refers to it and finds it is helpful "whenever I'm updating my [artist's] statement" or making plans for "where I would like to go next with my work."

Parts of her journals have actually become pieces of artwork. About three years ago, she was becoming

overwhelmed with a wealth of materials she had collected because "Everybody sends me things they think may interest me." As a media artist, she had been stockpiling bits of ephemera that she found appealing. She began cutting this collected material up into squares and collaging them onto paper, fifty inches by thirty-eight, in a quilt-like pattern. Eventually, she painted an acrylic version of this collage onto canvas, thus making two pieces. She has sometimes shown these works together, side by side.

All good work is done from memory whether the model is still present or not.

—Robert Henri

On the subject of artists' journals, Josette points out, "I think artists' journals are different than those of other people because our thought processes are different." (See chapter 2 under "How You May Be Thinking About Inspiration" for more on different kinds of thinking.)

Josette saves the "mistake" ribbons (correction tape) from her typewriter and has been using them with some handmade paper recently. This is another use for things from her past, a sort of "things journal" she constructed that forms a kind of paper quilt artwork. The "mistake" ribbon is almost clear, of a Mylar-like substance, and the letters typed on it are not whole words, "so they don't refer to anything in particular and the viewer can make of them what he wants." She doesn't like the effect of real photos printed on photographic paper, but instead prefers to work with other kinds of reproductions, such as pictures from old medical textbooks, for example.

What inspires her most? Going to galleries and seeing exhibitions. "Seeing good art always makes me want to get right home and start making new work." Another way that works for her is to go through the boxes of materials she's been saving and touch each piece.

A second artist, Judith Page, started making artwork from journals in an interesting way:

"I'd found a diary that I kept as a fourteen year old. I decided to just go on writing in it as if no time had passed at all. When I looked back, what amazed me was that the things about which I wrote were so similar to the subjects I'd write about today. Topics like boyfriends, grades (now, how someone had reacted to my work), complaints, or how I felt I had been wronged, still have my attention now as they did over twenty years ago. I made an artwork out of the diary's pages by assembling them on a wall in grid pattern and painting earthenware pots from different times and cultures over the written parts. The piece is called *Fleshpots* and the pages from the diary were assembled randomly based on the colors which I'd painted the pots so they don't read lucidly. All were some tone of flesh although the styles of the ceramic pots varied, from Etruscan to Greek to American Indian. As they are put on the wall, they become part of an installation that may include sounds when I am finished. I'd like to make it more like a fantasy journal—where you'd like to go in your mind. I guess that what I've chosen and left out was subliminal after I decided to make an artwork of the diary. What I saw from the diary was that keeping a written record was very much about earthly desires. I think that most people try to repress those desires, keeping them in a

hidden place, such as a diary or journal. They would rather be seen as looking for a more spiritual place. They find that more admirable, more acceptable.

"*Fleshpots* was finished last summer and all of this has to do with my move from Florida to New York City. When you're living outside of New York, you just keep things, because you have the room. I had a house and a garage. But space is so expensive and precious in the city that you have to decide what to keep and what to throw away. If you decide to keep a diary from when you were younger, the value it takes on grows. You're choosing to keep it over keeping something else. It was interesting to me—the handwriting didn't change that much from the handwriting when I was fourteen. Sometimes, one's handwriting changes so much you almost don't recognize it.

Imitation is not inspiration, and inspiration only can give birth to a work of art. The least of man's original emanation is better than the best of a borrowed thought.

—Albert Pinkham Ryder

"Artists' journals are more like a cross between a diary and a sketchbook. I keep one when I travel, I take notes of what I see, but it's more of an art diary than a diary about me.

"And you know, maybe journals or diaries should be obliterated because they can seem whiny. A journal can be a good place to complain, because no one ever hears it."

Turn: The Journal of an Artist, by Ann Truitt, is a book made up entirely of journal entries. It is wonder-

ful journal reading, made by an artist who resides in Maryland and exhibits at the André Emmerich Gallery in New York City. A sculptor, Ann Truitt gives interesting insight to day-by-day occurrences in her studio, as she travels, and into her life as a mother and grandmother. You follow her from sketch to completed project and share her feelings as an artist and instructor, teaching at the University of Maryland. She also writes about her involvement with Yaddo, an artists' colony where she spent considerable time and where she served as acting executive director when Curtis Harnack, the regular director, had to be away. I found it very intriguing to follow an artist's doings with an established facility like Yaddo and to hear about her dual roles within administrative as well as artistic circles.

Barbara Yoshida, a painter and photographer, only keeps a journal when she goes away, traveling to such interesting places as the art residencies that are sponsored locally in many national parks. She attended one such residency in Michigan, and another in Maine (more about how this can be done at the end of this chapter). She keeps a journal during these residencies because she wants to have it, along with her photographs, as a reminder of her thoughts and experiences to use in her work when she's back in her studio.

Journals Feed the Creative Process

As I've already pointed out, journals, for writers and artists, are places to store ideas that are not yet ready to be born. Journals become for us a kind of holding pen for thoughts that are not clearly worked out— thoughts that must sit somewhere while we decide

whether or not they are worthy of becoming actual artworks. Or, journals are for very exciting, often brilliant ideas that must wait because another work is commanding our present attention and we cannot stop and make something new until we finish what we are working on now. Sometimes, we lose these ideas, not stumbling upon them again for years, but when we do, it is amazing how fresh they remain.

Why does one not hold on to what one has, like the doctors and the engineers; once a thing is discovered and invented they retain the knowledge; in these wretched fine arts all is forgotten, and nothing is kept.

—Vincent Van Gogh

Nina Holzer writes about journal keeping and the creative process in her book, *A Walk Between Heaven and Earth:* "The reason many people block themselves from writing, from creating, is that they are not here. They have a head full of blueprints for the goal, they have elaborate outlines of how to get there, but they have never taken a conscious walk from their bedroom to their bathroom. They want to create, but they know nothing of their own creative process. Journal writing can provide fine insights into that process."

We artists can make use of this observation, even if it was originally intended for writers. For us, the "walk between the bedroom and the bathroom" may be taking a workshop in making handmade paper or months of going to the zoo to sketch dolphins when they dive in order to get the arch of their backs just right.

As I walked through an artist's street fair near my home, I met Minna Aaparyti, who makes journals for poets, playwrights, and artists. She lives in Philadelphia and she spoke with me about journals. "Journals," she asserted, "are important because you can put down a meandering thought or see something you've been thinking about crystalize on the page in front of you."

The requests she gets from artists are for journals that can open flat to be used more easily and for sturdy journals that will travel well. She saw one that had traveled a lot, when the artist was back in town. "It was great to see how well it had traveled. Really sturdy and beautifully worn."

When I asked how she had begun making journals, her answer surprised me. "When I was small, we lived in the Middle East and we had to move often, because there were many rebellions and uprisings. Instead of close friends, I had small journals, which I made from the time I was in the first grade, when I learned to write. I could pack them up whenever we had to move and take them with me. I still have all of them."

I asked her which of her materials sold best. "Things covered with Japanese paper always sell," she answered. "Then, the ones that I paint, which take longer, because I use yarn to design a pattern, wrapping it in an old design that I've seen and then covering the yarn with rice paper. I paint with acrylics on the rice paper and the design from the yarn comes through. They are strong, because of the layers. The binding I use is Coptic and comes from Ethiopia."

To order journals, or to find out where Minna will be selling them next, you may call her (during business hours only, please) at 215/923-6011.

What other kinds of writing could you put into your journal? What other uses could a journal have for opening you up and allowing you to be more creative? Kathleen Adams is founder of the Center for Journal Therapy in Denver, Colorado. The Center offers workshops, training, and consultations all across the country. Over one hundred certified instructors are available, offering a twelve-hour study course in journal keeping. (For journal workshop information, call them toll free at 888/421-2298.)

Kathleen Adams recommends writing a creative conversation between you and a piece of artwork or a blank canvas. Write both parts, one speaking for yourself and one in the voice of the artwork. The journal provides a table of understanding between you and the artwork, which has its own personality. Find out through writing a dialogue what the artwork wants.

Another way of deciphering the desires of the piece, whether you have begun it or not, is to ask the artwork to send you a letter. If your work has not yet been started, write your letter as the blank canvas. This can work really well if you are blocked. Put specifics in the letter, such as "I need this in the painting" or "This is something we should really be wondering about." The dialogue in your journal is two-way communication. The letter from your artwork to you constitutes one-way communication.

I asked Ms. Adams how a journal could help the artist think ahead. She told me to ask myself where I wanted to be a year from now. She continued: "Write it down and stamp and mail it in about six months. That is halfway to the time specified. You will see if course corrections are necessary, while there is still

time to make them. Think about where you are now. How far have you come? What do you want to accomplish? What are some of the things you can do to get there? Write it all down. The words will awaken your intuitive and creative wisdom, which, in turn, will help you make better decisions. Actually stating goals makes them more apt to be reached. Setting goals also gives the unconscious mind something to work for." Ms. Adams is also the author of *Journal to the Self,* a book on creating a journal of your life.

The process of painting for me is a process of revealing. The drawings are all about revelation—it's about exposure. But when you start a painting, there's always that part of you that wants to conceal, and let the painting be this mask. The thing itself is a mask. And the whole process is about trying to smash the mask, and be open again, be exposed, be vulnerable. Sometimes I'll start to draw and the painting will tell me what could happen. I'll discover it through drawing.

—Elizabeth Murray

Artists at National Parks

Many national parks invite artists to become artists-in-residence; these invitations are issued to artists on a local basis, rather than through a single national program. A directory titled *GO WILD!,* which was published by Bonnie Fournier, herself an artist, keeps up with everything you need to know about becoming

an artist-in-residence at some of the most beautiful and inspiring places in the world. Besides painters and sculptors, these programs welcome composers, videographers, performers, writers, and photographers. Many of the parks ask the artists to set aside some time to speak to park visitors about their work and/or contribute a piece of work to their programs. *GO WILD!* is available for $15.95. Write: Lucky Dog Multi-Media, Lowertown Lofts Artist Cooperative, P.O. Box 65552, St. Paul, MN 55165-0552. You can also call the Lucky Dog hotline, 612/290-9421, for the latest news about what's available at various parks.

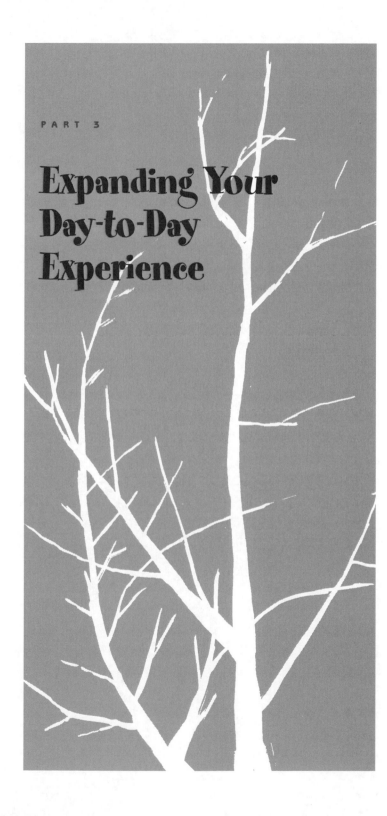

PART 3

Expanding Your Day-to-Day Experience

Inspiring Yourself

... avoid those forms that are too facile and ordinary: they are the hardest to work with, and it takes a great, fully ripened power to create something individual where good, even glorious traditions exist in abundance. So rescue yourself from these general themes and write about what your everyday life offers you; describe your sorrows and desires, the thoughts that pass through your mind and your belief in some kind of beauty—describe all these with heartfelt, silent, humble sincerity and, when you express yourself, use the Things around you, the images from your dreams, and the objects you remember.

—Rainer Maria Rilke

It may seem that we should be capable of inspiring ourselves, that we shouldn't have to wait for inspiration to come to us. You may say, "No one else knows me better than I do, so I should be able to gear my mind toward creative thoughts." But, this may be harder than we think. Knowing ourselves as well as we do, we are completely capable of fooling our-

selves, particularly since we may unconsciously feel that we don't deserve to succeed. If you think this description might fit you, it's time to recognize your need for some outside guidance. After all, you hold all the keys to your own inspiration. You just have to put them into the correct locks.

Sometimes, the experiences you've had in the past just need to be put into a new setting so that you will see them in a different way. Narrative writers call this a change in point of view. Computer writing or cyberspace fiction allows for interactive stories, and you can imagine what I am leading you to in applying this to a conversation about art.

Try this: Take an incident that you remember from your past. You re-member it a certain, specific way, but try turning it around so that you and another person involved in the event change places. See it now from her perspective. Your point of view shifts, you view the event from the vantage point of a different age or gender, and your understanding of what transpired changes.

Think about the first time you went away to live at school. Before it happened, you probably had a vision of how it would be to meet new friends on that first day. Now, think of how different the first day actually was. You were so scared of how you would seem to everyone else that you clammed up and didn't speak to anyone for several days. Now, skip to the next year when you went back to school. You had friends from the year before to catch up with, the setting was familiar, and you were probably glad to go back to this place where you had been living on your own. Just a year had passed, yet you felt completely different. Call this exercise, "I used to think . . ., but now" or "I can't remember . . ." or "I wish I had done . . ." Or, it might even be "Everything that happened then, but five years later . . ." or "The first time I . . ." or "I wonder whatever happened to . . ."

Oftentimes, creativity needs a bit of shaking to loosen the cobwebs in place from years of thinking one way. Examine your ideas. Does changing your point of view make them more interesting?

To see how point of view can shift, take a magazine page that contains only an illustration. Cut the page into one-inch strips vertically or horizontally. Reassemble the page randomly and tape the strips together from the back.

To help you get started, perhaps we should explore some of the issues that all artists face. Let's begin with the subject of light. How you use light may be so much a natural part of your artistic process that it has become involuntary, like breathing. Maybe you need to examine it. Portraying a subject—any subject—using lighting differently may present you with a whole new jumping-off point. Try it out and see for yourself.

The light for drawing from nature should come from the North in order that it may not vary. And if you have it from the South, keep the window screened with cloth, so that with the sun shining the whole day the light may not vary. The height of the light be so arranged as that every object shall cast a shadow on the ground of the same length as itself.

—Leonardo da Vinci

Artists and Light

Pure, clear light, reflected light, light at a distance—so many different kinds of light. No matter what kind of art they make, light is one of the most universal elements artists must deal with in their work. Artists know that by highlighting certain surfaces they are able to convey depth and a source of light. Consider how the Impressionists worked with light, or used light to give drama to a scene. True, there have been artists whose work did not deal with light, such as conceptual artists and abstractionists (think of Ad Reinhardt) or medieval artists who worked inside churches. Other artists have played with different kinds of light; for example, think of Toulouse-Lautrec's renditions of gaslight in the nightclubs of Paris and Ernst Ludwig Kirschner's depiction of electric light as it began to appear in the streets at the turn of the twentieth century. One of Kirschner's "light" works, *The Street,* was a painting of people emerging from a theatre. That picture has stayed in my mind for many years because he so accurately rendered that disorienting sensation of coming into real light from artificial light.

How important has light been in your work and how have you rendered it?

De Chirico's surrealist street scenes would not be nearly so effective without his incredible use of shadows cast from an eerie light source. Sometimes, the art is extremely effective *because* of a lack of light source, as in the paintings of evening scenes by Magritte.

Try seeing your work from above, like a fly on the ceiling. The light will change as well as the shadows cast. You may want to try a vantage point that is not at eye level. If you have set up a still life for example, before you begin to paint, try looking at it from below or behind or from very close up. All of these moves will have an effect on the way you render the light and how your viewers will perceive the piece.

For more observations on light, let's return to Leonardo da Vinci's notebooks:

> An opaque body will appear smaller when it is surrounded by a highly luminous background, and a light body will appear larger when it is seen against a darker background. This may be seen in the height of buildings at night, when lightning flashes behind them; it suddenly seems when it lightens, as though the height of the building were diminished. For the same reason such buildings look larger in a mist, or by night, than when the atmosphere is clear and bright.

One of the most recent observations I have made about artists and light came from an artist of our own times, Julian Schnabel. In a video interview, he described using broken white pottery, glued to his large canvases, as a way of conveying light. His use of broken pottery thus puts him in the long tradition of painters who used touches of white on the edge of the

Art tends toward balance, order, judgement of relative values, the laws of growth, the economy of living—very good things for anyone to be interested in.

— Robert Henri

subject's coat to show the direction from which light flowed. The interior light in many of Van Gogh's works (such as scenes in the artist's bedroom or the exterior called *The Night Café*) exemplifies a lighting problem that has preoccupied artists for a long time. Café light has long been a favorite of artists for illuminating their subjects. This may be because they were drawn to cafés in search of interesting subjects or because the light itself created an ambiance that they wished to capture. Consider outdoor daytime light, too. Through the years, this is one type of light that has *not* changed, because the source of illumination—the sun—has not been altered.

Magazine editors have long favored lamp light on a desk to fluorescent ceiling light in their offices. Lamp light conveys intimacy, while harsh overhead lighting casts sharp shadows and is unkind to facial expressions. Also, fluorescent light, although now available in many shades, is usually bluer than incandescent light bulbs, which tend to have a yellow glow. Blue light is much harsher than golden yellow, and it will tend to make skin look older and less flush with feeling.

Perhaps you have some observations of your own to add to this. Your thoughts on this topic could continue the historical fascination with the constantly changing quality of light into the twenty-first century. What about light reflected from computer screens or the changes brought about by digital light?

As you think about light, watch for Chicago artist Ed Paschke's air-brushed paintings, which perfectly

convey glowing neon light. They are so well rendered that you will find yourself reaching out to see if they are painted or installed!

Details

Architect Mies van der Rohe once suggested that God is in the details. What he was implying was that, in every project, attention must be paid to the details. Don't shortchange a beautiful work by failing to improve every part. A painting should give your eye something to do, it should keep it moving as well as lead it toward a central subject. The details can help you accomplish this. I remember sitting in a seminar at the Whitney Museum where a guest artist was speaking. I didn't make note of the artist's name, but one comment I distinctly remember was that the formal concern of a painting is to bring "what is known to be on the inside of the painting to the outside."

No white or black is transparent.

—Leonardo da Vinci

You may have indicated "tree" by sketching a trunk and some leaves, but until you have convinced the viewer of the tree's authenticity, it is only an image, not a real tree. To accomplish this, the details can make all the difference. What *kind* of tree, for instance?

Backgrounds may be flat and dull, but you can convey an amazing richness in the details. Like the curling of a leaf in the *background* or the spit of a dashing line in an abstract, the details give credence

to what you are putting into the *foreground*. No matter what you are representing or what mood you are trying to convey, the details make anything that you paint more believable. Ask yourself what else should be in the picture as well as what you have decided on for its subject. Try reproducing something in tiny detail that has been said before in the overall scheme of the work—perhaps echo the general direction that the main subject has already taken. As you begin to insert details into your work, it will become easier to continue and expand your projects.

Working in Two Ways

Another element that you might address is the change in style demanded by different media while you're working in different genres. Be like the writer whose major working format is novels but who still also feels the urge to write poetry. Some art writers—for example, Joseph-Emile Muller, author of *Fauvism*—believe that Kirschner's work in woodcuts flattened and solidified his style, changing, to good effect, the style of his paintings. Think about artists who have changed their artistic style to make one set of works, then returned to a former style for others. We spoke of the changes in Frank Stella's work earlier; artists who have used diverse forms of art making have also reflected this. Look at the recent art that combines cartoonlike rendering in the same work with more formal techniques. While this may be rather jarring upon first viewing, it is not unlike a visual shorthand that aptly represents life in the nineties.

Creativity can be made easier by what action toy inventor Stan Weston calls "the logical combination

\mathcal{G}od is in the details.

of two or more existing elements." These, when
combined, "can result in a new concept." Consider
experimenting with your work in one genre by add-
ing bits of the work you've made from other fields. I
remember deciding to add painted backgrounds to
my collages, which were colorful torn pieces of paper.
Using canvas on board for a base and painted back-
grounds for the collages gave an added depth that
was not there before. It also offered a solution to
puckering, the result of using watered-down glue on
lightweight paper. When I tore my collage pieces
from one side only, leaving the white torn inside of
the paper exposed, it inadvertently gave the effect of a
slanted light source, which I liked and used, giving my
abstract work a nice sense of depth. Recently, I saw
another collagist's work similar to mine but with the
addition of crayon marks on both the backgrounds
and glued patches of paper, which seemed to unite
background and foreground. This is very interesting
to me and some form of this thinking may affect, or
even guide, some future changes in my artwork.

Does the juxtaposition of two styles of art making within the same work
offer a fresh new way for your work to proceed? You may have set up
rules to keep them separate and apart, while combining them shows
your viewer a new way to see your work. Keep it in mind.

Stan Weston, the father of the G.I. Joe action toy,
also urges artists to "find a high concept. The best

ideas can be described fast." In addition, he recom-
mends that you "read as much as you can." For
artists, this might translate into *see as much as you
can*. Although going to as many gallery shows as
possible might seem to be a bad idea, sure to leave
you overwhelmed and discouraged, maybe it's not.
Artist Josette Urso says that nothing gets her going
like seeing good art. Afterward, she heads right for
her studio to begin work. If that's all it takes to inspire
her, why shouldn't you try it? The point here is that
more exposure to more things can only help you.

Taking a Second Look

One of the most painful things for an artist to do is to
take another look at his own work that never got
finished. Perhaps it is time to play the devil's advocate
with one of your unfinished pieces to resolve it,
instead of justifying your avoidance of it. Psycholo-
gists call this the Gestalt "two chair" theory. For this
exercise, you will need two chairs, seated closely
together.

While sitting in one of the chairs, ask yourself a question about a prob-
lem you are having. Then, move to the other chair and answer the
question. You're allowing yourself to be two people here, giving yourself
some room to get further back and see the piece with what my friends in
theatre call "fresh eyes." Whereas you may have the answer to your
problem in one part of your mind, it might not be evident to the other
part. Hence, for a time, you must split yourself in two. You will give
yourself the answer. Listen to your responses (it helps to play this game
out loud, perhaps even with a tape recorder on) and don't discard any
advice the "answering" figure gives you.

Back to the "fresh eyes" metaphor: My pal Susan Gregg used to direct staged readings for playwrights—often, it was the first time they would see their new plays being presented—at New Dramatists, a workshop space nurturing playwrights in New York. She'd often invite me along on the occasions when a new play was to be read, later buying me beer and, along with the playwright, quizzing me about when I first knew certain facts in the play. Susan and the author had spent so many hours preparing for the play's presentation that they sometimes lost sight of what the audience knew or when they realized it. Partly finished paintings are like not-quite-finished plays. Factual details may yet be unclear to your viewer.

Funny thing about painting, you don't know what makes it right, but you know when it's wrong.

—Charles Hawthorne

If you could see a piece of artwork as gaining input from several people, the way a play does, rather than just suffering alone, perhaps these works of art would not burden you with the unbearable amount of responsibility as they now do. For this exercise, you'll need a good friend whose judgment you trust in other matters and not necessarily someone from the art world. Like the playwright of the fledgling play above, you'll have to surrender control of the work in order to let others tell you what they see (or feel) and what they don't. And like that playwright, if your name is on the artwork after it is complete and a success, you're still going to get the credit for its brilliance, no matter how many people have given you advice on it.

In *Creators on Creating,* edited by Frank Barron, Anthea Barron, and Alfonso Montuori, there is an essay by Tony Kushner (author of the play *Angels in America*), which is called "Is it a Fiction that Playwrights Create Alone?" Kushner talks about the many people whose input changed and affected his play. He helps us to explore creativity as a collaborative process.

As Kushner observes, the American tradition of individuality "has made us traditionally see creativity as the work of solitary geniuses, but in fact, especially in the creation of a play, many voices can add depth and color to the work." Collaboration might add to your work as well, so it might be worth your while to experiment in this area. Certainly, when it comes to matters of gender, it may pose a difficult challenge to portray the opposite gender's point of view. If you are female, get a perspective for your male figures by consulting men.

Nostalgia and Other People's Memories

Nostalgia and memories are full of ideas, which, like oranges, need only to be squeezed to flow with rich, inspiration-producing nectar. I remember working on a project once, with a girl who came from Iceland. As we became friendly, she told me more about her homeland and her plans to return and see once more the exotic northern lights that fill the nighttime winter skies with flashes of brilliant colors. I had heard of these spectacular light shows and, very intrigued, encouraged her to tell me more. She said that tourists would rent cars to drive into the vast and empty interior of the country for the beautiful light displays,

Without ethical consciousness, a painter is only a decorator.

—Robert Motherwell

which were visible nowhere else. As I had not been to any of the Nordic countries at that point, I was fascinated at the prospect of something about which I knew little and had never experienced. In particular, I remember her telling me about a mountain that was actually red—as red, she opined, as cadmium red paint! Although I still have not been to Iceland, I *do* carry this image of the cadmium red mountain with me, and I think of it every time I hear mention of Iceland. Although the imagery and memory were both secondhand and I had no involvement in the nostalgia, it was nonetheless a stirring, inspiring thought. I urge you: Think back to something once told to you that still remains with you as a vivid visual image.

Other people's memories contain images that can be used in painting just as easily as if you'd experienced them yourself. Go back and try painting from a memory told to you by someone else. You will be amazed at the depth and color that can result and the extent to which you are able to recreate another's memory.

Nostalgia can be summoned up, even if it is not your own. No one is more aware of this than the advertising industry. At certain times of the year, such as the holiday season, we are all urged to remember certain scenes: for example, family dinners at Thanks-

giving when we enjoyed turkey and all the trimmings or caroling through the snow at Christmas—even though you may not like turkey and grew up in sunny California. The idea is to convince you that you did share these memories with everyone else and, by and large, you become convinced that you did. No artist evoked nostalgia better than Norman Rockwell, whose pieces produced during World War II became part of our collective memory. In fact, the government solicited him to visually render the Four Freedoms in order to rally support for the war effort from American citizens, many of whom were émigrés.

My point in bringing up nostalgia here is to show you that you, too, can use nostalgia in your art, even if you are the wrong age to feel nostalgic about your subject or you have no sympathy for what is being missed, regretted, or celebrated.

Try using the nostalgia idea now to see what I mean. Choose an event and render a drawing in honor of it, regardless of whether you remember it yourself or not. Here are some topics you might want to try, or you can think up one of your own. You might have nostalgia for motorcycles, apple pie, cartoon characters, World War I, Charlie Chaplin, Art Deco, the first Sputnik, baseball, Luciano Pavarotti, and so on.

Using Cause and Effect

Traditionally, art makes unusual connections for civilization. Nothing shows more clearly the result of excess than Picasso's painting, *The Absinthe Drinkers*. Likewise, no words can convey the loneliness and inner concentration better than Cézanne's *Card-*

A painter paints a picture with the same feeling as that with which a criminal commits a crime.

—Edgar Degas

players. How about Munch's *The Scream?* Cause and effect are useful tools for painters, from the desperation of men stranded at sea in Géricault's *The Raft of the Medusa* to Goya's *The Third of May, 1808,* to Seurat's pointillist evocation of the Parisian working class at rest in the park on a Sunday, *Sunday Afternoon on the Island of La Grande Jatte.* You may recognize it as Stephen Sondhcim's Broadway play, *Sunday in the Park with George.*

Showing Motion

Paintings or other visual art often show action, as in scenes of battle, for example. One criticism of some art is that the figures are wooden, unspontaneous. To brush up your technical skill on this front, practice the exercise below.

Using a colored pencil, make a simple line drawing of, let's say, a man walking. Place this figure close to the left of your page. Now, exchanging the colored pencil for one of another color, make the drawing again, this time one-half inch to the right of the first drawing. Repeat this step, changing colors with each drawing, until your page has seven nearly overlapping drawings, each one-half inch to the right of the next. The result should give the impression that the man is moving. Try this again, using two drawings, one showing the man's weight on his left foot, and another with his weight on the right. This time, use individual sheets of

paper, but keep moving the man one-half inch to the right each time. After seven or eight drawings, clip them together at the top and flip through the entire stack. You should be able to see the man walking from left to right across your pages.

You can see an object grow using the same technique—first, by finding a small object and, then, by enlarging it on a copier ten times, each time making the enlargement 5 percent bigger. When clipped at the top and flipped through quickly, you can see the object "grow."

Reflecting Time

Likewise, many artists deal with time—its passing and the arrival of new changes to society. Manet's woman and child portrait would have been a touching scene no matter when it was painted. But *The Railway— Gare St. Lazare,* with a railroad engine charging through the background, was particularly arresting and meaningful in 1883 because of the changes that were occurring then. The train's speeding, black hulk and dusty smokestack speak of the changes fomented by the Industrial Revolution.

We've already spoken about those artists who addressed changes in light from natural to electrical, but consider now how the development of photography affected painting style. The art movement called Photorealism, in the late 1970s, parodied snapshots, celebrating their flatness and their lack of depth of field. This way of seeing a photo—transformed into a painting, painted to look like a photo—placed another remove between artist and subject.

All painting echoes the time in which it is made (it can't help it). Certainly the artworks owned by the National Aeronautics and Space Administration (NASA) could only have been painted within the last forty years. All eight hundred of them portray contemporary space exploration. Likewise, the airport gallery in Milwaukee, which houses the Mitchell Gallery of Flight, showcases the history of human flight.

> How does your artwork reflect the time in which it is being painted? Does your work echo the art of a hundred years ago? What about it says "now" and not "then?" What small but important changes could you make that would turn then into now?

Remember: Galleries and art critics are on the lookout for new visions, not competent renditions of the old. You may ultimately decide that you prefer to keep the style and subject matter of another time and period, but at least the decision will be an informed one, one made by you and not others.

Inspired by Not Knowing

For a long time, I thought that art existed to make clear life's mysteries. Clarity, I believed, was what was sought. Now, I have decided that art is meant to be a mystery. Leonardo da Vinci, it is said, worked on the

If I didn't start painting, I would have raised chickens.

—Anna M. Moses

A background is not to be neglected. It
is a structural factor. It is as important
to the head before it as the pier is impor-
tant to the bridge it carries. The back-
ground is a support of the head.

—Robert Henri

Mona Lisa for four years. Yet, what he was finally able
to accomplish in this masterpiece was mystery. The
painting allows for different things to be experienced,
depending on the viewer or how many times it is
seen. Allow for possibilities in your work. Allow your
viewer to participate in experiencing your work. Art
that is definite is not good art. The viewer is much
more intrigued by not being quite sure, by seeing
ambiguity rather than a scene that can only be read
one way. When that happens, the work will not last,
because eventually there is nothing new to see. For an
example of how a painting seems to change, turn
your attention to the work of Francis Bacon. His
work, created between the 1950s and the 1990s, uses
an almost traditional, representative style to convey a
scene. Then, he subtly skews the viewer's vision,
and everything important in the painting becomes
blurred. This change from the expected to the surpris-
ing puts the viewer at a sudden and temporary dis-
advantage. One must look again, to be sure of what
he has seen. Viewers are put in the uncomfortable
position of not quite trusting their own eyes. This
blurring causes us to look harder, to try to reassure
ourselves of our own faculties. At different times, we
see different things. This is one of the interesting
qualities also possible in video art. Similarly, one of
the attractions of Eric Fischl's paintings seems to be a

very straightforward rendering of suburban scenes,
which then change, because the subject matter does,
or has within it, something completely unexpected.

How Things Change

Change—real or imagined—can stimulate the imagi-
nation. For instance, when your brother marries one
of your good friends, she is suddenly called your
"sister-in-law." A friend may need you to help him
with a project, and suddenly he is temporarily your
"boss." Situations are not always predictable; they
shift. Altered circumstances may allow you to see
something differently.

> Think of times when something becomes something else. List five things
> that are one thing and then become another.

I remember a series of still lifes that I made about
ten years ago. Because I like bright colors, these
works had a kind of comic strip appearance to them
on paper. In the process of creating them, I started to
let each object take on a life of its own. I had as-
sembled a collection of mundane items from around
my own home and studio—a jade plant, an artist's
hand model with movable fingers, a small portable
TV. In the process of rendering these, I had moved

I've been 50,000 times to the Louvre.
I have copied everything in drawing,
trying to understand.

—Alberto Giacometti

them all several times until, at last, they became clubby and related to each other with a noisy attitude about themselves. I was in a "let's try something I wouldn't normally do" mood. I made the background red, which I know you are not supposed to do because red advances everything toward you, but I did it anyway. The TV became a really hideous coral, but seemed to have some relationship to the cadmium red background. The jade plant I left rather lifelike, in two shades of green—one chartreuse, the other a deep kelly. At some point, I outlined all of the parts with a charcoal pencil. For spontaneity, I smeared the charcoal, so that the objects looked as if they were on a subway that had stopped suddenly, throwing them forward. (This step had to be anchored down with a spray of fixative, or it would have rubbed off.) This was definitely an "in your face" painting. At this point I realized that there was an energy here that I could emphasize even more. I drew large jagged lines

Do not fail, as you go on, to draw something every day, for no matter how little it is it will be well worth while, and it will do you a world of good.

—Cennino Cennini

across the screen of the TV. It now seemed to be on a tear, broadcasting at high volume. The hand model's movable fingers seemed to gesture toward the jade plant, which jumped to one side as if to get out of the way. The hand model was obviously becoming the aggressor here, so, to make it stand out, I painted it bright turquoise. The entire series of paintings (about ten pieces) has been shown and one now belongs to a

museum. I still had the drawing I am describing here for about ten years, when somebody who owns several of my other pieces, called to ask if the "TV drawing" was still available. He bought it, and put in his office—he thinks its hysterical! I don't understand the whole episode—but I recommend that you have such an adventure, if only to meet another side of yourself.

The value of repeated studies of beginnings of a painting cannot be over-estimated. Those who cannot begin do not finish.

—Robert Henri

While change is sometimes difficult to accept or understand, altered circumstances may lead you to a fresh perspective. One way to make yourself more open to the positive aspects of change—preparing yourself to accept it and embrace it when it does occur—is to consciously experiment with it.

Make a partially finished drawing and copy it on a copier five times. Now, finish each one differently. Here you have stopped midway in your work and chosen to finish it in five different ways. Do you like one better than another? Is one more mysterious than another? Why? What did you do that made it less definite? Can you do this exercise each day for a week? You will become more comfortable with change and possibility each day. This is a lesson that can go far toward helping you believe in other answers, other choices.

Keeping an eye out for social change can become a preoccupation, too. As the new century begins, you

may feel that what you care about has not been addressed in fine art and you are anxious for change. As the twentieth century began, a similar situation existed. Howard Gardner's book, *Creating Minds*, specifically looks at the lives and creativity of Picasso, Freud, Einstein, Stravinsky, Eliot, Graham, and Gandhi. All of these subjects lived during World War I (1914–1918), in what has come to be called the modern era. One cause for creative change within the domains of arts, crafts, science, and intellectual synthesis, Gardner feels, was that the understandings "[of] . . . the nineteenth century were no longer viewed as adequate." The creations of these seven brought forth "a return to the basic elements of each domain: the simplest forms, sounds, images, puzzles—a purification process" that combined "the most elemental impulses with the most sophisticated understandings." I mention this to you now because change is necessary, whenever art has only itself to draw its experiences from.

Allow for Spontaneity

Spontaneity is the salt on the tomato, the tiny shot of black that Matisse knew would raise the value of all the wonderfully bright colors he used, that mysterious quality that we *don't* control. Artists must welcome the spontaneous to enter into the process of creating. The term *spontaneous* is defined as that which comes without constraint, effort, or premeditation. For example, you may accidentally spill yellow paint on a canvas that has no yellow in it, yet realize that the yellow was exactly what the picture needed. But you had no plan to introduce yellow on that

> *Schwitters carried to a Dada extreme the use of commonplace, non-artistic materials in making works of art.*
>
> —Alfred H. Barr, Jr.

canvas. When you permit the yellow to remain as part of the finished work, you're allowing for spontaneity. Spontaneity, for those of us who are control freaks, may be the disaster of the day and, yet, permitted to remain, it can become the genius of the piece. In fact, people may come forward and ask you how you thought of that wonderful touch of yellow. At first, it will be hard to keep a straight face, as you demurely offer an answer but, later, you'll realize that you're getting credit for something that could just as easily have been the ruination of an otherwise good, but dull, artwork. If a wild rose somehow insinuates itself into a bed of cultivated flowers, the result may be spectacular, if unplanned—and so it is with happy accidents. The English language even has a word for such felicitous accidents—*serendipity*. (For more on mistakes, see "In the Trenches," chapter 11.)

Think about spontaneity now. Showing up at the wrong time, two similar names that cause a mix-up, picking up the wrong coat, meeting another person who knows someone you know. . . . If you are open-minded, all kinds of incidents (or accidents) can result in spontaneous events!

I remember one night, after a rock concert at Radio City Music Hall, a group of friends and I took a cab back to the Village. Our cab driver was new to New York, having moved here from the West Coast. He was about our age and, when he said he hadn't been able to make new friends yet, we invited him to dine with us in a downtown restaurant. Completely unplanned, this event was totally spontaneous, and lots of fun!

Words Paint Images

Sometimes, a single word can offer you an exciting image for creating. Think about times when a single word made a tremendous difference. A work of art can often be inspired by a single syllable. A suggestive word may conjure up an image for you, full-blown and ready to be painted. Certainly, some words are more evocative than others, more apt to bring an image to mind. I'll give you an example: *lost.*

Here's a game played by early European Dadaist painters and poets who were living in Switzerland in order to avoid the draft during World War I. They would experiment with chance by cutting single words from a newspaper, placing them into a paper bag, and pouring the contents onto the floor. Then, they would pick up the words and randomly place them together, side by side. The string of random words would form a poem, which, more often than not, made absolutely no sense. Many Dadaists later became Surrealists, celebrating their dreams as subjects in their art.

Dreaming Inspiration

I was anxious to see what effect dreams could have on inspiration for the creative person. Sheila Lavery, in *The Healing Power of Sleep,* says that a day of quiet and contemplation "can double our normal quantity of . . . sleep and possibly produce richer dreams."

"Often," Dr. Patricia Garfield asserts in her book, *Creative Dreaming,* "the dreamer is consciously working on a product when his dream life suddenly provides him with a crucial element that he is able to recognize and use. Some of these dream products are

famous—for example, Coleridge's poem *Kubla Kahn*. Occasionally, the creative dream image simply appears, without the dreamer being occupied at all with the idea in his waking life. Most creative workers don't know that it is possible to deliberately evoke creative dreams." But creative dreamers, such as painter Jasper Johns and writers Carlos Castenada and William Styron, have often used dreams to embellish the creative process. William Styron's dream of the plot for *Sophie's Choice* caused him to drop another book project and begin the new one immediately. Perhaps an inspiring dream could be a catalyst to start your mind working on a new project. Dr. Garfield notes that "intense occupation with any subject is likely to induce dreams of it." This might mean, for example, that you could program yourself to dream about a particular place, event, person, or so on. According to Dr. Garfield, most creativity comes from finding new combinations of known elements. She points out that the more varied the dreamer's experience, the greater the chance of his hitting upon a new combination.

First it should be learned that one and the same color evokes innumerable readings. . . . distinct color effects are produced—through recognition of the interaction of color—by making, for instance, two very different colors look alike.

—Josef Albers

Intense interest in an idea or problem is the first step toward solving it. If you are vainly seeking a solution to a problem, Dr. Alexander Borbély, author

of *Secrets of Sleep,* says that "a popular saying for a difficult problem is to 'Sleep on it.'" Dr. Borbély continues, pointing out that because thoughts roam more freely when we are asleep, we may be able to find solutions in the dream state, when the spontaneous associations prevail.

There is such a thing as the impression of luminosity.

—Ludwig Wittgenstein

In order to be able to use our dreams creatively, according to nearly all experts on sleep and dreams, we all must find our own way to access our dreams. One way seems to be to think creatively and exhaustively on the topic right before going to sleep. This will plant the idea for dreams on the subject that you wish to dream about. Another debate seems to center on when you should wake up to note an idea. Some experts tell of writing something down, only to find it is unreadable the next morning, while others report of dreamers who have awaken, beginning to experiment with a new dream immediately. Don't stop after the first solution to your creative problem. Write it down but keep looking for messages in future dreams to give you more information. According to Dr. Garfield, one creative dreamer, writer Robert Louis Stevenson, invented "Brownies"—little people who helped him create the text of his stories. He invented the Brownies so that, psychologically, he could allow himself to dream up the Brownies' stories. The more desperate he was for funds, the more prolific the Brownies became at inventing stories that Stevenson could use. Likewise, experts suggest that the more we

are able to control our dreams, the more use they will
be to us.

Starting Over from Scratch

We don't usually look to the corporate world for
creativity and inspiration, but it may have something
to teach us about new approaches to creative work.
Business people are steeped in corporate culture
where new ideas for work processes are based on
what has worked before. But in today's business
environment, a tried and true solution may not be
the best option, given the ever-evolving available
technology.

The essential ingredient to creativity is
wasting time.

—Wired Magazine

In their book, *Joint Application Development*, Jane
Wood and Denise Silver write that jump-starting
creative thinking may involve getting groups to think
about starting over from scratch. To apply this to
artists is a bit harder because many of us are a
bit vague about how we normally begin to work.
Whether we begin with our tools, with work we've
done in the past, or perhaps following the directions
of a teacher, we want to now start in a completely
different way. If you cannot identify how you began
the last work of art you made, think of a method that
you are sure you did *not* use. A little variety with
regard to your starting methods will give you, at least,
another set of problems to solve. Shaking loose from
the method you usually employ will stop you from

relying on the solutions that you have settled on before. Maybe you have begun a painting by sketching the large areas in pencil before applying any paint. If this describes your preferred method, try applying paint directly onto a blank surface. If you traditionally work on a horizontal surface, turn your canvas around and try composing vertically. In other words, challenge yourself.

Finding New Places

What we have to do is to discover, for
by the act of discovery we make life
possible, in the sense that we reconcile
it with its mother, Eternity.

—Giorgio de Chirico

Think for a moment about place. Usually, when you
work on your art, you are in your studio. But that
may not be where the original inspiration for the
work came to you. In fact, you may have been sitting
in traffic waiting for cars ahead of you to move when
a good idea surfaced. Or, perhaps you were chasing
an adventurous toddler down the beach. Place and
creative thought sometimes have very little in com-
mon when they collide, but particular places may help
you conjure up thoughts and ideas.

Think about your past—about places where you
have traveled and what your visual impressions were.
When I think of Los Angeles, I always begin by
thinking of the city's streets, laid out in neat rows,
which you see when you look out the window of an
airplane preparing to land. Thinking about Hong
Kong used to bring back the scary feeling that flying

into that city brought me, with buildings and moun-
tains closely crowding around me as the plane headed
for the old airport. Thankfully, a new airport with
more room around it has replaced the earlier one.
Coming into Venice, Italy, on a train, I was thrilled by
the way the city seems to float on water, everything
being of uniform height. These memories are precious
images that every artist stores within; they only need
to be recalled to bring pictures to mind once again.
Have you ever been to Mexico? What was the first
instance you remember of being in a "foreign"
place? If you haven't yet travelled internationally,
perhaps you have images of the coast of Maine, or the
Delmarva (Delaware, Maryland, and Virginia) Penin-
sula. Or the Rocky Mountains. Or perhaps you flew
into New York City out of a fog, finding a forest of
buildings below you for the first time. Imagery cre-
ated by place is very emotionally moving and it is
often hard to describe verbally . . . so be visual!

Devote a sketchbook to places that you have visited, putting down rough
sketches that will cue your thoughts to expand further. Sketch your
memories of the people you saw there as well as the locales—bridges,
buildings, parks, statues, and landmarks. Think about experiences that
you have had on a small scale, such as a footbridge in Venice, as well as
in large areas like the Place de la Concorde in Paris. If you took pictures,
glue them into the sketchbook to help convey and recapture the feelings
that these places gave you.

Are there places where you like to go and think?
Could you pinpoint particular venues where you have
come up with interesting ideas in the past? If so, then

many more visits there will probably yield more
thoughts in a creative vein. Don't even try to psycho-
analyze why these places have been so fruitful for
you, but start instead with a list—in fact, start it now.

List three places that have been the setting for the birth of an idea, even
if they seem mundane to you at first. Maybe one was a sofa, a window
seat, a tree you climbed. Whatever they were, acknowledge them now.
Simply by paying tribute to them now, you may think about those past
inspirational incidents more and figure out how to reproduce them again.
I'll bet you one thing, though: I'll bet you were alone, wherever they
happened.

1. _____

2. _____

3. _____

Inspiration in Everyday Places

In addition to the places that have helped you be
productive in the past, I've come up with a list of
other spots that you might not have thought of.
Someday when you're looking around for a place to
think, try one of these.

- *Gardens.* Public gardens are usually almost
 empty, and they offer great places for a good
 think by yourself. Also, gardens are often found
 near churches and around historical sites. Going
 outside your studio will introduce you to new
 figures and situations that won't present them-
 selves if you stay cooped up inside. Moreover,
 watching others will remind you of incidents in
 your own life that you hadn't thought of in years.

- *Cemeteries.* Yep, they don't get a lot of traffic, and they are usually pretty well kept, too.
- *Parks.* These institutions provide you with a place to sit and, again, they're often underused (except during special events like 10 K runs). However, it's best to avoid them after dark, when emptiness may make these spots unsafe.
- *Libraries.* Sometimes, all that's required for inspiration is your presence in a local public library. They often have a garden nearby, and peace and quiet are a guarantee. Try out the main reference room or wander into the fiction stacks. One thing that you shouldn't do is peruse another artist's exhibition if there happens to be one—it might be distracting.
- *Your old school.* If you live in the same town where you went to grade school, try a return trip some time when school is not in session. One of my earliest encounters with paint happened when the older kids painted the first-floor windows with tempera for the winter season. We were taken on a walk around the school to see them. What a joy! Of course, this made me anxious to paint them myself, a feeling that continued to grow until I was old enough to try it.

 A trip like this works best on weekends. Just roaming the grounds of your old school will bring back a trove of memories that haven't come to mind in years. It's usually better to return to your old grade school rather than high school, unless you were one of the lucky few who had a happy time there. The adolescent years were painful for many of us.

- *Other sights for deep concentration.* A local yoga
 center, a poetry center, a tea shop where a
 simple cup of tea can extend your welcome for
 hours, historical houses, the stoop of a local
 church. Take a note pad. These places are sure
 to get you thinking. If one of your old neighbor-
 hoods is near you, maybe a short walk there will
 produce some fruitful memories.

Sometimes, we get a great idea while we are
someplace we can't work. Say, you're at a family
reunion or a friend's wedding, or miles from home in
a place (let's say your son's scout camp) where there
may be no tools for you to play with an idea. It's
torture beyond all imagining until you are able to
reach your workplace and try your idea out.

Where those who are not artists are
trying to close the book, he [the artist]
opens it, shows there are still more
pages possible.

—Robert Henri

If I were to name the room of a house where I feel
most comfortable, it would be the garage. Why?
Because, to me, that is the room where things get
repaired or fixed—including my creative self. Nails,
tools, lumber—all of those things necessary to make
something into something else were there. Maybe you
feel like creating something exotic from something
ordinary. My grandfather had a hardware store when
I was small, and my first memories of many visits
there include putting my arms into the nail bins as far
as I could push them. I'm sure that you have such

vivid memories; you only have to resuscitate them. Maybe your favorite room for early memories was the dining room or, perhaps, the kitchen.

As we study these early experiences, we are beginning to pinpoint your personal sources for inspiration. This is as it should be. The place where inspiration comes to you will have your colors, your sounds, your special music. That is why every artist's work is like a fingerprint. Every journey is a separate one and, as we said in the beginning, blissfully no two are alike.

A Journey Through Color

Here's another idea. Choose a color, any color at all. It could be a color that you have trouble with—say, brown. Now, go for a short walk, just a few blocks. Look at everything that is brown. Any shade or variation of brown. Think of twelve different browns. What would it take to compose each one? Think of all the brown experiences that you have had. You know the composition of brown—red and yellow. Or red and black. Or yellow and black. Of course, to some degree, the medium will determine the values of each brown, like the Edwardian browns that are so effective in a gouache or the transparent, watery browns you often find in watercolors of horses or the opaque browns in an old bridge done in oil paint.

Now, try to paint an entirely brown painting. Use shades from red-brown to yellow-brown, to velvety chocolate. You may have thought of brown as a dark color, but you will be amazed at the browns you can get when you concentrate on them. What about living things that are brown, say

horses? Thinking of horses' colors brings several more browns to your palette. Think about dirty browns (mud) and clean browns (baby rabbits). Think about your resistance to this color, and ask yourself why this color bothers you. This involvement with brown may take you several days, as you sort out why some browns annoy you more than others. Now, what browns do you like? Maybe reddish brown, like the color of new loafers when you were growing up—you might have bought them in September to start a new school year. After several days of brown, you may feel that you have explored it thoroughly.

We all have a favorite color, a color we associate with ourselves. Mine's yellow. What color best describes you?

Exotic Places

To help your imagination find and store different and interesting backgrounds, there's nothing like a change of scenery. The travel/education jaunts described below are guaranteed to put exotic places into your thoughts. Even if it's only for a long weekend, you will have lots to think about when you get back in the studio.

Hence the painter will produce pictures of small merit if he takes for his standard the pictures of others. But if he will study from natural objects he will bear good fruit; as was seen in the painters after the Romans who always imitated each other and so their art constantly declined from age to age.

—Leonardo da Vinci

STONEHENGE

A circle of large standing stones on Salisbury Plain in southern England. Stonehenge is believed to have been built about 4,500 years ago, probably as a site of worship. The way in which the stones were placed aligns them exactly with the sun as it rises on the dates of the summer solstice (June 21) and the winter solstice (December 21). The stones, composed of material that is harder than granite, were hauled from twenty-odd miles away. Their path led through a flat valley and up an incline to the sight on Salisbury Plain where they rest today. Even before the stones were assembled, the plain and several others near it were used for the construction of raised circles of earth to create earlier worship areas. The circles still contain particles of bone and pottery, which confirm the dating determined by archeologists.

The stones that stand at Stonehenge now consist of a pattern of two vertical ones and a lintel stone across the top of the other two. The standing stones have a carved ridge that fits exactly into the cross stone to hold it securely. It has been determined from examining stones that have fallen through time, that the standing stones were placed with one-third of the stone below ground.

Visitors to Stonehenge are kept from approaching too closely by hurricane fencing and the site is closed during the solstice periods when the number of travelers increases.

THE AUSTRALIAN OUTBACK

One of the most unusual adventures that artists may enjoy is traveling into the Australian Outback, a region that includes the desert in the central part of

Pictures made up of refinements, subtle gradations, melting transitions call for beautiful blues, beautiful reds and beautiful yellows, substances which move the sensual basis of man's nature. That's the starting point of Fauvism: The courage to find what is pure in the means.

—Henri Matisse

Australia around Alice Springs and Queensland, which lies to the north. Tribes of native-born Aborigines inhabit both areas and make original art that reflects their understanding of the land and the Creating Ancestors, who they believe gave the flat land its shape. Because the Aborigines do not have a written language, all history is transmitted through storytelling, dance, song, and artwork. The artwork is painted outdoors on rocks, pieces of bark, and flat slabs, and it commemorates events that are part of "Dreamings," which are believed to have taken place in or near the painting. Such sites resound with mythology and are still held in special regard today. These paintings also convey laws handed down by the Creating Ancestors as well as traditions of the Aborigines. However, Aborigines do not limit their artwork to rocks and bark—they also paint their bodies. The works of art can be enjoyed for their pure aesthetic value, but they also contain stories of the creation, the land, and the history. Although the materials used to create the paintings have changed, the symbols are still the same. Art done in the desert area looks very different than the work made in the forestlike area to the north, known as the Arnhem

Land. Today, through the creation of traditional arts and crafts, Aborigines keep their cultural heritage alive. Rediscovered in the early 1970s, the Aboriginal art and its people had endured a long period of suppression.

You can arrange to travel in groups or individually, with professional guides using air-conditioned, four-wheel-drive vehicles. To receive free information about traveling to Australia, call toll free, 888/528-7872 or 800/633-3404. Arrangements may also be made on the Internet at *www.redcentre.com.au/,* or you can visit the Aboriginal Art and Culture Web site at *www.aboriginalart.com.au/.*

To see examples of the art of the Aboriginal people, you can visit several gallery Web sites that specialize in it. Among these are:

- Jinta Desert Art, Aboriginal Art Dealers: *www. jintaart.com.au/index1.htm*
- Songlines Aboriginal Art (also has galleries in San Francisco and Amsterdam): *www. aboriginalart.com/*
- Walonia Aboriginal Art Imports: *www.walonia.nl/*

SEDONA, ARIZONA

Sedona, in northern Arizona, is a small tourist town settled near towering formations of red rocks. These rocks were named for the shapes they brought to mind: Cathedral Rock, the Chapel of the Holy Cross, Steamboat Rock, Chimney Rock, and Cockscomb, among them. Located near the Grand Canyon, Sedona's majestic rocks are easy reminders of the long-vanished rivers that shaped them. Over time, artists have found Sedona and settled there, creating

an up-to-date artisan community with galleries and shops. Resident Native Americans and Mexican explorers have left their influence on the area. Completely surrounded by the Coconino National Forest, Sedona is home to a diverse community of writers, artists, jewelers, potters, and antique dealers. An international film festival and chamber music and jazz festivals provide artists with an active spare-time calendar.

He who resolves never to ransack any mind but his own, will soon be reduced, from mere barrenness, to the poorest of all imitations; he will be obliged to imitate himself, and to repeat what he has before often repeated.

—Joshua Reynolds

Over forty galleries and shops in Sedona include: The Art Exchange, Tatewari Gallery, the Hugh Perry Gallery, the Turquoise Tortoise and the James Rarliff Gallery. For information, call 520/204-5823. The Sedona Arts Center has ongoing exhibits and may be called for information at 520/282-3809. Consider taking trips by plane, jeep, helicopter, and balloon, which offer close-up viewing of the sights in the Sedona area. Sedona is located about 120 miles north of Phoenix, and ample lodgings are available. Spirit Steps Tours offers Sedona's only all-spiritual tours, with visits to Sedona's Vortexes, the Wheel of Cosmic Revelation, and Native American Ruins, as well as seminars, workshops, and retreats of a spiritual nature. You can reach them at 800/728-4562. Don't forget to pack your sketchbook and journal.

Walking to New Places

Closer to home, inspirational "travel" can entail taking walks. Plan an after-breakfast or after-dinner ritual; keep this up for a while and you'll reap the many rewards. Setting off aimlessly, with no particular destination in mind, can prove quite fruitful if you keep it up for about twenty minutes. At first you'll notice nothing, but give it time. I think this is an emptying period, when, one by one you let your thoughts go. Even if you're keeping up quite a pace, you'll begin to stop thinking about everyday worries and get on to more abstract ideas.

Films As Sources of Inspiration

One of the greatest visual resources we hold in our memories is of films we have seen. Such a visual warehouse of stored images can be extremely enlightening, taking our minds to places and eras that we weren't able to visit personally. Who can forget the rolling great plains and cliff-dense exteriors in *North by Northwest*? Or, the sweaty, crowded images of India in *Jewel in the Crown*? What about the landscape of Singapore in *The Year of Living Dangerously?* Films can be wonderful resources to help an artist visit a distant land or era (the glittering Romanov society in Moscow) or locale (the film noir Paris of post–World War II). I was sitting with a group of friends one night, talking of films we loved, when Thomas Mann's *Death in Venice* came up. Several people spoke of particular parts that enthralled them. "The most moving part for me," one said, "was the vase of hydrangeas on the table." Such attention to

small details as this will make *Death in Venice* memo-
rable for years to come. It is an important lesson in
specificity for painters, too.

Make a list of twenty films that have affected you, including films in which
the story wasn't that moving, but which offered imagery that has stayed
with you. Might there be an artwork in your future where closer study of a
film could make your imagery clearer, more exact, more luminous, more
challenging?

It is perhaps Manet who was the city-
dweller par excellence. 'To enjoy the
crowd is an art' declared Beaudelaire,
and Manet seems to have developed the
art to an extraordinary degree. It is with
him that the city ceases to be picturesque
or pathetic and becomes instead the
fecund source of a pictorial viewpoint, a
viewpoint toward contemporary reality
itself.

—Linda Nochlin

Art Ancestors:
Help from the Past

All the past can help you.

—Robert Henri

In searching for inspiration, we have many fine examples from the past of artists who have used their journals to record ideas that became inspirations, just as we can now. Reading about them, we can learn the way they employed journals to remind and re-inspire them, and we can also see how much our problems are like theirs were. Likewise, reading about their experiences can make us feel less alone, a problem we often face. We sometimes feel, sitting in an art history lecture, that artists who lived before us somehow managed to escape this period of searching for creative inspiration. This may be due to the way art historians present past artists' lives in a smooth chronological manner. Art historians skim over the struggles for inspiration and the bleak periods when work is impossible, as they are less important than those times of tumultuous creativity. Nevertheless, the

good times could not exist without the bad. Like spaces between these words, they are essential, yet empty.

In this section of the book, my aim is to help you understand that art can come from other art, that something in someone else's creative record may relate to your art in a way that starts you thinking. Therefore, the more you know about the history of art, the more possibilities you can tap into. The more you know about how to dig yourself out of a hole, the less holes will scare you when you find them. In the same way that you have dwelt on your five senses and attuned them to pick up inspirations that may stray past, these other resources may lead you to a museum or bookstore to learn more about another artist with whom you weren't that familiar before.

Not one great mind coming after them [great artists] but owes them tribute, and finds in them the prototype of his own inspiration.

—Eugène Delacroix

I once spent a whole weekend in bed reading a huge volume on Kurt Schwitters, the German collage artist who made art during World War II. He so completely believed in collage that he made his whole house in Berlin into a collage! Called the *Merzbau,* photos are all that exist of it today, since it did not survive the war. At about the time of its destruction, the Museum of Modern Art was negotiating to bring it to New York City. One can tell that it was spectacular, a brick structure with a unique interior of glued shapes completely painted white. And how like an

artist to want to live inside his art! His work was interrupted when he was forced to flee from the Nazis on foot with his son to Norway. He carried a live mouse with him in his pocket all the way! When the war ended, Schwitters chose to live in England. His work as a collage artist came to influence much of what is still being made today.

One always begins by imitating.

—Eugène Delacroix

If the solutions of other artists can help you overcome roadblocks in your own work, take advantage of the examples they set. Here are some other artists whose journals may be helpful today.

Eugène Delacroix

Delacroix kept a journal from 1822 until his death in 1863. (We are very much indebted to Walter Pach for his work on the 1937 English translation of Delacroix's journals.) Delacroix was twenty-four when he began writing his thoughts down to reread later. He was French and lived during a time when European art was strongly influenced by the conquests of Napoleon. The large, heavily populated canvases of nineteenth-century France, such as Géricault's *The Raft of the Medusa*, one figure of which Delacroix had posed for, obviously made a tremendous impression on the young artist. Their subjects were larger than life and clothed in such a way as to make them seem timeless. The journal that Delacroix kept in 1832, on a trip to Morocco, was most influential for the painter during the rest of his life. He saw these countries as totally

romantic. Delacroix wrote, "This people is wholly antique." The nobility and stateliness of the Moors, the beauty and modesty of the women, the "majesty which is lacking among ourselves in the gravest circumstances" brought to his mind life in Greece and Rome at their greatest moments. He wrote later to a friend that "it was among these people that I really discovered for myself the beauty of antiquity."

Every visible body, in so far as it affects the eye, includes three attributes; that is to say: mass, form and colour; and the mass is recognisable at a greater distance from the place of its actual existence than either colour or form. Again, colour is discernible at a greater distance than form, but this law does not apply to luminous bodies.

—Leonardo da Vinci

Delacroix, with his classical European background, saw Morocco and Algeria, where he also traveled, as the Orient. The use of color, kept alive for centuries by the Orientals, expressed a freedom that the Europeans had never allowed themselves in their clothing. The Moroccan and Algerian delight in the senses was foreign to anything Delacroix had experienced before.

The following year, after returning home from Morocco, Delacroix began the first of many great murals that were to occupy so much of the rest of his life. This commission, passed on to him by Géricault, was for a church decoration. Although, as his life progressed, Delacroix grew more and more assured

in his expertise on architectural rendering, it was the use of color for which he was famed. His later work greatly influenced Renoir and Cézanne. Van Gogh made studied variations of his pictures. Delacroix's vivid chromatic sense must be credited to the influence of his Moroccan journals, which he read again and again.

Delacroix's time was also that of Jacques-Louis David and Jean-Auguste-Dominique Ingres, and, as well, the social cartoonist Honoré Daumier. The academy of the French court was very narrow in the kind of art that it would support. Artists who did not work in the prescribed way would receive neither the support of the court nor commissions that would support them financially as they worked. Likewise, such an artist would find no opportunities for exhibiting his work.

An image produced in a mirror is affected by the colour of the mirror.

—Leonardo da Vinci

The large, wall-sized canvases that filled public buildings were far different in intent from the easel paintings that Ingres specialized in. The public art of the day addressed a collective audience; the portrait paintings were for more solitary enjoyment. Delacroix gave us the large murals that accurately portray the classical times in which they were set.

Leonardo da Vinci

Leonardo da Vinci kept notebooks and journals throughout his life and urged everyone else (particu-

larly artists) to do the same. Some of these notebooks were about science, some were full of studies on contemporary weaponry, and some were just as yours might be—full of sketches of people, animals, landscapes, architecture, and so on. Living in sixteenth-century Italy, Leonardo embodied our concept of the Renaissance man. Artists everywhere emulate his work, and it is interesting to look at the ideas he held concerning learning about and absorbing life and beauty. His notebooks give us an idea of how he reasoned and what he felt was important, and they can be explored today in *The Notebooks of Leonardo da Vinci* (Dover, 1970). For another publication that tells a great deal of the times and history of Leonardo da Vinci, consult Giorgio Vasari's *Lives of the Painters, Sculptors, and Architects,* first published in 1568.

Leonardo's notebooks offer paths to artists for exploration and thought. They are, in a way, about the same subject matter as this book. Examine what you find there, and you will see how perhaps the greatest artist has left us all his keys for finding inspiration.

The image of the shadow of any object of uniform breadth can never be (exactly) the same as that of the body which casts it.

—Leonardo da Vinci

Leonardo's great instincts were led by curiosity. He loved to solve riddles, loosen knots, watch birds in flight. In one of his notebooks, he designed machines that would enable people to fly. He was an avid student of anatomy, believing that he couldn't draw the human figure until he understood what went on under the skin. This is still one of the predominant

theories artists hold today. He dissected dead bodies of horses as well as humans in his quest to know how the body worked, so that it might be portrayed more convincingly in his drawings. Today, anatomy books with full-scale drawings are available in libraries to help you understand the workings of the body. Curiosity was, for da Vinci, crucial to learning about many other areas, too. He walked the hills and valleys of Tuscany studying rocks and terrain, just as he had studied the structure of the bones and skin of the body. He was interested in the way certain fabrics draped and folded and in astrology and the placement and movement of the stars. He drew round orbs over and over to study the movement of light and shadow; he drew landscapes to convey ideas about perspective and distance. His notes to students to watch the way light falls on muscles is one of the truly great gifts that he left us.

Which is best, to draw from nature or from the antique? and which is more difficult to do outlines or light and shade?

—Leonardo da Vinci

Da Vinci experimented with the same materials over and over, making mistakes, persisting in his pursuit of knowledge of how the physical world worked. He performed many experiments in trying to understand perfectly what there was to be known about how animals walked and ran, why dusk fell as it did, how the wind moved. He was ahead of his time in believing that the artist must continually refine the senses. Suffice it to say we are in good company in our pursuit of sense-enhancement.

Da Vinci also believed that one should leave oneself open to embrace ambiguity, uncertainty, paradox. He felt that one who views a work of art is transfixed by what he isn't sure of. Look at his painting of the *Mona Lisa*. What exactly makes her so mysterious? Her smile? Her eyes? Da Vinci kept the facial expression to the eyes and around the mouth. What exactly did he do to arrive at this paradox of expression that is slightly different every time you look at her?

Make your work carry out your purpose and meaning. That is when you draw a figure consider well who it is and what you wish it to be doing.

—Leonardo da Vinci

Da Vinci felt comfortable with the conflict that is necessary for creativity. In today's world, as in da Vinci's, conflict is an element of design that can enrich a work of art, while allowing for tension and resolution.

Da Vinci believed that we are all smarter than we know. Some of us are more logical, while others are more intuitive. Which type of thinker are you? Do you logically reason each step, or do you see one whole image? The view that da Vinci espoused was similar to the left brain/right brain theories that we are familiar with today. In fact, we would say that da Vinci himself was equally left- and right-brained. His interest in thinking, experimenting, and gathering logical and factual proof was countered by his artistic ability to make the magic of illusion work for him. His notebooks were written backwards, to be read only with the aid of a mirror.

For da Vinci, it was important for the artist to maintain physical fitness. In many records and notations of the times, including Vasari's *Lives of the Artists*, da Vinci was described as physically fit and the possessor of a fine physical form. Today, artists are not particularly known for being in good physical condition. Since perhaps the Abstract Expressionist era of the fifties, it has been considered necessary for artists to smoke and drink and stay out at night. Probably because the "la bohème" model has been so popular, the artist has been thought too poor to keep a healthy meal schedule. Artists in other fields, such as actors, dancers, and performance artists, have more of a reputation for healthful living.

At a certain point American painters, one after the other, began to consider the canvas as an arena in which to act instead of a space in which to reproduce, redraw, analyze or 'express' a present or imagined object. Thus the canvas was no longer the support of a picture, but an event.

—Harold Rosenberg

Visual artists also bear the additional burden of working with supplies that are often toxic to breathe and bad for their skin. I remember a young Eva Hesse, who died tragically at the age of thirty-four, the victim of poor ventilation in her basement studio.

Even if your finances don't permit a steady gym schedule, you can and should pursue a regular regimen of daily walks and healthy meals. Da Vinci felt and wrote that artists should find grace in their own lives before painting and drawing. Artists today can

bike, run, and exercise at low or no cost. How physically fit are you? Do you arrange your studio so that there is good ventilation and moving air can blow away any bad odors from where you work? (More on designing your studio to work better for you in chapter 11.) Also, how is your posture? Do you walk tall, giving your spine plenty of room to separate and move freely?

In their pursuit of the same supreme end Matisse and Picasso stand side by side, Matisse representing colour and Picasso form.

—Wassily Kandinsky

Perhaps you remember the TV show *Connections* on PBS, hosted by James Burke. Its premise was that many disparate subjects and objects throughout history were connected, either through inventions in one field that sparked others in a different field, or by knowledge newly discovered, which impacted on the body of knowledge in diverse spheres of learning. Da Vinci believed that all knowledge was connected, and he lived his life fascinated by areas such as astronomy, which didn't directly relate to his art, but which gave his art a sense of believability.

An openness to what is happening in many fields will ultimately enrich your art, as it did da Vinci's. A trip to a nature museum may reward you as you follow studies of the earth's solar system and the movement of the current weather system. Studies of life in Antarctica today can lead you to further explore the travels of Commodore Matthew Perry, or the movements of polar bears. Da Vinci's gift to us,

found within his notebooks, is a description of a way to live that, if followed, can fill our lives and help us find inspiration all around us.

Modern Journals

Many artists have filled their journals with day-to-day reminders of business and studio events they wished to recall. Keith Haring noted that the paint of a painting was not dry on the day after he finished the artwork, when he was supposed to sign the painting at a big event that had been planned around it. This was in Europe, and Haring may have been unfamiliar with the supplies that he had used or the length of time required for the paint to dry completely. As a result, he was faced with some paint smearing as he signed the work. He recalled with embarrassment his experience with the wet paint. Other artists kept records of how many days they had worked, if and when they needed assistants, and how much they were paid.

Of all Cubist paintings the most famous in America is Marcel Duchamp's "Nude descending a staircase" of 1912. . . .

—Alfred H. Barr, Jr.

Another artist, an older Edouard Manet, practiced writing notes to his family heirs regarding the Louvre Museum getting his famous painting *Olympia* after his death, yet not wanting anything else he had painted. He did not want the single painting to be all that represented him and he urged his heirs "not to let her go cheap."

Edouard Manet needn't have worried for the fate

of his *Olympia*. Today she occupies her own wall in the Louvre, and Manet's reputation has been secured through the many paintings that artists can study in museums around the world.

From the drying time required for paint to how to use a shadow most effectively to how many assistants one should hire, artists from the past have shared their lives and skills with us in their journals. These were unconscious gifts, left behind unknowingly for another generation of artists who can use and add to them through journals of their own.

Creating Spaces for Inspiration

White light is simultaneously presence and absence, the marking of an empty space.

—Jack Goldstein

I've always wished there was a TV program on artists' studios, because every one that I've ever seen has been endlessly fascinating—a customized workplace (even if messy) for one person only—the artist who works there. This is the place where you want to feel most comfortable, most secure, and most receptive to inspiration, and you are responsible for making it so.

Two Studios

I remember working for a painter in her seventies, who, at that particular time, kept herself very isolated from other people. I'm happy to say I hear that she has become more outgoing and I'm sure this has given her more happiness. When I worked for her, she lived in the garret of an old townhouse in Green-

wich Village. Her easel was large and not easily moved. The walls were like stucco and held a generation's worth of dust.

Her studio was typical of what you might imagine a painter's studio looking like—fifty or seventy-five years ago. Light came into the room from slanted ceiling windows and was only strong enough to work under for several hours around midday. There was almost no electric light in the room at all. A mezzanine balcony, where her husband (a poet) had worked, was half a flight of stairs above, and often, years ago, they had both occupied this large square room simultaneously. The studio was never dusted or swept, as the artist did not want wet paintings to absorb any stray matter. Several comfortable chairs accommodated guests and a large Bosendorfer piano was covered and off to one side of the room. A single letter holder held whatever correspondence required the artist's attention. She entertained guests here in the afternoon and had many impressive ones.

Now, I will describe another studio for you. This one was part of a renovated stable, with long tilting ramps still in place, just inside the front door. Industrial tiles covered the ramps providing the many visitors and delivery men with surer footing. The recent renovation of the stable provided the owner with three floors of extended studio space. As I traveled around the space, I was conscious of many drawings, paintings, and prints framed and adorning the walls. A large open kitchen was the center of the main floor with a big, rounded country-style table, where the staff (of various number, depending on the work in progress) and artist shared meals. Several

large dogs—retrievers, labs, and rottweilers—sprawled on the bare floors, sleeping and oblivious to strangers who walked past. A floor above, long white tables held work that was drying, and paintings of enormous size leaned against bare walls. Light was everywhere, entering the space from huge tilted windows that could be opened at the artist's desire. Fluorescent lighting supplemented natural light and made working longer hours possible. An office was arranged along one wall, where several phone lines blinked and a fax machine ground away, bringing information about the artist's career and sales to a central location that was overseen by a full-time office staff.

 Small rooms or dwellings discipline the mind, large ones weaken it.

—Leonardo da Vinci

These two descriptions of artists' studios probably seem as different as the artists themselves. Yet, each studio worked for the artist who had created it. Each studio reflected the economics that were possible in designing that studio. I have been in lots of studios since these two, and I don't think it is an exaggeration to say that most artists have laid out a plan that works for them, whatever kind of art they make. Whether in garreted attics or slick open-plan lofts, several things remain constant. One is the need for light. Another is the need for a place where newly made art can rest and dry into permanence. Yet further is the need for a place to experiment with a new tool or new paints.

Feng Shui

The ancient Chinese art of feng shui (say "fung shway") can offer us help in designing the proper environment for creating and can even provide us with guidance on colors that are able to lift our energy or modify our moods. Feng shui is the art of interior design and object placement, which is said to promote health, creativity, opportunity, and prosperity. It can also promote emotional healing and spiritual peacefulness. What feng shui offers to the artist is a mindfulness of herself and how she works. This can be turned into choices about where and how one will work, where the light will fall from, and the placement of tables, easels, and equipment.

For those of you who have an interest in this mindfulness, I refer you to Nancy SantoPietro's book, *Feng Shui: Harmony by Design*. In it, she describes how feng shui evolved in ancient China and discusses the basic principles and how you may apply them for more harmonious living. I have included these principles here, since I had a firm belief in the influence of the placement of objects even before I knew what this field was called.

One of the important elements of feng shui is fountains, placed in the home to promote a sense of restfulness. These may have once been of major size, but today small fountains can be had that are only the size of a mixing bowl. The experts at feng shui say movement is important to protect positive energy and clear away dead ideas. Wind chimes, mobiles, or fountains can help to adjust your studio's creativity level.

As I describe these elements to you, my thoughts

go to the workspace of a photographer who lives near me. I had never thought about it before, but describing these feng shui elements completely describes her studio! She is a world traveler and has absorbed much of what she has seen. Although her space is not large, it never seems crowded, and although she entertains there a lot, everyone who comes there seems to fold into the space immediately, finding a spot in which to be comfortable.

To me there is no past and future in art. If a work of art cannot live always in the present it must not be considered at all.

—Pablo Picasso

Feng shui mindfulness stresses the importance of mirrors. They can open up a space, reflect good areas, and expand them and deflect negativity. Life forces such as plants, pets, or flowers are positive additions. Music will keep energy moving so your radio or tapes should have a place in your studio. Many of these elements may have been part of your studio before, but, if not, see which additions can add to your feeling of the possibilities for a good day in the studio.

The Feng Shui Institute of America, in Wabasso, Florida, provides general information on feng shui and will also help you get building plans approved by feng shui masters. To contact the Institute, write Feng Shui Institute of America, P.O. Box 488, Wabasso, FL 32970; call 561/589-9900; or fax 561/589-1611.

Did you know that certain colors are more apt to enhance creativity—that certain colors draw energy? Certain colors can "ground" you; other colors are power colors; others still can make you feel romantic.

Theo Gimbel's book, *Healing with Color and Light,* draws on both ancient wisdom and modern science to help improve one's mental, physical, and spiritual health, using the potent energy of color and light. Nancy SantoPietro contends that oranges, turquoise, teals, and vibrant blues all enhance creativity. Those colors that draw energy include reds, golds, and rich purples. Those that confer a sense of power are golds, black, burgundies, reds, and royal blue. To lift your energy, try red, yellow, turquoise, or bright colors. You may prefer to have your studio painted all white but, because this is a neutral color, it may allow inner conflicts to remain unresolved. Ms. SantoPietro recommends white for trim, doors, and ceilings.

Still another element of feng shui is the placement of furniture in relation to doors and entrance ways. Placement of the bed is particularly important—both as an aid to getting better rest and, as well, with regard to security.

Feng shui can be very helpful to you in making your studio the place you run to, not from, each time you wish to express yourself.

How You Work

How you work influences whether or not you receive inspiration. What exactly do you do first? Most artists actually don't know how they work. Ask yourself: When do I work? What happens in the morning? What happens in the afternoon? When do I work least? When do I paint, as opposed to correcting my own work?

Writing a notebook on your work habits may help you to understand why you work as you do. Find ways to improve your overall performance by studying when you work best and when you are noticeably absent. See if you can improve ventilation and light in order to gain more productive time in the studio. Try to read your notes as if you were an outsider, and make some analytical judgments about what might be improved. Does enough heat fill your space or would an electric heater be welcome? How about the amount of counter space? Could a drop-down wall shelf add to this, while still being out of the way when not needed? How about the storage space? I recently had my own design built and was amazed at the amount of things I could get into it! Definitely worth the investment, and tax deductible, too.

How do you deal with diversions or distractions when you work? Does a ringing phone signal the end of your creativity? Do small family emergencies call a halt to your artistic endeavors for the rest of the day? Do chores you meant to do interfere with your mental state and result in work stoppage? Be honest and note these tendencies in your work notebook.

In the Trenches

How long does your average work session last? Do you frequently go away and come back to paint again, or do you stay with it for long periods of time? When your work is going well, you lose all track of time. Hours go by like minutes, and you can forget to eat altogether.

The most interesting mysteries are the mysteries in broad daylight.

—Gary Stephan

Think about working itself. You may experience a trancelike state as you continue, and at this time it becomes hard to accurately judge your work. Leave that for a different day, when you can divide up your painting and judging activity and split yourself into two people.

It is important to monitor the whole process—from one side of the work to the other. Staying true to the original idea that led you to make this work may be unusually difficult if you don't keep a sketch or some written notes to go by. And, we rarely dream about the work as a whole anyway, preferring to "see what happens" as we work.

J see them as walking away from the wall. Jt's a feeling J have that the work is active.

—Moira Dryer

Beginning your work may be easier than keeping up the momentum, and here we can take some more advice from writing instructor Natalie Goldberg, again in *Writing Down the Bones*. Natalie advises writers to keep their hands moving and to work for prescribed lengths of time. This exercise works for visual artists, too. While creativity may be an un-predictable unknown, the rules for the exercise concern two very controllable elements: physical activity and a given length of time.

Self-doubt may begin to creep in as you proceed. Something is not right here. What to do? Well, you can start over, or you can see where these different decisions will lead you. If something you had planned changes, follow along to see where it leads.

Be sure to check your mental time clock and be sure that you are working "in the present." "Be here now," as Baba Ram Dass used to say.

As you work, mistakes will occur. That is inevitable. Because making art is about choices, some choices will be the wrong ones. We artists make lots of mistakes. It's part of what we do! When we do, our options are apparent. Testing and rejecting ideas is what art is all about! Don't let the sight of a mistake ruin your whole work session.

Here's an idea. Purposely make a mistake in something you are working on. Now, find your way out of it. What are your options as you look at the work and see something you don't like? There may be only one or two other possibilities, or you may find an opening. Maybe try changing a tool or the medium you are working with, introducing texture, or shifting the light source slightly. As you try experimenting in this way, you will find that you trust the testing more and fear the risks less.

I used to go out with a playwright. When something he'd written didn't work out as he had expected, he'd say, "Well, I'll just have to fix that." Funny, the idea of "fixing" a work of art. Somehow, I just couldn't accept the idea that a creation wasn't born perfect. Fixing was something one did to the sink, but to a new play? Especially when I would watch as he put different words into his characters' mouths, thus changing the exposition of the play. Visual artists can do the same thing. Preparing for changes, though, is harder than simply painting out a figure. Admitting a mistake is difficult, even if no one is looking but you.

What exactly is a mistake? You may want to play

against mistakes when they occur to make something more interesting. At the point where you have seen the mistake, you are not making fine china, but rather trying to find a solution you can live with. A chip in your china, so to speak, may be more interesting than china someone else made that is perfect. Addressing chaos may prove fascinating. Some people say that making art is creating order out of chaos.

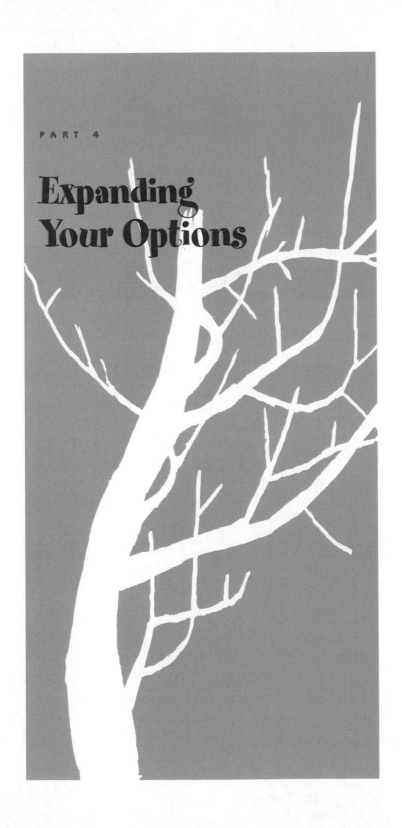

PART 4

Expanding Your Options

Keeping Inspiration Alive

*You cannot govern the creative impulse;
all you can do is to eliminate obstacles
and smooth the way for it.*

—Kimon Nicolaides

Ionce attended an all-day class taught at the Open
Center in New York City by Betty Kronsky, an art
therapist and psychologist who worked with artists.
The Open Center offers many one-day seminars, and
the intensity of working together all day gives many
who attend the impetus to find new approaches to
their problems. The subject of our class was artists'
blocks and ways to deal with them. My particular
problem was that I would begin a new painting, be
very excited, paint like a madwoman, and then sud-
denly stop, not knowing what to do next. Ms. Kronsky
began the class, as I recall, by asking us to do some
free drawings on a large newsprint pad. Then, after
that we did some meditation and as we loosened up,
she asked for a volunteer to tell the class about her
own experience with an artist's block. My hand went
right up. I was there for help, and if I had to stand in

front of the whole world to tell my story, so be it. No one else volunteered, so the job of pouring out artist troubles fell entirely upon me.

"Tell us about before you begin a painting," Betty said. Now at this stage, I was painting large canvases that had to be specially made. After I had determined a size, the stretcher was built and delivered, and canvas had to be stretched and stapled onto it with a heavy-duty stapler. This usually took the larger part of a day, followed by painting on the gesso (primer), sanding for smoothness, applying a second coat of gesso, and, then, a final sanding with even finer sandpaper. This is usually called the priming process, and until it's finished, artists are more like crafts-people and less like creative artists.

I have not worked at all Nothing seems worth putting down—I seem to have nothing to say—It appalls me but that is the way it is.

—Georgia O'Keeffe

I can remember lying in bed the night before I began the painting, looking across the room at the prepared canvas. Sometimes I would look at it for hours, inspecting to see if anything about it was not perfect. My eyes would mentally begin the painting process. I usually had a small drawing in a sketch-book, which showed the general plan I was going to put on the canvas as a background, but after that, the work was very ad hoc and would change and grow as things developed.

When I got up the next morning, I would begin and work steadily for maybe five hours. This work

progressed at a fast pace, with me slamming around, sure in my knowledge that it would end up a beautiful, colorful work. Then, suddenly, nothing, no idea what to do next, complete stop. What had happened?

Betty looked at me intently. She spoke to the class and I slowly: "When you describe this process, you talk in a low, rushed manner and we can feel your excitement at beginning the new work. Your breathing is shallow, your intensity is very transferrable, we are becoming as excited as you were at this point. When you breathe so shallowly, it is difficult for oxygen to get to your brain, to allow you to think and create at the same time."

The idea that something physical might be the problem had simply never occurred to me. My problem had seemed so completely a mental/psychological one, nothing as mundane as the way in which I was breathing, getting air into my lungs, had even dawned on me. Yet, even as she spoke, I knew that Betty had a valid point.

It is highly courageous to launch a frontal attack on the main lines and the main structure of nature, and cowardly to advance by aspects and details; art is really a battle.

—Edgar Degas

"Try to be conscious of how you are breathing as you begin to paint and breathe deeply enough to get oxygen to your brain—you're cutting off your own supply of energy when you breathe so lightly that nothing takes fresh blood to your brain allowing you to think new thoughts.

"Secondly," Betty continued, "I didn't hear you mention that you stopped for lunch, or had a snack as you worked. How can fresh thoughts about this painting come to you when you are almost running on empty in the energy department?"

Again, I was stunned at the reference to my physical human self. Looking back now, it seems so obvious that I was actually running out of gas as I painted. So intent was I on what I was doing, that how I was getting it done was my least concern. The Open Center class that day was a real turning point for me. My blocks have not been back and I really owe it to Betty Kronsky.

When you hit a block, you feel hopeless—as if nothing can help; it is hard to care about anything. Even one small stroke from your brush appears lost, dismal. It is important not to give up now. Michell Cassou and Stewart Cubley, in their book *Life, Paint and Passion,* suggest thinking about what you would do if you suddenly lost control of what you were painting. Better still, they say, what if a crazy lady came through the door and started to paint on top of your painting? They suggest that imaginary people can often help you to start feeling again. I say don't limit it to crazy ladies coming through the door of your studio, try animals—maybe a big friendly bear with a paint brush!

Overcoming Blocks

This story of my experience at a creative blocks workshop has stayed with me almost completely. Perhaps you saw glimpses of yourself in it. There are many kinds of artist's-block problems caused by many

things, but we must not forget that attention to our physical well-being and stops for snacks as we paint are essential to doing a good job. It goes without saying that good ventilation in your studio can help you breathe fresher, cleaner air, stay alert, and think more clearly. While some blocks can be traced to psychological reasons, we must remember that we have to keep the physical engine in tiptop running order, too.

 A good painting is a remarkable feat of organization.

—Robert Henri

Here are some other suggestions for overcoming blocks that occur as you are working.

Look at your work in a mirror. Better still, a mirror of a mirror. What bothers you about it will become more apparent as you see it reflected. This suggestion, which comes from Leonardo da Vinci, is nearly five hundred years old, but the honesty seen in a mirror can't be faulted and is as valid as it was the first time the master tried it.

Put the work up in your studio where you will see it as you come and go and are not concentrating on it.

Or, try placing it on top of your TV, where you will catch glimpses of it during commercial breaks. Catch yourself off guard for honest looks that you might miss when concentrating too hard.

Remember that what you thought you would get when you first planned this work and what you actually get will not be the same thing. This will be because:

- You are thinking as you work, and making changes
- Accidents will happen and you may like them enough to leave them in your work
- Your materials and the brush you choose to use all have their own characteristics, and must be factored into the equation
- Things will be happening to you while you work on this piece that will have an effect on your decisions about the piece—art is all about decisions

I like the following suggestion by Anna Held Audette in *The Blank Canvas*: Put your work, if it will fit, into a copy machine. Because of all the possibilities such a machine offers, you can readily see your work in many different sizes. Or you can merely make five or six copies of the work as you have it now and try out experiments while never hurting your original.

Another suggestion by Anna Held Audette is to observe your current works as a group, where certain characteristics will stand out. Rather like families when they gather, your work will easily reveal what common characteristics stand out.

Jerry Mundis, 212/924-4459, works with writers who are blocked, claiming to end blocks forever after one four-to-five-hour session. Jerry is a writer himself, with seventeen novels and seven nonfiction books as well as more than one hundred articles, essays, and short stories to his credit. He is a former consulting editor of the *New York Times*. His advertisement in a local spiritual and personal growth paper caught my eye: "I can break writer's block in one four-hour consultation." I wanted to hear what he

thought caused these blocks and if there was a way to
apply his thoughts to artists' problems.

A good picture is a well-built structure.

—Robert Henri

He surprised me by saying that there is no such
thing as a writer's block. "It is not an inability to
work," he said, "but a choice."

Just below the level of consciousness, he says, one
decides whether to work on a project or not. Forms of
reasoning for why not to work on a project might
include:

- The "as soon as" syndrome ("As soon as I get
 my house cleaned . . ."), which provides a con-
 stantly changing agenda for why and when the
 writing will get done.
- The "last minute crisis" syndrome, where a book
 is needed in order to gain tenure, or an article
 that has been long promised is now due.
- The "inability to stick to a project" case, where
 the writer skips between projects A, B, and C
 but never settles on one long enough to finish it.
 Artists who divide their art making between
 panting, prints, artists' books, etc., might be in
 this category.
- The "inability to finish an enterprise," where the
 writer is always writing, but never finishing. The
 writer is not paralyzed, but the import of having
 a project to hold his attention won't allow him to
 finish and be done with it. Unfinished master's
 dissertations are perfect examples of this cat-
 egory. (And we all know about paintings that
 await completion.)

- The "block-specific situation," or paralysis, where you can write (or paint) anything, except for this one. You freeze up when it comes to one specific project, but you can work on anything else. One of Jerry's clients was a lawyer who had been blocked from writing on a particular aspect of his work for twelve years.

Any of these sound familiar to you? Through evaluating and categorizing these "block types," Jerry has developed a system that can help anyone who has such a problem.

He starts the four-hour session by making his client comfortable, sitting opposite her, offering a beverage, and beginning slowly. He asks his client to describe her block. Together, they work on defining the problem for roughly a third to a half of the session. The rest of the session is given over to techniques that Jerry says can help overcome any work stoppage. It's important that the client understand the dynamics of her block exactly.

Invention depends altogether upon execution or organization; as that is right or wrong so is the invention perfect or imperfect.

—William Blake

In some cases, the physical workplace may be so full of mixed signals that creative work is impossible. He recommends that you establish "visual anchors," which mark out your place to work. Even if you use the same areas for several different parts of your life, remove things that cause you to feel conflicted

about working. Items like flower pots, children's clothes, dog leashes, and photos of loved ones may subtly remind you that you are taking time away from loved ones in order to pursue your creativity. Replace such things with items like a sketchbook, brushes, or a colorcard for paints; these will signal to you that this is a workplace, and here you are free to work—to create art. When this area is configured, it becomes special. It triggers within your mind the fact that serious work is done here. You don't do anything else here but make art. Jerry maintains that, although this may be "mildly Pavlovian," it truly works. Make your creative working time sacrosanct—everything else revolves around it.

I now find that carrying a drawing so far that it becomes a substitute for the sculpture, either weakens the desire to do the sculpture, or is likely to make the sculpture only a dead realization of the drawing.

—Henry Moore

I remember reading about a female artist who had a small child. To avoid interruptions while she worked, she installed a screen door to the entrance of her studio and hired a sitter to be with her child while she worked. This artist established a tangible border between her creative life and life's other demands, which may be what you will need to do in order to signal to yourself and others that you are serious about your creative work.

Try to establish a regular time for working. It doesn't have to be a nine-to-five job. Many times,

according Jerry, writers or artists who have been blocked will try to make up for lost time by overworking themselves. This may turn into unrealistic expectations, and they'll soon be out of sync with the other demands of their lives.

Finally, myths about other writers or artists may intimidate a blocked subject. A list of artist myths is included in chapter 3. Some of the writer myths will sound familiar:

- I don't measure up to famous writers
- Good writers are all geniuses
- Real creative writing is an ecstatic experience

These myths are three big killers that can operate on a creative person and stop inspiration cold.

Jerry follows up the session by asking his clients to work a full week, and he then calls to see how it has been going or if there are any questions. Sometimes, he says, there are misunderstandings of something that had been discussed during the session. Two weeks later, he calls again to see how the work is going.

It is not unusual, Jerry says, for him to get a call back in six months to two years from clients whose blocks have returned, primarily because they have stopped going through the exercises he had suggested. Once they get reoriented to Jerry's exercises, they get unblocked and can work again.

Completing the Work

Once you get back to work, how will you know when you've finished? Unlike finishing other projects, such as building a deck, or baking a layer cake, finishing an

artwork does not imply that it now can be used. You can sit on the deck, invite friends over, cook out on it. When a cake is finished baking, you can eat what you have made.

The artist who uses a given form begins each painting further along, deeper into the process, than an expressionist, who is, in theory at least, lost in each beginning. . . .

—Lawrence Alloway

But what about this creation of yours? When you were planning it and it was still just an idea, did you say, "When I get to such and such a stage, I'll know it's complete." Or, "When I can see that so and so appears true, I'll be finished." Simply by saying "I'll know when it's finished," you are giving the work permission to be ongoing. Thankfully, we often receive a deadline by which time a work must be finished. This can help you, as most of us work better with a completion date in mind. Knowing that a handsome check is waiting has probably caused quite a few paintings to be completed.

But one thing is for sure—no one can tell you it's finished but you. I think it is easier to set guidelines at the beginning of a work than at the end, so keep plans for endings in mind as you start on the piece. Then, celebrate as you finish. (You can always go back and adjust a bit, after the celebration!)

Exploring the Edges

The spirit, like the body, can be strength-
ened and developed by frequent use. . . .
And for this reason it is necessary for
the artist to know the starting point for
the exercise of his spirit.

—Wassily Kandinsky

Have you ever had a creative problem that haunted you night and day defying a solution? Maybe you've worked on a piece of art until you came to a complete stop and didn't know where to go next—like being on a highway that suddenly had no signs, no directions. Big murals often take years to complete. Even small works may require a great deal of your time, particularly if they are ornate. But maybe it's hard for you to devote too much of your time to one particular project, and perhaps you're ready for an unusual solution. Recently, I have taken an interest in the theory of brainstorming, and maybe there is something in this method that may help you solve your specific and difficult problems.

Brainstorming

Alex Osborn, of the advertising agency BBD&O, coined the term "brainstorming," which referred to the method he had devised for obtaining new ideas. He would gather the staff together in one room to toss out whatever ideas came into their heads, with no criticism allowed. Large corporations and private think tanks have been employing brainstorming since the thirties in order to address the more vexing questions that puzzle them.

Dreams and reality are united in our imagination. The artist possesses the means to create only after he has effective command of his faculty of empathy which he must develop simultaneously with his imagination.

—Hans Hoffmann

Try brainstorming, as corporations do, for solutions to your own problems. Whether your problem concerns a creative matter (say, something you are making), or a tactical career move, such as how to approach a certain dealer, you may find the right solution via a brainstorming session.

Yes, you say, but I'm the *only* member of my organization! I don't have a group for this exercise. How can I offer myself suggestions? Simple. Write them down. Tape record them and play them back to yourself. Gather them on individual slips of paper or a single list. And don't forget to admit to yourself that it will take time to "noodle" through this situation until good ideas or solutions can be found.

You can break brainstorming down into several steps, from big overall plans to more detailed steps in segmented order. I list everything possible, from the sublime to the ridiculous.

J myself have proved it to be of no small use, when in bed in the dark, to recall in fancy the external details of forms previously studied, or other noteworthy things conceived by subtle speculation; and this is certainly an admirable exercise, and useful for impressing things on the memory.

—Leonardo da Vinci

Since its inception, the experts have made some modifications to the method of brainstorming. Silent brainstorming (participants write down their ideas rather than calling them out) has helped those who might be intimidated or feel shy about shouting out their suggestions. Incremental brainstorming—perhaps writing down a single idea each day—might work best for you. If you use one of those daily calendars that supplies a page for each day, try writing on the daily sheets and keeping them, rather than throwing them away. In corporate sessions, organizers often place pads of paper around the room, asking the group to move to each pad, reading what's been written down and adding some modifications to it. If you have several things that you're trying to work out, try placing several pads of paper around your studio and writing a topic on each pad. Or, divide up one problem into smaller subproblems, and separate them into several lists. This way, you can solve each

subproblem individually, and gain a little distance from the matter.

We are not here to do what has already been done.

—Robert Henri

Another way to brainstorm involves using storyboards, much like cartoon frames. Storyboard pads are available in any art supply store. This technique was thought up by Walt Disney to plot out the action in his animated cartoons. Alfred Hitchcock also used it to plan his film shots. Performance artists may find this way of working to be particularly helpful, because time and a series of sequences is involved. You can simply sketch out the order in which you want things to occur. For other types of artists, such as sculptors, storyboards may also work particularly well. Story boards can often help the sculpting artist plot interaction between the work and the viewer and, therefore, can help determine, for example, which way an artwork is to be placed. For video artists, this tool clearly offers a terrific advantage. When the piece incorporates a script, for instance, parts of the dialogue can be placed alongside of the sketches, giving clues as to how fast the frames should be moving or whether or not additional dialog is needed.

Self-Hypnosis

Self-hypnosis can be learned and, in certain situations, may help you to find new solutions to your art-related problems.

After examining several systems of self-hypnosis,

I believe that the most successful element in all of the methods I studied is complete relaxation. You can accomplish this either by lying down on the floor or sitting upright in a comfortable chair. As in preparation for yoga, clear your mind of bothersome thoughts and concentrate on your breathing.

As you begin, follow the advice of health-care writer Sheila Lavery: "Tell yourself that you have nothing to do but relax. Think only of the breath moving in and out of your body. Then, without lifting your head, roll your eyes back and look up as if you were looking for your eyebrows. Fasten your eyes on a spot on the ceiling. Take four long deep breaths. Inhaling, hold each breath for the count of ten and as you exhale, tell yourself to 'relax now.' Repeat this step four times, holding your breath progressively longer each time."

"Because it is impossible to go into hypnosis while reading instructions," Sheila maintains, "you may want to first read them into a tape and then play them back. Speak in a slow, relaxed voice and put some soft atmospheric music in the background." Alternatively, Sheila suggests, "another idea is to buy a self-hypnosis tape that comes complete with a guided visualization exercise. Do not be surprised if you do not feel as if you are in a trance. Hypnosis simply feels like a state of deep relaxation."

There is something in my work that touches feelings and ideas that have been latent.

—Ross Bleckner

While in the relaxed hypnotic state, try to picture the elements that you feel will belong in your next artistic project. Like furnishing a new home, perhaps only one thing is missing to make the work complete. Hypnotists who offer classes in self-hypnosis say you may fall asleep under hypnosis. Tell yourself that on the count of three you will reawaken and feel completely refreshed.

The color of a background is not as it is, but as it appears when the artist is most deeply engaged with the figure in front of it. It is not seen with the direct eye.

—Robert Henri

Caution: The mentally unstable or those who have a history of psychiatric problems should seek professional advice before undertaking self-hypnosis. If you consult a hypnotherapist, make sure that he or she is a member of a recognized body and insured to practice. In order for self-hypnosis to have the possibility of being effective, it works best for people who are ready and willing to change their habits and prepared to practice the technique regularly.

Use Your Sleep Time!

Have you ever noticed how clearly you see things in the morning after a good night's sleep? Sleep is a necessary restorative for a healthy mind and body, but sleep time can also be used to develop your ideas and your artwork. While I have already touched on this subject in "Dreaming Inspiration," of chapter 8, I'd like to offer here a few more suggestions concerning the productive use of sleep.

Conscientious and exact imitation of nature does not make a work of art. A wax figure confoundingly lifelike causes nothing but revulsion. A work of art becomes such when one re-evaluates the values of nature and adds one's own spirituality.

—Emil Nolde

You can use the time you spend sleeping to plan the details of your next project or to solve the problem that's driven you nuts all day. Giving your brain an assignment before going to sleep makes sense, too. Thinking about it all day without finding a solution may have worn you out but working on it while you sleep won't tire you in the least. If you go to sleep thinking about a problem you've been trying to solve, chances are you will dream about it and come up with some manageable solutions that might not have occurred to you before (and perhaps would not have otherwise!). Take advantage of the time you spend sleeping when a part of your brain is still awake and alert. Here are a few tips to help you attain optimum sleep time.

For top performance, you truly need a good night's sleep. In her book, *The Healing Power of Sleep*, Sheila Lavery recommends that you begin preparing for sleep an hour before you actually go to bed. Prerecorded relaxation tapes will help you shed the thoughts of the day and unwind. As well, the right type of music will help you relax, and don't forget about the nurturing benefits of a warm bath. If you are going to include any natural sleep panaceas in your routine, such as herbal or homeopathic remedies, these should be taken about half an hour before you wish to

fall asleep. If you're a nighttime TV watcher, Sheila contends that your TV should be kept out of the bedroom. Avoid programs that extend past your normal bedtime and that entail graphic content such as scary or overexciting programming that will keep you awake or induce nightmares. Avoid reading anything about work. Snacks before bedtime are a standard habit for many of us. I can remember having a bowl of Wheaties with my dad before bedtime from the time I was quite young. Just remember to restrict snacks to foods that are light and drinks that are sleep inducing. Don't go to bed angry, as anger can often keep you awake. Try to settle arguments during daylight hours, and don't start an argument right before bedtime.

Writer Pete Hamill says he takes a nap every day, usually right after lunch. Awaking refreshed, just as in the morning, he says that this midday snooze enables him to have his quality morning time twice each day!

The Self-Help Bookshelf

The next time you visit a bookstore, check out the self-help section. While it will not specifically offer artists help, the way a monthly magazine such as *Art Calendar* does, you may be able to use some of the sugges-

I usually go in with the thought of a landscape in mind. My imagery contains the unconscious language of everything we see on television. I have a certain need in what I produce to get at the digital quality of things. So much visual information that comes to us now is digital, digitized.

—Barry Bridgwood

 The really valuable thing is intuition.

—Albert Einstein

tions that are offered there. Books on how to write effective letters, how to communicate well with others, and how to read and understand people by their outward mannerisms, can all help you work out an intriguing problem. Take a particular problem with you as you peruse those self-help books, and answers will start popping out at you. It's all a matter of concentration: You will find what you are bent on looking for. Some of the most unusual sources may offer the key to an inspiration you've been seeking.

Don't forget to listen to your work—the work itself can lead you to the way to solve a thorny problem. Don't underestimate yourself—intuition that has fueled you in creating a work can be employed in sorting out a knotty situation. Listen to yourself—hear what an expensive therapist would hear if she were treating this problem. Remember: Therapists can only work from the information that you give to them.

I remember once needing a large tube to ship some drawings out of town. As I took the dog out for a walk, I was thinking, "Now where am I going to find that tube that I need?" I found no less than four solutions while on my walk. It was amazing—tubes were falling out of windows there were so many answers to my quandary! I arrived home laughing because there were so many solutions to my problem. I had just centered my concentration on one area and solutions had presented themselves. Sometimes a problem is really just a puzzle that we have to solve; not really a problem at all.

Summoning Your Inspiration–Your Choice

ollo May asserts: "Everyone uses from time to time such expressions as 'a thought pops up,' an idea comes 'from the blue' or 'dawns' or 'comes as though out of a dream' or 'it suddenly hit me.'" It is really a "breakthrough of ideas from some depth below the level of (your) awareness." In other words, you've already got the answers you're seeking and are carrying them around inside you, but can't reach them with your conscious mind. Now that you've read this book, I hope you've gained a few more techniques for accessing those ideas.

Like the titles of each section of this book, the theme here has been to help you to expand. Maybe reading this book has jarred loose some helpful ideas that you knew about once but forgot. No matter how much creativity you think you've been given, you should always be on the lookout for ways to make the most of it.

The search for inspiration is as individual as you are and as distinct as your own creativity. Through methods such as journal keeping, meditation, and viewing ancient art from the other side of the world, you can expand your day-to-day experiences. You will find that, by expanding your options for making art, you'll give your art career, wherever it may be currently, a clearer voice—now several decibels LOUDER. You didn't set out to make your art like someone else's, and the suggestions here won't lead you in that direction. Ultimately, Jerry Mundis is right. To work on your art is a choice for you to make. I hope this book will become well-worn as you come back, time and again, to explore inspiration and ways to stimulate your mind in finding new ideas to make your art. Here, I'll suggest my other book, *The Artist's Guide to New Markets,* to check out when you're ready to find markets for your new art.

How you decide to use this book will be an individual choice but, hopefully, however it's used, you will take what you need from it to sustain yourself on your creative quest. Art, like life itself, is a traveling experience. Wherever you go, always remind yourself that you can draw upon your life and your experiences for a unique dose of inspiration.

Goethe once wrote to a young artist: "The moment one definitely commits oneself, then providence moves too. All sorts of things occur to help one that would otherwise never have occurred. A whole stream of events issues from the decision, raising in one's favor all manner of unforeseen incidents and meetings and material assistance which no man could have dreamed would have come his way. Whatever you can do or dream you can, begin it. Boldness has genius, power, and magic in it. Begin it now."

Credits for Quotes

CHAPTER 1

3. Henri Matisse. Source unknown.
7. Paul Klee. In Ian Crofton, *A Dictionary of Art Quotations* (London: Schirmer Books, 1988).
9. El Greco. In Donna Ward La Cour, *Artists in Quotation* (Jefferson, N.C.: McFarland & Co., 1989).
11. Robert Henri. *The Art Spirit*, 1923 (Reprint, New York: Westview Press, 1984).
16. Leo Steinberg. Source unknown.
17. Leonardo da Vinci. In Jean Paul Richter, ed., *The Notebooks of Leonardo da Vinci*, vol. 1 (New York: Dover Publications, 1970).
19. E. H. Gombrich. *The Story of Art*, 16th ed. (London: Phaidon Press, 1995).
20. André Derain. In Crofton, *A Dictionary of Art Quotations*.
23. Ludwig Wittgenstein. *Remarks on Colour* (Berkeley and Los Angeles: University of California Press, 1978) 13.

25. Linda Nochlin. *Realism* (New York: Pelican Books, 1971).
27. Daniel Buren. *Journal of Contemporary Art* 1, no. 1 (Spring 1988): 9.

CHAPTER 2

29. Marc Chagall. In La Cour, *Artists in Quotation*.
30. Robert Henri. *The Art Spirit*.
32. Georges Braque. In Crofton, *A Dictionary of Art Quotations*.
34. Robert Henri. *The Art Spirit*.
35. Robert Delaunay. In Crofton, *A Dictionary of Art Quotations*.
36. Robert Henri. *The Art Spirit*.
37. Leonardo da Vinci. In Richter, ed., *The Notebooks of Leonardo Da Vinci*, vol. 1.
38. Robert Henri. *The Art Spirit*.
39. Ludwig Wittgenstein. *Remarks on Colour*, 27.
40. Josef Albers. *Interaction of Color*, rev. ed. (New Haven: Yale University Press, 1975).

41. Leonardo da Vinci. In Richter, ed., *The Notebooks of Leonardo Da Vinci*, vol. 1.

43. Donald Judd. In Gregory Battuck, ed., *Minimal Art* (New York: E. P. Dutton & Co., 1968).

43. Wassily Kandinsky. In Crofton, *A Dictionary of Art Quotations*.

CHAPTER 3

47. Hans Hofmann. *Search for the Real*, rev. ed. (Cambridge, Mass.: M.I.T. Press, 1977).

49. Robert Henri. *The Art Spirit*.

50. Leonardo da Vinci. In Richter, ed., *The Notebooks of Leonardo Da Vinci*, vol. 1.

52. Robert Henri. *The Art Spirit*.

53. Ralph Goings. In Linda Chase, *Ralph Goings* (New York: Abrams, 1982), 18.

55. Giorgio Vasari. In Crofton, *A Dictionary of Art Quotations*.

56. Joshua Reynolds. Ibid.

57. David Reed. *Journal of Contemporary Art* 1, no. 1 (Spring 1988): 73.

65. Carlo Ridolfi. In Carla Gottlieb, *Beyond Modern Art* (New York: E. P. Dutton & Co., 1976).

CHAPTER 4

67. Anna Freud. In La Cour, *Artists in Quotation*.

69. Vincent Van Gogh. *The Complete Letters of Vincent Van Gogh*, vol. 2 (Greenwich, Conn.: New York Graphic Society, 1959), 320.

71. Gail Sheehy. In La Cour, *Artists in Quotation*.

73. Alica L. Pagano. Ibid.

75. Robert Henri. *The Art Spirit*.

77. Georges Braque. In Crofton, *A Dictionary of Art Quotations*.

78. George Moore. Ibid.

81. André Derain. Ibid.

CHAPTER 5

83. J. Krishnamurti. *Think on These Things* (New York: HarperCollins, 1989).

85. Eugène Delacroix. In La Cour, *Artists in Quotation*.

87. Robert Henri. *The Art Spirit*.

93. Edgar Degas. In Crofton, *A Dictionary of Art Quotations*.

99. Maurice Vlaminck. In Joseph-Emile Muller, *Fauvism* (New York: Frederick A. Praeger, Inc., 1967).

101. Robert Rauschenberg. In *Painters Painting*, film documentary, 1972, produced and directed by Emil DeAntonio. Available through Museum of Modern Art Film Department, New York. Text available through Museum of Modern Art, New York.

102. Source unknown.

CHAPTER 6

105. Pablo Picasso. In La Cour, *Artists in Quotation*.

107. Stanley Rosner and Lawrence Abt. Ibid.

111. Michelangelo Buonarroti. Ibid.

112. Willem de Kooning. Ibid.

115. Ben Shahn. *The Shape of Content* (Cambridge, Mass.: Harvard University Press, 1957).

117. Robert Henri. *The Art Spirit*.

118. Thomas Hart Benton. In Nancy Edelman, *The Thomas Hart Benton Murals in the Missouri State Capitol* (Jefferson City, Mo.: The Missouri State Council on the Arts, 1975).

119. Robert Henri. *The Art Spirit*.

120. Leonardo da Vinci. In Richter, ed., *The Notebooks of Leonardo da Vinci*, vol. 1.

121. Robert Henri. *The Art Spirit*.

122. Hans Hofmann. *Search for the Real*, rev. ed.

123. Sigmund Freud. Quoted by Howard Gardner on "Booknotes," C-SPAN, 1998.

125. Giorgio Vasari. In Crofton, *A Dictionary of Art Quotations*.

126. Andy Warhol. In *Painters Painting*, film documentary, 1972, produced and directed by Emil DeAntonio. Available

through Museum of Modern Art Film Department, New York. Text available through Museum of Modern Art, New York.

131. Edgar Degas. "Bravo Profiles." Bravo Cable Network, 1999. Produced by Laura Pierce and Frances Berwick. Distributed by R.M. Associates in London.

CHAPTER 7

133. Leonardo da Vinci. In Richter, ed., *The Notebooks of Leonardo Da Vinci*, vol. 1.
137. Robert Henri. *The Art Spirit.*
139. Albert Pinkham Ryder. In Crofton, *A Dictionary of Art Quotations.*
141. Vincent Van Gogh. Ibid.
144. Elizabeth Murray. *Journal of Contemporary Art* 1, no. 2 (Fall/Winter 1988): 32.

CHAPTER 8

149. Rainer Maria Rilke. *Letters To A Young Poet* (New York: Random House, 1984), 7.
151. Leonardo da Vinci. In Richter, ed., *The Notebooks of Leonardo Da Vinci*, vol. 1.
153. Robert Henri. *The Art Spirit.*
155. Leonardo da Vinci. Ibid.
157. Mies van der Rohe. Source unknown.
159. Charles Hawthorne. In La Cour, *Artists in Quotation.*
161. Robert Motherwell. Ibid.
163. Edgar Degas. Ibid.
165. Anna M. Moses. Ibid.
166. Robert Henri. *The Art Spirit.*
167. Alberto Giacometti. Source unknown.
168. Cennino Cennini. In Crofton, *A Dictionary of Art Quotations.*
169. Robert Henri. *The Art Spirit.*
171. Alfred H. Barr, Jr. *Cubism and Abstract Art* (Cambridge, Mass.: Harvard University Press, 1986).
173. Josef Albers. *Interaction of Color*, rev. ed.
174. Ludwig Wittgenstein. *Remarks on Colour*, 27.
175. *Wired* Magazine. Date unknown.

CHAPTER 9

177. Giorgio de Chirico. In Crofton, *A Dictionary of Art Quotations.*
181. Robert Henri. *The Art Spirit.*
183. Leonardo da Vinci. In Richter, ed., *The Notebooks of Leonardo Da Vinci*, vol. 1.
185. Henri Matisse. In Crofton, *A Dictionary of Art Quotations.*
187. Joshua Reynolds. Ibid.
189. Linda Nochlin. *Realism.*

CHAPTER 10

191. Robert Henri. *The Art Spirit.*
192. Eugène Delacroix. In Hubert Wellington, ed., *Journal of Eugène Delacroix* (Ithaca, N.Y.: Cornell University Press, 1880), 378.
193. Eugène Delacroix. In La Cour, *Artists in Quotation.*
194. Leonardo da Vinci. In Richter, ed., *The Notebooks of Leonardo Da Vinci*, vol. 1.
195. Leonardo da Vinci. Ibid.
196. Leonardo da Vinci. Ibid.
197. Leonardo da Vinci. Ibid.
198. Leonardo da Vinci. Ibid.
199. Harold Rosenberg. In Crofton, *A Dictionary of Art Quotations.*
200. Wassily Kandinsky. *Concerning the Spiritual in Art* (New York: Dover Publications, 1977).
201. Alfred H. Barr, Jr. *Cubism and Abstract Art.*

CHAPTER 11

203. Jack Goldstein. *Journal of Contemporary Art* 1, no. 1 (Spring 1988): 38.
205. Leonardo da Vinci. In Richter, ed., *The Notebooks of Leonardo Da Vinci*, vol. 1.
207. Pablo Picasso. In Crofton, *A Dictionary of Art Quotations.*
209. Gary Stephan. *Journal of Contemporary Art* 2, no. 1 (Spring 1989): 67.
210. Moira Dryer. *Journal of Contemporary Art* 2, no. 1 (Spring 1989): 53.

CHAPTER 12

215. Kimon Nicolaides. In La Cour, *Artists in Quotation.*

216. Georgia O'Keeffe. In Roxana Robinson, *Georgia O'Keeffe* (New York: Harper & Co., 1989), 392.

217. Edgar Degas. In Crofton, *A Dictionary of Art Quotations.*

219. Robert Henri. *The Art Spirit.*

221. Robert Henri. *The Art Spirit.*

222. William Blake. In Crofton, *A Dictionary of Art Quotations.*

223. Henry Moore. Ibid.

225. Lawrence Alloway. In Gregory Battuck, ed., *Minimal Art.*

CHAPTER 13

227. Wassily Kandinsky. *Concerning the Spiritual in Art.*

228. Hans Hofmann. *Search for the Real,* rev. ed.

229. Leonardo da Vinci. In Richter, ed., *The Notebooks of Leonardo Da Vinci,* vol. 1.

230. Robert Henri. *The Art Spirit.*

231. Ross Bleckner. *Journal of Contemporary Art* 1, no.1 (Spring 1988): 45.

232. Robert Henri. *The Art Spirit.*

233. Emil Nolde. In Crofton, *A Dictionary of Art Quotations.*

234. Barry Bridgwood. *Journal of Contemporary Art* 1, no. 2 (Fall/Winter 1988): 54.

235. Albert Einstein. In La Cour, *Artists in Quotation.*

IN CLOSING

238. Attributed to Goethe. Added to text in John Anster's translation of *Faust,* 1835.

Bibliography

Adams, Kathleen. *Journal to the Self*. New York: Warner Books, 1990.

Agee, James, Walker Evans, and Jeena Terry, eds. *Let Us Now Praise Famous Men*. Boston: Houghton Mifflin, 1989.

Albers, Josef. *Interaction of Color*, rev. ed. New Haven: Yale University Press, 1975.

Audette, Anna Held. *The Blank Canvas*. Boston: Shambhala Publications, Inc., 1993.

Bareau, Juliet Wilson, ed. *Manet by Himself: Correspondence and Conversation*. Boston: Little Brown, Bullfinch Press, 1991.

Barr, Alfred H., Jr. *Cubism and Abstract Art*. Cambridge, Mass.: Harvard University Press, 1986.

Barron, Frank, Alfonso Montuori, and Anthea Barron, eds. *Creators on Creating*. New York: Tarcher/Putnam, 1997.

Battuck, Gregory, ed. *Minimal Art*. New York: E. P. Dutton & Co., 1968.

Bayles, David and Ted Orland. *Art and Fear*. Santa Barbara, Calif.: Capra Press, 1994.

Benton, Thomas Hart. *An American in Art: A Professional and Technical Autobiography*. Lawrence, Kans.: University Press of Kansas, 1969.

——. *An Artist in America*. Columbia, Mo.: University of Missouri Press, 1983.

Berger, John. *Ways of Seeing*. New York: Viking/Penguin, 1990.

Borbely, Alexander. *Secrets of Sleep*. New York: Basic Books, 1986.

Cage, John. *Silence*. Middletown, Conn.: Wesleyan University Press, 1973.

Cassou, Michell and Stewart Cubley. *Life, Paint and Passion*. New York: Tarcher/Putnam, 1995.

Chase, Linda. *Ralph Goings*. New York: Abrams, 1982.

Crofton, Ian. *A Dictionary of Art Quotations*. London: Schirmer Books, 1988.

Csikszentmihalyi, Mihaly. *Creativity: Flow and the Psychology of Discovery and Invention*. New York: HarperCollins, 1994.

——. *Flow: The Psychology of Optimal Experience*. New York: Harper & Row, 1990.

Edelman, Nancy. *The Thomas Hart Benton Murals in the Missouri State Capitol*. Jefferson City, Mo.: The Missouri State Council on the Arts, 1975.

Elderfield, John. *Kurt Schwitters*. rev. ed. New York: Thames & Hudson, 1985.

Fiske, John. *Understanding Popular Culture*. London and New York: Unwin Hyman Ltd., 1989.

Gardner, Howard. *Creating Minds*. New York: Basic Books, 1993.

Garfield, Patricia Ph.D. *Creative Dreaming*. New York: Simon & Schuster, 1995.

Gimbel, Theo. *Healing with Color and Light*. New York: Fireside Books, 1994.

Goldberg, Natalie. *Writing Down the Bones*. Boston: Shambhala Publications, Inc., 1986.

Goldberg, Philip. *The Intuitive Edge*. Los Angeles: Jeremy P. Tarcher, Inc., 1983.

Goleman, Daniel, Paul Kaufman, and Michael Ray. *The Creative Spirit*. New York: Dutton Books, 1992.

Gombrich, E. H. *The Story of Art*. 16th ed. London: Phaidon Press, 1995.

Gottlieb, Carla. *Beyond Modern Art*. New York: E. P. Dutton & Co., 1976.

Grimes, William. "Along Publisher's Row." Reprinted in *Authors Guild* (Spring 1998): 31.

Hackett, Pat, ed. *Popism: The Warhol '60s*. New York: Harcourt Brace, 1990.

Haring, Keith. *Keith Haring's Journals*. London: Viking Penguin, 1996.

Hemingway, Ernest. *A Moveable Feast*. New York: Scribner Classics, 1964.

Henri, Robert. *The Art Spirit*. 1923. Reprint, New York: Westview Press, 1984.

Hofmann, Hans. *Search for the Real*, rev. ed. Cambridge, Mass.: M.I.T. Press, 1977.

Holzer, Burghild Nina. *A Walk Between Heaven and Earth*. New York: Bell Tower/ Harmony, 1994.

Howard, Francis Minturn. "Rockefellers Knew Intent, Rivera Asserts." *New York Herald Tribune*, 19 May 1933.

——. "Rivera Murals Banned in N.Y.," *New York Herald Tribune,* 9 May 1933.

Jamison, Kay Redfield. "Manic Depressive Illness and Creativity." *Scientific American*, February 1995, 64-65.

Kandinsky, Wassily. *Concerning the Spiritual in Art*. New York: Dover Publications, 1977.

Khalsa, Dharma Singh M.D. with Cameron Stauth. *Brain Longevity: The Breakthrough Medical Program that Improves Your Mind and Memory*. New York: Warner Books, 1997.

Kimmelman, Michael. "Trying To Separate Ben Shahn's Art From His Politics." *New York Times*, 13 November 1998, Sec. E.

Krishnamurti, J. *Think on These Things*. New York: HarperCollins, 1989.

La Cour, Donna Ward. *Artists in Quotation*. Jefferson, N.C.: McFarland and Co., 1989.

Laliberté, Norman, and Richey Kehl. *100 Ways to Have Fun with an Alligator and 100 Other Involving Art Projects*. Blauvelt, N.Y.: Art Education, Inc., 1969.

Lamott, Anne. *Bird by Bird: Some Instructions on Writing and Life*. New York: Pantheon Books, 1994.

Lavery, Sheila. *The Healing Power of Sleep*. New York: Fireside Books, 1997.

Lochte, Dick. "An Appetite for Mystery." *Bon Appetit*, August 1998, 26.

Maisel, Eric. *Affirmations for Artists*. New York: G. P. Putnam's Sons, 1996.

Mann, Thomas. *The Magic Mountain*. trans. John E. Woods. New York: Vintage Books, 1996.

Massey, Robert. *Formulas for Painters*. New York: Watson-Guptill Publications, 1967.

May, Rollo. *The Courage to Create*. New York: W. W. Norton, 1974.

Muller, Joseph-Emile. *Fauvism*. New York: Frederick A. Praeger, Inc., 1967.

Nochlin, Linda. *Realism*. New York: Pelican Books, 1971.

Pach, Walter. "Rockefeller, Rivera, and Art," *Harper's Monthly Magazine*, September 1933, 476.

"Painters Painting." Produced and directed by Emilio DeAntonio. Available through Museum of Modern Art, New York, 1972. Film documentary.

Progoff, Ira. *At a Journal Workshop*. Rev. ed. Los Angeles: J. P. Tarcher, 1992.

Richter, Jean Paul, ed. *The Notebooks of Leonardo da Vinci*. Vol. 1. New York: Dover Publications, 1970.

——. *The Notebooks of Leonardo Da Vinci*. Vol. 2. New York: Dover Publications, 1970.

Riding, Alan. "Reviled in Life, Embraced in Death." *New York Times,* 12 August 1998, sec. E.

Rilke, Rainer Maria. *Letters to a Young Poet.* New York: W. W. Norton, 1994.

Robinson, Roxana. *Georgia O'Keeffe*. New York: Harper & Co., 1989.

Rooney, Andy. "Along Publisher's Row." *Authors Guild Bulletin,* Spring 1998, 31. From column owned by Tribune Media Services, Chicago.

Rosanoff, Nancy. *Intuition Workout*. Santa Rosa, Calif.: Aslan Publishing, 1991.

Rowan, Roy. *The Intuitive Manager.* Berkley, Calif.: Berkeley Books, 1987.

SantoPietro, Nancy. *Feng Shui: Harmony by Design*. New York: Berkeley/Penguin Putnam Inc., 1996.

Shahn, Ben. *The Shape of Content*. Cambridge, Mass.: Harvard University Press, 1957.

Shaman, Sanford Sivitz. "An Interview with Philip Pearlstein." *Art in America*, September 1981, 126, 213.

Shattuck, Roger. *The Banquet Years*. Rev. ed. New York: Random House, 1979.

Tompkins, Calvin. *Off the Wall*. New York: Penguin Books, 1980.

Truitt, Anne. *Turn: Journal of an Artist*. New York: Penguin Books, 1980.

Van Gogh, Vincent. *The Complete Letters of Vincent Van Gogh*. Vol. 2. Greenwich, Conn.: New York Graphic Society, 1959.

Vasari, Giorgio. *Lives of the Painters, Sculptors and Architects*. 1568. Reprint, New York: AMS Inc., 2000.

Wakefield, Dan. *Creating from the Spirit*. New York: Ballantine, 1996.

Webster's New World Dictionary. 2d college ed. New York: Simon & Schuster, 1982.

Wellington, Hubert, ed. *Journal of Eugène Delacroix*. Ithaca, N.Y.: Cornell University Press, 1880.

Weschler, Lawrence. *Seeing Is Forgetting the Name of the Thing One Sees*. Berkeley/Los Angeles: University of California Press, 1982.

Wittgenstein, Ludwig. *Remarks on Colour*. Berkeley and Los Angeles: University of California Press, 1978.

Wood, Jane and Denise Silver. *Joint Application Development*. 2d ed. New York: John Wiley & Sons, Inc., 1995.

Yudkin, Marcia. *Intuition: The Key to Creativity*. Taped speech delivered in Saratoga Springs, N.Y., April 5, 1992.

Index

A

Aaparyti, Minna (journal maker), 142
Aboriginal art and culture Web sites, 186
Aborigines, the, 185
Abstract Expressionist era, the, 199
academia, 68
activists, artists as, 68, 118; *see also* Ben Shahn;
 Thomas Hart Benton; Diego Rivera
ACTUP, 68; *see also* Keith Haring
Adams, Kathleen, 143
advertisers,
 use of nostalgia, 162
 use of our spare time, 84
Aesthetics,
 realizing different kinds of, 122
 what are, 101, 121
affirmations, 50, 58
 giving yourself, 59
Agee, James, 86
aloneness, artists alone together, 83, 86
ambiguity, 70, 166
Americans for the Arts, the, Web site, 98
André Emmerich Gallery, the, 140
Armory, show of 1913, 116
Art Calendar magazine, 234
Art Dealers of America, Web site, 95
"art muscles," 110

art world, the, 68, 70
"artistic aerobics," 50, 129
artists,
 alone, 92
 chronicling society, 99
 collaborating, 53, 83
 on-line, 95–98
 ordinary people, 74
 video, 230
artwork,
 blocks to, 223
 collaborating, 83, 160
 completing, 225
 editing your, 71
 how you begin, 208
 two different styles of, 156
 re-examining, 158, 235
Artswire (Web site), 95
attention, importance of paying, 8, 141
Audette, Anna Held, 220
Australian Outback, the, 184

B

background, importance of, 155
Bacon, Francis, 166
Barron, Anthea, 160
Barron, Frank, 160

Bayles, David and Ted Orlando, 69
benchmark, making your, 71
Benton, Thomas Hart, 116
Berger, John, 15
"block types," 222
blocks,
 artists, 213
 class in, 213–218
 Anne Lamott on, 29
 Jerry Mundis on, 221
Bonnard, Pierre 25
Borbély, Alexander, 173–4
Bosendorfer piano, 204
brainstorming, 227
 in groups, 230
 incremental, 229
 silent, 229
Brangwyn, Frank, 112
breathing,
 inspirational, 78
 inspired, 217
 yogic and meditational, 79
Brooklyn Museum of Art, the, 111
Brownies, Robert Louis Stevenson's, 174

C

Cage, John, 86
Cassou, Mitchell and Stewart Cubley, 218
Castenada, Carlos, 173
cause and effect, 162
cemeteries, 180
Center for Journal Therapy, the (Denver, CO), 143
Cézanne, Paul, 37, 195
change,
 afraid to, 54
 habits, through self-hypnosis, 230
 how things you know can, 167
 in an artist's style, 26
chaos, 106, 212
child, finding your inner, 76
childhood, 48, 80
children's books, 119
Christie's, Web site, 97
Circe, your personal advocate, 49
choice,
 and inspiration, 238
 your, 237
Cocteau, Jean, 111
collaboration, 83, 160
Coleridge, Samuel Taylor, 173
Collage (catalog of journal supplies), 134
color, your favorite, 183;
 working with one you have trouble with, 182
Columbia University, Research Center for Arts

and Culture, 74
confidence,
 building, 49, 88
 why it's important, 47
 your confidence bank, 49
"Connections" (TV show), 200
cookbooks, 37
Cornell, Joseph, 25
Creating Ancestors, the, 185
creativity,
 and living forever, 75
 and moods, 57
 building it, 49
 what can stop it or slow it down, 48–49
 what kills, 48
 finding your inner child, 76
creativity killers, 49, 77
criticism, 60, 73
cropping,
 your own work, 13–14
 Philip Pearlstein and, 13–14
 see also edit
Cubist era, the, 111
Curry, John Steuart, 116
Csikszentmihalyi, Mihaly, 8

D

Dass, Baba Ram, 211
Daumier, Honoré, 195
David, Jacques-Louis, 195
da Vinci, Leonardo, 88, 94, 110, 153, 165, 195
dealer, 74
Degas, Edgar, 100
Delacroix, Eugène, 193
details, importance of, 155
DHEA (substance produced by humans), 126
Diaghilev, Sergey Pavlovich, 111
De Chirico, Giorgio, 152
Dialogue House Associates, 135
diet,
 when to eat what, 124
differences,
 seeing, 166;
 small, but important, 14
Disney, Walt, 230
drawing,
 in public, 101
 judging your, 41
 life, 93
 trees, 108
 see also sketching
dreams, using your, 172
 learning to dream for inspiration, 175
Drew, Elizabeth, 47

E

Ealy, C. Diane, 39
Eating,
 healthier foods and working more
 effectively, 124
Echo (Web site), 97
editing,
 fragments versus the whole thing, 12–13
 how to, 71
 your work, 71
effects on your art,
 economic situation, 111
 ethnicity, 111
 location—urban or rural, 112
 parents or caretakers, 111
 politics, 111, 112
Einstein, 170
Eliot, T. S., 170
emmigrants, 7
emotionalism, in drawing, 122
enabling inspiration, 19–21
Equitable Life building, the (New York), 117
exercise, 79, 126
expanding, your options, 237

F

failure, 62
fattening medium, 34
 see also mediums
fears,
 artists', 68
 facing your, 68
 of failure, 69
 of the art world, 68, 70
 of your creativity, 67
 of your talent, 69
 of yourself as "the artist," 73
feelings,
 "gut", 80
 when inspired, 16
focus, 65
feng shui, 206–208
 in your studio, 207–208
 what is, 206
films, 188
finishing, a work, 225
Fischl, Eric, 56, 166
"fixing" a work of art, 211
Finn, Huckleberry, 117
Finster, Reverand Howard, 70
found objects, 77
Fournier, Bonnie, 144
fragment, versus whole, 12–13
Frankie and Johnny, 117

"fresh eyes," 156
Freud, Sigmund, 170

G

Gamblin, Robert, 34
Gamblin Artists Color Company, 34–35
Gandhi, Mahatma, 170
Gardner, Howard, 170
gardens, public, 179
Garfield, Patricia, 174
Gauguin, Paul, 37
Gericault, Théodore, 163, 193
gestalt, "two chair" theory, 158
Getty Museum, the, Web site, 97
Gimbel, Theo, 208
Goethe, Joann Wolfgang von, 238
Goldberg, Natalie, 21, 210
Goya, Francisco José de, 163
Graham, Martha, 170
Green, Jim (tai chi expert), 87
Greenwich Village, 203–204
Gregg, Susan, 159
Grimes, William, 37
growing, 61
groups, 93
Guild, the, Web site, 98

H

Hamill, Pete (writer), 234
Haring, Keith, 68, 201
Harnack, Curtis, 140
Hemingway, Ernest, 18
Hill, Joe, 114
Hitchcock, Alfred, 230
Holzer, Nina, 141
Hootie and the Blowfish (music group), 122
Hopper, Edward, 117

I

ideas, 85;
 in your work, 119
 nurturing, 129
images,
 from dreams, 172;
 from memory, 80
 from words, 172
 switching places in, 158
image templates, create your own, 22
Intensive Journal, the, 135
imaginary people, losing control to, 218
indexing, your ideas, 106
individuality, tradition of, 160
information, you already have, 80
Ingres, Jean-Auguste-Doninique, 193

inspiration,
aesthetic, 122
and starting over, 175
enabling it to come, 84
inspiring ourselves, 149
from color, 183
from films, 189
from singing, 18
what worked before, 16–18
which one to follow, 123
intuition, 80
Irwin, Robert, 10

J

James, Jesse, 117
Jamison, Kay Redfield, 57
Johns, Jasper, using dreams, 172
journals,
artists who keep one, 136
artists who kept them in the past, 191
artwork from, 138
feed the creative process, 133, 140
keeping one, 133
how to make and keep, 135
Minna Aaparyti (journal maker), 142
modern, 201
supplies, 134
when you travel, 139

K

Kate's Paperie (New York), 134
Kennedy Center, Web site, 95
Kienholtz, Edward, 133
Kimmelman, Michael, 114
King, Martin Luther, Jr., 114
Kirschner, Ernst Ludwig, 152, 155, 156
Koons, Jeff, 122
Kronsky, Betty, 213–218
Kushner, Tony, 160

L

Land, Edwin, 43
Lamott, Anne, 29–30
Lascaux, the caves of, 75
Lavery, Sheila, 233
learn, 60
Lenin, Vladimir Ilyich Ulyanov, 113
Leo Castelli Gallery, the, 26
libraries, 180
life drawing, 93
light, how you use, 152, 154
lighting, 101, 151
Los Angeles County Museum, the, Web site, 96
Los Angeles Times, the, 135

Louvre Museum, the 202
Web site, 96
Lucky Dog Multimedia, 145
Lycos (Web site), 97

M

Magritte, René, 11, 152
Maisel, Eric, 59
Manet, Edouard, 201
Mann, Thomas, 86
Massine, Léonide, 111
Massey, Robert, 86
University of Maryland, the, 140
Matisse, Henri, 24, 36, 170
May, Rollo, 67, 237
mediums,
fattening, 34
gelled alkyd, 34
wax, 34
meditation, 79
memories,
childhood, 80
olefactory, 35
other people's, 160
tasting, 36
work, 106
mess, making one, 77
methods, of working, 106
Metropolitan Museum of Art, the, 27
Web site, 95
MIT Visual Arts Center, the, Web site, 96
mind, stilling yours for inspiration, 89
"mistake ribbons," 137
Missouri, state capitol mural, 117
Mitchell Gallery of Flight, the, 165
Mon, Bascha, 53
Montuori, Alfonso, 160
Moods, and creativity, 57
Moors, the, 194
mortality, and art, 75
Moses, Grandma, 122
motion, in art, 163
Muller, Joseph-Emile, 156
Munch, Edgar, 163
Mundis, Jerry, 220
museums, 53, 68, 75, 169
Museum of Modern Art, the (New York), 33, 192
music,
in your studio, 208;
pathways to your past, 18
myths,
about creativity, 58
writers believe, 224

N

naming, 10, 12
National Aeronautics and Space Administration, 165
National Air and Space Museum, 16
negative space, 108
networking, 92
New Dramatists (New York), 159
New School, the, 117
New York Central Art Supply, 34
New York Times, the, 114
Nijinsky, Vaslav Fomich, 111
Nin, Anais, 135
Noguchi, Isamu Museum, 16
nostalgia,
 advertisers use of, 162
 others, 160
 uses of, 162
 yours, 160
notes, 9
Nussbaum, Felix, 75

O

Olitski, Jules, 33
O'Keefe, Georgia, 25
Open Center, the (New York), 215
Oppenheimer, Meret, 33
on-line, addresses for artists, 95–98
organizing, your mind for inspiration, 105
Osborn, Alex (inventor of brainstorming), 228

P

Pach, Walter, 113
Page, Judith (journal artist), 138
parks,
 artists visit, 140;
 artists programs at, 145
Paschke, Ed, 154
past, in your artwork, 62, 149; *see also* memories
Pearlstein, Philip, 13
physical condition, of artists, 199
play, importance of, 76
Picasso, Pablo, 24, 86, 111, 114, 131
Place de la Concorde, the (Paris), 178
places,
 everyday, 177, 179
 exotic, 177, 183
 inspiring, 179
point of view, 62, 111
 changing your, 151
politics, 111, 112
Pollock, Jackson, 117
Poons, Larry, 33
Pop Art era, the, 26, 99

Progoff, Ira, 135
Proust, Marcel, 36–37
Public Art Fund, the (New York), Web site, 96

Q

quiet, importance of, 90
questions, dumb, 43–44

R

Radio City Music Hall, 171
Rauschenberg, Robert, 33, 77
RCA building, the (New York), 112
Regionalists, the, 116
Renoir, Pierre-Auguste, 195
repetition, 76
Review magazine, Web site, 97
reviews, how to write your own, 44
Rhoplex, 34
Rilke, Rainer Maria, 86
Rivera, Diego, 112
Rockefeller Center, the, 113
Rockwell, Norman, use of nostalgia, 162
Rooney, Andy, 45
Rosenberg, Julius and Ethel, 114
Rosenquist, James, 26–27
Rowan, Roy, 81

S

Sacco, Nicola, 114
safe, feeling, 58
SantoPietro, Nancy, on feng shui, 206
Satie, Eric, 111
Schnabel, Julian, 153
Schwitters, Kurt, 192
school, your old, 180
Sedona, Arizona, 186
seeing, 14
self-assurance, *see* confidence, 56
self-esteem,
 and professionalism, 48, 51
 repairing your, 49
self-help bookshelf, creating your, 234
self-hypnosis, how it works, 230–231
senses, the five, 192
 hearing, 18
 seeing, 7
 sensual experiences, 38
 smelling, 36
 tasting, 36
 touching, 31
serendipity, 170
Sergava, Katherine, on exercises for touching, 32–33
Sert, José Maria, 112

Seurat, Georges, 163
support groups, 74
Shahn, Ben, 114
Shattuck, Roger, 86
sketching, 101, 141; *see also* drawing
sleep, importance of, 232
smelling, 35–36
solitude,
 and creativity, 83
 essential, 83
 for passage into adulthood, 85
 value of, 83
 your time alone, 84
solutions, 173, 227
Sondheim, Stephen, 163
Sotheby's, Web site, 97
space, finding your, 203; *see also* solitude
spontaneity, 77, 170
Steinbeck, John, 116
Steinberg, Leo, 16
Stella, Frank, 27, 156
Stevenson, Robert Louis, 174
stilling, your mind, 89
Stonehenge, 184
storyboards, 230
Stravinsky, Igor Fyodorovich, 170
stress, 125
studio,
 inviting groups, 54
 using feng shui, 204, 206
 working in, 23
style,
 building your, 24, 111
 changes in an artist's, 130
subject,
 color as, 33
 finding your, 33, 72, 110, 116
Styron, William, 173

T

tactility, in art, 33; *see also* touching
talent, 69
technique, 69, 72
thinking,
 how you were taught, 30
 linearly versus holistically, 39–43
time, passage of, 164
timeliness, in art, 165, 211
Tompkins, Calvin, 86
tools, listening to your, 24
touching, 31
Toulouse-Lautrec, Henri de, 100, 152
trees, 108

Truitt, Ann, 139
trust, 71

U

Urso, Josette, 136, 158

V

Van de Rohe, Mies, 155
Van Gogh, Vincent, 24, 153
Vanzetti, Bartolomeo, 114
Vasari, Giorgio, 195, 199
Velazquez, Diego Rodriguez de Silva, 115
video, how to make a, 54–55
"visual anchors," 222
vitamins, to improve work habits, 124, 126
Vlaminck, Maurice de, 25

W

Wakefield, Dan, 18, 58
Warhol, Andy, 89
Web sites, 95–98
Weston, Stan, 156–157
Whitney Museum, the, 33, 155
Wilde, Oscar, 86
Wood, Grant, 116
Wood, Jane and Denise Silver, 175
Words, making images, 21, 172
work habits, 106
 changing, 211
 recognizing your, 208–209

XYZ

Yahoo! (Web site), 97
yoga, 79, 91
Yoshida, Barbara, 140
Yudkin, Marcia, 81, 122

Books from Allworth Press

The Artist's Guide to New Markets: Opportunities to Show and Sell Art Beyond Galleries *by Peggy Hadden* (softcover, 5½ × 8½, 248 pages, $18.95)

The Fine Artist's Career Guide
by Daniel Grant (softcover, 6 × 9, 304 pages, $18.95)

The Artist's Resource Handbook
by Daniel Grant (softcover, 6 × 9, 248 pages, $18.95)

The Fine Artist's Guide to Marketing and Self-Promotion
by Julius Vitali (softcover, 6 × 9, 224 pages, $18.95)

Artists Communities, Second Edition
by the Alliance of Artists' Communities (softcover, 6¾ × 10, 240 pages, $18.95)

Uncontrollable Beauty: Towards a New Aesthetics
edited by Bill Beckley with David Shapiro (hardcover, 6 × 9, 448 pages, $24.95)

The End of the Art World
by Robert C. Morgan (paper with flaps, 6 × 9, 256 pages, $18.95)

Sculpture in the Age of Doubt
by Thomas McEvilley (paper with flaps, 6 × 9, 448 pages, $24.95)

Beauty and the Contemporary Sublime
by Jeremy Gilbert-Rolfe (paper with flaps, 6 × 9, 208 pages, $18.95)

Lectures on Art *by John Ruskin* (softcover, 6 × 9, 264 pages, $18.95)

The Laws of Fésole: Principles of Drawing and Painting from the Tuscan Masters *by John Ruskin* (softcover, 6 × 9, 224 pages, $18.95)

Imaginary Portraits *by Walter Pater* (softcover, 6 × 9, 240 pages, $18.95)

Legal Guide for the Visual Artist, Fourth Edition
by Tad Crawford (softcover, 8½ × 11, 272 pages, $19.95)

Business and Legal Forms for Fine Artists, Revised Edition
by Tad Crawford (softcover, includes CD-ROM, 8 ½ × 11, 144 pages, $19.95)

The Artist-Gallery Partnership: A Practical Guide to Consigning Art, Revised Edition *by Tad Crawford and Susan Mellon* (softcover, 6 × 9, 216 pages, $16.95)

Please write to request our free catalog. To order by credit card, call 1-800-491-2808 or send a check or money order to Allworth Press, 10 East 23rd Street, Suite 210, New York, NY 10010. Include $5 for shipping and handling for the first book ordered and $1 for each additional book. Ten dollars plus $1 for each additional book if ordering from Canada. New York State residents must add sales tax.

To see our complete catalog on the World Wide Web, or to order online, you can find us at *www.allworth.com.*